Impossible Mourning

Impossible Mourning

HIV/AIDS and Visuality After Apartheid

Kylie Thomas

Lewisburg
BUCKNELL UNIVERSITY PRESS

Published by Bucknell University Press
Copublished with Rowman & Littlefield
4501 Forbes Boulevard, Suite 200, Lanham, Maryland 20706
www.rowman.com

10 Thornbury Road, Plymouth PL6 7PP, United Kingdom

Copyright © 2014 by Kylie Thomas

All rights reserved. No part of this book may be reproduced in any form or by any electronic or mechanical means, including information storage and retrieval systems, without written permission from the publisher, except by a reviewer who may quote passages in a review.

British Library Cataloguing in Publication Information Available

Library of Congress Cataloging-in-Publication Data

Thomas, Kylie, author.
 Impossible mourning : HIV/AIDS and visuality after apartheid / Kylie Thomas.
 pages cm
 Includes bibliographical references and index.
 ISBN 978-1-61148-534-9 (cloth : alk. paper) — ISBN 978-1-61148-535-6 (electronic)
 1. AIDS (Disease)—South Africa. 2. AIDS (Disease)—South Africa.—Psychological aspects. 3. AIDS (Disease)—Patients—South Africa—Death. 4. Bereavement—South Africa. 5. AIDS (Disease) and the arts. I. Title.

RA643.86.S6T47 2014
362.19697'9200968—dc23

2013030822

∞™ The paper used in this publication meets the minimum requirements of American National Standard for Information Sciences—Permanence of Paper for Printed Library Materials, ANSI/NISO Z39.48-1992.

Printed in the United States of America

For Jared, Alastair, Sophie, and Jemma

Contents

List of Illustrations ix
Acknowledgments xiii
Introduction: A Language for Mourning 1

1. Speaking Bodies 13
2. Passing and the Politics of Queer Loss Post-Apartheid 35
3. Traumatic Witnessing: Photography and Disappearance 61
4. Mourning the Present 87
5. Disavowed Loss During Apartheid and After in the Time of AIDS 107
6. Refusing Transcendence: The Deaths of Biko and the Archives of Apartheid 123
7. *(Without) Conclusion: "The Crisis is Not Over"* 149

Bibliography 155
Index 165
About the Author 169

List of Illustrations

	Cover *Smoke Portrait* , 2005 by Diane Victor. Courtesy of Diane Victor.	
1.1	*Self-portrait*, 2002, by Nomawethu Ngalimani, courtesy of the Bambanani Women's Group.	15
1.2	*Self-portrait*, 2002, by Ncedeka, courtesy of the Bambanani Women's Group.	19
1.3	*Self-portrait*, 2002, by Nondumiso Hlwele, courtesy of the Bambanani Women's Group.	21
1.4	*Self-portrait*, 2002, by Bongiwe, courtesy of the Bambanani Women's Group.	31
2.1	*Nomonde Mbusi, Berea, Johannesburg, 2007*, 2007 by Zanele Muholi. Courtesy of Zanele Muholi and Stevenson, Cape Town and Johannesburg.	41
2.2	*Triple III*, 2005 by Zanele Muholi. Courtesy of Zanele Muholi and Stevenson, Cape Town and Johannesburg.	43
2.3	*Ordeal*, 2003 by Zanele Muholi. Courtesy of Zanele Muholi and Stevenson, Cape Town and Johannesburg.	44
2.4	*Case Number*, 2004 by Zanele Muholi. Courtesy of Zanele Muholi and Stevenson, Cape Town and Johannesburg.	45
2.5	*Hate Crime Survivor I*, 2004 by Zanele Muholi. Courtesy of Zanele Muholi and Stevenson, Cape Town and Johannesburg.	45
2.6	*Hate Crime Survivor II*, 2004 by Zanele Muholi. Courtesy of Zanele Muholi and Stevenson, Cape Town and Johannesburg.	47
2.7	*Aftermath*, 2004 by Zanele Muholi. Courtesy of Zanele Muholi and Stevenson, Cape Town and Johannesburg.	48

x List of Illustrations

2.8 *Nosizwe Cekiso, Gugulethu, Cape Town, 2008*, 2008 by Zanele Muholi. Courtesy of Zanele Muholi and Stevenson, Cape Town and Johannesburg. 53
2.9 *Gazi T Zuma, Umlazi, Durban, 2010*, 2010 by Zanele Muholi. Courtesy of Zanele Muholi and Stevenson, Cape Town and Johannesburg. 54
2.10 *Penny Fish, Vredehoek, Cape Town, 2008*, 2008 by Zanele Muholi. Courtesy of Zanele Muholi and Stevenson, Cape Town and Johannesburg. 56
3.1 *Patients with HIV and TB at Matibi Mission Hospital in Zimbabwe who are separated from the rest of the patients sit outside in an "isolation" section to prevent the spread of TB. In this area 37 percent of pregnant mothers are testing HIV-positive. Zimbabwe now has the highest level of HIV infection out of any country in the world with 35 percent of the adult population testing positive*, July 1993 by Gideon Mendel. Courtesy of Gideon Mendel. 64
3.2 *The wife of a patient with AIDS at Matibi Mission Hospital in Zimbabwe feeds him*, July 1993 by Gideon Mendel. Courtesy of Gideon Mendel. 65
3.3 *The wife of a patient at Matibi Mission Hospital in Zimbabwe takes care of her husband who was very ill with AIDS related infections*, July 1993 by Gideon Mendel. Courtesy of Gideon Mendel. 70
3.4 *The wife of a patient with AIDS at Matibi Mission Hospital in Zimbabwe carefully lifts up her husband. Seconds later he died from kidney failure*, July 1993 by Gideon Mendel. Courtesy of Gideon Mendel. 71
3.5 *Grieving family members at Matibi Mission Hospital in Zimbabwe*, July 1993 by Gideon Mendel. Courtesy of Gideon Mendel. 73
3.6 *Mzokhona Malevu (29) and twenty-one family members live in a two room shack in Enseleni. He is bravely open about his AIDS*, by Gideon Mendel. Courtesy of Gideon Mendel. 75
3.7 *Mzokhona Malevu sleeps in his family's two-roomed squatter shack in Enseleni Township near Richards Bay in northern KwaZulu/Natal, South Africa.*, 2000 by Gideon Mendel. Courtesy of Gideon Mendel. 77
3.8 *Mzokhona Malevu who was severely ill with AIDS-related infections is carried by his brother through the squatter camp the family lives in to the nearby road where he can get into a vehicle which will take him to the local clinic*, 2000 by Gideon Mendel. Courtesy of Gideon Mendel. 78

3.9	*Treatment Action Campaign March, International AIDS Conference 2000. Durban, South Africa,* 2000 by Gideon Mendel. Courtesy of Gideon Mendel.	80
3.10	*Thendeka Mantshi lives in a Khayelitsha squatter community. She discovered that she was HIV-positive when her baby was born HIV-positive. They are part of a new treatment program aimed at demonstrating that people living in poor African communities can benefit from the same medications available in Western countries, or to well-off individuals in Africa,* 2001 by Gideon Mendel. Courtesy of Gideon Mendel.	81
4.1	*Smoke Portrait,* 2005 by Diane Victor. Courtesy of Diane Victor.	91
4.2	*Smoke Portrait,* 2005 by Diane Victor. Courtesy of Diane Victor.	92
4.3	*Smoke Portrait,* 2005 by Diane Victor. Courtesy of Diane Victor.	93
4.4	*Smoke Portrait,* 2005 by Diane Victor. Courtesy of Diane Victor.	96
4.5	*Sixolile Bojana,* 2005 by Pieter Hugo. Courtesy of Pieter Hugo and Stevenson, Cape Town and Johannesburg.	98
4.6	*Attwell Vuyani Mrubata,* 2005 by Pieter Hugo. Courtesy of Pieter Hugo and Stevenson, Cape Town and Johannesburg.	99
4.7	*Nyameka J. Matiyana,* 2005 by Pieter Hugo. Courtesy of Pieter Hugo and Stevenson, Cape Town and Johannesburg.	101
4.8	*Monwabisi Mtana,* 2005 by Pieter Hugo. Courtesy of Pieter Hugo and Stevenson, Cape Town and Johannesburg.	103
5.1	*A mother and grandmother mourning the loss of a tiny babe, Tembisa, October 21, 1989,* by Gille de Vlieg. Courtesy of Gille de Vlieg.	109
5.2	*Women mourn the death of Themba Dlamini, Driefontein, March 23, 1990,* by Gille de Vlieg. Courtesy of Gille de Vlieg.	118
6.1	*Amnesty Hearings, Port Elizabeth, Eastern Cape, December 1997,* by Jillian Edelstein. Courtesy of Jillian Edelstein.	129
6.2	*Gideon Johannes Nieuwoudt (left) and Mike Barnardo, a member of the witness protection team, Cape Town, March 31, 1998,* by Jillian Edelstein. Courtesy of Jillian Edelstein.	131
6.3	*Ntsiki Biko, widow of Steve Biko, Port Elizabeth, 1997,* by Jillian Edelstein. Courtesy of Jillian Edelstein.	132

6.4	*Belgium Biko, the younger brother of Steve Biko, at the Biko family home, Ginsburg Location, King William's Town, February 1997*, by Jillian Edelstein. Courtesy of Jillian Edelstein.	133
6.5	*The Death of Steve Biko*, 1983 by Ezrom Legae. Courtesy of Bruce Campbell Smith.	134
6.6	*It Left Him Cold—the Death of Steve Biko*, 1990 by Sam Nhlengethwa. Courtesy of Sam Nhlengethwa and the Standard Bank Collection at Wits Art Museum.	135
6.7	*Biko Series* Detail, 1980 by Paul Stopforth. Courtesy of Paul Stopforth.	137
6.8	*Biko Series* Detail, 1980 by Paul Stopforth. Courtesy of Paul Stopforth.	138
6.9	*Biko Series* Detail, 1980 by Paul Stopforth. Courtesy of Paul Stopforth.	140
6.10	*Elegy for Steve Biko*, 1981 by Paul Stopforth. Courtesy of Paul Stopforth.	142
6.11	*Portrait of a Man with Landscape and Procession (Bantu Steven Biko, 1946–1977)*, 1995 by Jane Alexander. Image used courtesy of the artist and the South African National Gallery, Cape Town; DALRO, Johannesburg; and VAGA, New York.	143
7.1	*Anonymous (covering face) is a university student at Maputo University in Mozambique. Due to the extreme stigma he might face, he chose to not include any of his clothes in the photograph in case they might identify him. "I can't be identified because it may have a bad impact on my position as a university student. I can't even allow you to say what my faculty is. Here in Mozambique there is discrimination promoted by the government. In one of his speeches the prime minister said Mozambique should not invest in educating people with AIDS as there is no hope for them. The government only cares about getting enough qualified technicians for its objectives. If my faculty discovered my status there is a real possibility that they would discriminate against me. Even if they don't expel me straight away, they would try all sorts of devious means to get rid of me."* c. 2002 by Gideon Mendel. Courtesy of Gideon Mendel.	153

Acknowledgments

I am grateful to the AW Mellon Foundation, the National Research Foundation, and the American Council of Learned Societies African Humanities Program for granting me fellowships that have sustained me financially over the writing of this work.

I was very fortunate to have been a graduate student at the University of British Columbia in Vancouver, Canada, while Ross Chambers was a visiting professor there and to have attended his class, "Witnessing and the discourses of extremity." The texts we read profoundly influenced the work I was to do afterwards about HIV/AIDS in South Africa.

I would like to thank Jonathan Morgan, Nondumiso Hlwele, Victoria, Nomonde, Ntombizodwa Somlayi, Babalwa Cekiso, Ncedeka, Bongiwe, Cordelia Ndzamela, Kali van der Merwe, Noloyiso, Jane Solomon and Thozama for the work we did together on the *Long Life* book project.

I am very grateful to John Higgins, my dissertation supervisor at the University of Cape Town, who has encouraged, worried about, and advised me for a decade now. I am grateful to Gabeba Baderoon, Louise Green, Noëleen Murray, and Sandy Young for their friendship and support during the writing of my dissertation. In 2002–2003 I was a visiting fellow at the departments of Rhetoric and of Medical Anthropology at the University of California at Berkeley. I thank Judith Butler and Lawrence Cohen, my generous advisors there. Maud Ellmann, Deborah Posel, and Gabriele Griffin examined my doctoral study and wrote critiques that shaped the form and content of this book.

In 2008, I held a post-doctoral fellowship in the Department of Fine Art at Rhodes University in Grahamstown. I would like to thank Brenda Schmahmann, then head of department there, and now Research Professor at the University of Johannesburg, for her support of my work. It was in Grahamstown

that I met Diane Victor whose "Smoke Portraits" occupy a central place in this book. I am very grateful to her for allowing me to make use of her work on the cover. In 2009–2010 I was a post-doctoral fellow in the Archive and Public Culture Research Initiative in the Department of Social Anthropology at the University of Cape Town. I am grateful to Carolyn Hamilton for inviting my work into that project and for her great skill in connecting people. Thanks to Alexander Dodd, Michael Nixon, Jacqueline Maingard, Litheko Modisane, Mbongiseni Buthelezi, Victoria Collis-Buthelezi, Daniel Herwitz, Lucia Saks, Josette Cole, Thokozani Mhlambi, Nick Shepherd, Cóilín Parsons, Grant McNulty, John Wright, Megan Greenwood, Marlene Winberg, and Niklas Zimmer for their engagement with my work. Thanks also to Sally Frankenthal, Mugsy Spiegel, Francis Nyamnjoh, Susan Levine, Patti Henderson, Colleen Peterson, Marcelle Faure, Mona Hakimi, and Jess Auerbach. I am particularly grateful to David William Cohen for his critical and insightful readings of my work and for his encouragement. I thank Njabulo Ndebele for his support for my work over many years.

Since 2011, I have been working at the Center for Humanities Research at the University of the Western Cape, first as a researcher with the Violence and Transition Project and from August 2012 as an ACLS African Humanities Program Fellow. I would like to thank Premesh Lalu, Nicky Rousseau, Heidi Grunebaum, Suren Pillay, Lameez Lalkhen, Brian Raftopolous, and the fellows and associates at the CHR for the vibrant intellectual space they have provided.

Jane Bennett, Yaliwe Clark, Helen Scanlon, Adelene Africa, Gillian Mitchell, Wardah Daniels, Jennifer Radloff, Selina Mudavanhu, and Hilda Ferguson at the African Gender Institute provided me with a lovely and supportive place in which to work at the University of Cape Town. I would also like to thank Lilian Jacobs at the Center for African Studies, University of Cape Town.

Thanks to Paul Weinberg for his support. I also thank Gabeba Baderoon, Joey Hasson, Meg Samuelson, Annie Leatt, Tessa Lewin, Sasha Rubin, Kathy Sandler, Anya Mendel, Fiona Ross, Ingrid Fiske, Cal Volks, Colette Gordon, Natasha Distiller, Andrew van der Vlies, Konstantin Sofianos, Maurits van Bever Donker, Kitya Nowicki, Gail Meyers, and Louise Green.

Sergio Alloggio encouraged me to forgive my earlier self and retain some of the sections of this book written years ago. I am grateful to him for this and for his readings of my work.

I owe a special thanks to Greg Clingham, commissioning editor and director of Bucknell University Press, for his response to my work. Pamelia Dailey and Sam Brawand at Bucknell University Press and Brooke Bures at Rowman and Littlefield have been wonderful throughout the book pro-

Acknowledgments xv

duction process. I am very grateful to Jennifer Poole for her help with the preparation of this manuscript. I would also like to thank Nasrin Olla for her help with finding missing references and Brian Michael Muller for his help with the images.

This project has meant that I have had the privilege of corresponding with many of the artists I most admire and whose works have inspired the readings in this book. My great thanks to Jane Alexander, Paul Stopforth, Zanele Muholi, Gideon Mendel, Pieter Hugo, Sam Nhlengethwa, Gille de Vlieg, Jillian Edelstein, and Diane Victor. I would also like to thank Julia Charlton at the Wits Art Gallery; the Michael Stevenson Gallery, Cape Town; the Goodman Gallery in Johannesburg; the South African National Gallery, Cape Town; and Bruce Campbell Smith. Gille de Vlieg and Paul Stopforth have been inspiring and generous interlocutors. I thank Ingrid de Kok and Eddie Maluleke for allowing me to include lines from their poems.

I am indebted to my aunts, Trudy and Joan, to my mother, Sandy, and to my grandmother, Stella.

Introduction

A Language for Mourning

𝒯his book has been a long time in the making. The thinking and writing it contains cannot be unbound from the births and deaths that have affected me over the course of its production. The deaths of Xoliswa, Andile, and Neliswa, people I met and worked with in Khayelitsha in 2001 and who all died of AIDS in 2002, found me without a language for grief. The language I was immersed in, a language of activism and protest, left little space for mourning. I chronicled these losses in poems I wrote at the time, but I could not find a way to speak of these deaths to others without becoming enraged. My fury about the failure of the state and of civil society to recognize the crisis the epidemic presented meant that politics eclipsed mourning over and over again.

I did not grieve these deaths, at least not in any proper way. I did not attend any funerals. I was close to many people in their dying, but I never bore witness to the dead. And had I been at any burials they may have only served to compound my inability to accomplish the work of mourning since AIDS, most likely, would not have been spoken there.

In 2001, I attended the "AIDS in Context" conference held at the University of the Witwatersrand in Johannesburg. Nono Simelela, then the Head of the Department of Health's HIV/AIDS directorate, broke down and wept. Zackie Achmat, the chairperson of the activist movement the Treatment Action Campaign (TAC), spoke on the same panel and responded by noting that although we all wanted to cry this was not the time for tears but for action. And just as during the struggle against apartheid, mourning needed to take a particular form, could not be detached from the injunction: *mobilize*. Use these deaths to prevent the deaths of others! One thousand people dying of AIDS each day and one thousand new infections! Treat the People!

I was in my early twenties then, moving between the hip spaces of post-apartheid (yet still largely white) urban Cape Town where I lived and the sad, derelict places in the townships where people would gather at support group meetings to share their painful stories about living with HIV/AIDS. This was a truly bleak time for the hungry, the cold, and the sick who had been promised houses, security, and comfort and who were realizing that even if these promises were not false, they would not be actualized any time soon. The fact that the government was refusing to provide treatment and care for people living with HIV/AIDS was the most telling sign of the disjuncture between the promises of the new constitution and the everyday lives of the majority of South Africans.

In 2001, when I started research work for my doctoral dissertation at the University of Cape Town, I also began to work as a volunteer with the Memory Box Project, an art and narrative therapy and advocacy project based at the university's AIDS and Society Research Unit (ASRU). Together with Jonathan Morgan, I facilitated workshops for people living with HIV in support groups at clinics and hospitals in many of the informal settlements that surround the city. From the middle of 2001, and for the next year, we were to work in Khayelitsha, a black African township on the Cape Flats, almost exclusively.[1] At least three times each week we traveled from the university, situated on the slopes of Table Mountain, to the township, leaving the affluence and comfort of the spaces we occupied in the city behind us. Of the 400,000 people thought to be living in Khayelitsha at that time, 40,000 were estimated to be HIV-positive.[2]

This book was written in the shadow of Table Mountain, the stony heart around which the suburbs and townships of the city of Cape Town are located. The mountain was incorporated by the architects of apartheid to fundamentally organize the spatial and social geography of this place, the general principle being that the further away you are from the mountain the more marginal your place in the life of the city. While much has changed in post-apartheid South Africa, the geography of segregation remains largely intact. This spatial divide is a telling signifier of the continuities between the inequalities of the present and the past.

The divide between the material conditions of life in the township and of the lives of affluent city-dwellers is extreme—while there are exceptions, the majority of those who live in Khayelitsha are struggling to survive.[3] The conditions of life of those who live outside the bounds of the city are, for the most part, invisible to those who dwell within the city limits. Movement between the spaces of the city and the townships is economically prohibitive for many township dwellers. Having arrived in the township many people never attain the means to travel out again, either to return to the rural places they left

behind or even to simply journey into the city or surrounding suburbs. It also remains uncommon for white people to travel outside of white spaces and into black or colored areas; most white Capetonians travel past these vast shacklands at high speed, on their way to the airport or to the winelands situated not far beyond the townships. The majority of people living with HIV/AIDS in South Africa dwell in high-density, economically impoverished spaces like Khayelitsha. The failure of the state and of South African society more broadly to adequately respond to the crisis of the HIV/AIDS epidemic is connected to this spatial divide that is at one and the same time economic and psychic.

The Memory Box Project began its work at a support group run by the Red Cross in Khayelitsha. The cold room in which the support group was held slowly filled up as the group members arrived: forty women, two men and twenty babies. I would never think about people living with HIV and AIDS in abstract terms again. Many of the support group members were visibly ill, and those who did not appear extremely sick did not look well either. Several of the babies had terrible coughs. One man in particular seemed to be on the verge of death. He sat slumped over in his chair with a crazed expression on his face, his emaciated body in a state of collapse. At that time none of the members of the support group had access to anti-retroviral therapy (ART). We ran Memory Box workshops in the support group and slowly learned about the lives of the group members. Several weeks passed and the very ill man we came to know as Lamla, stopped attending. Jonathan and I assumed that he would die. The following month though, he returned and looked remarkably strong. He stood in the center of the circle of battered white plastic chairs and spoke at length in Xhosa. He seemed like a man possessed. Afterward we learned that he was testifying to the fact that he had started ART through Médecins Sans Frontières (MSF) and had been returned to life. We had witnessed the seemingly miraculous power of ART right before our eyes. Jonathan and I decided to record Lamla's story and the story of his wife, Nompumelelo, also a member of the support group. This was published as "Clutching onto Hope."[4]

Working in that particular support group in Khayelitsha in 2001 was the most intense and difficult work I have ever done. The support group members were all unemployed and lived in shacks, most were young, single mothers of babies or small children and all were HIV positive. In the absence of adequate health care and nutrition and in particular, without access to anti-retroviral drugs (ARVs) they would all be dead within the next few years. It rapidly became clear that conducting therapy sessions and interviews with the hungry, sick support group members was an inadequate response to the crisis they were facing. I tried to hold onto the notion that it was important to document their stories in order that their struggles would be made visible. By July of 2001,

six of the people I had worked with in Khayelitsha had died. Over 320,000 people died of AIDS in South Africa that year, and there were approximately the same number of new infections, yet the state's refusal to provide access to ART seemed unshakeable.[5]

At the beginning of 2002 I coordinated a project at the South African National Gallery in Cape Town which formed part of the "Positive Lives" photographic exhibition. The members of the Red Cross support group in Khayelitsha created memory boxes in the gallery space. I interviewed each participant about the images they had made and then transcribed their testimonies to display in the gallery alongside their memory boxes. The stories I recorded told of lives of struggle and despair. At that point, the chance that these people would attain access to ART seemed extremely remote, and many of the participants were traumatized and depressed. The photographic images on the walls around us reflected the devastating effects of the pandemic in southern Africa. Some of the photographs were of emaciated people dying of AIDS. While the images were powerful they were also disturbing and they elicited strong emotional responses in many of the participants in the Memory Box Project. But over the course of the two months we worked in the gallery, the space filled up with radically different depictions of people living with HIV/AIDS. Alongside the growing number of intensely colorful memory boxes was a series of images taken of people who had access to ART. South African photographer Gideon Mendel had begun to document the work of the TAC and of MSF in Khayelitsha. These new images were exhibited alongside Mendel's earlier works and the extreme contrast between these two sets of photographs conveyed the sense of hope that access to treatment promised.[6]

At the end of March 2002, Jonathan and I began to work in two support groups run by MSF in Khayelitsha. One of the support groups was for patients receiving ART and the other was for women who had had access to treatment during pregnancy to prevent vertical transmission from mother to child. We invited the support-group members to participate in a book project to document how ART was affecting their lives. *Long Life: Positive HIV Stories* portrays the lives of thirteen women through life narratives, photographs, and images they created of their own bodies.[7] The book was the result of a year of art-making and storytelling workshops and was published at the end of 2003.[8] Just before the book was launched, the South African government announced the adoption and details for the operational plan for comprehensive treatment and care for HIV/AIDS. The plan incorporated the provision of ART in the public health sector for South Africans with a CD4 cell count of less than two hundred. The importance of this shift in the government's position on HIV/AIDS cannot be overstated, but, as many

local doctors and activists noted, the real work of addressing the needs of people living with HIV and AIDS was only just beginning.

During the time I worked in Khayelitsha, I was witness to the important work MSF was doing in providing treatment for people living with HIV/AIDS. I saw how, once people were receiving treatment, they were returned to health. I also saw that there were many more sick people than the clinic could provide for and that, in spite of the critical intervention MSF was making in unambiguously showing that ART could be effectively administered in resource-poor settings, many people did not have access to treatment and, as a result, were dying. On each of my return journeys to the city from the township I would travel towards the mountain, which resembled more and more a vast tombstone, its blind face a metaphor for the myopia of the residents of the city. I imagined a commission being established to restore to the dead their proper names, to undertake to inscribe them in stone, across the face of the mountain, incontrovertible evidence of their lives, their deaths.

As my desire to simply make visible the lives of people living with HIV/AIDS attests, I began this project with the rather naïve idea that if they could tell their stories, if they could only be heard, they would be recognised as subjects of and by the law. I soon came to see that the problem lay less in whether people living with HIV/AIDS were represented than in *how* they were represented. I came to understand that the entry of people living with HIV/AIDS into the realm of representation could, and often does, only serve to compound their desubjectivisation. Like Eric Michaels, the author of the brilliantly titled memoir of living with and dying of AIDS, *Unbecoming*, this book seeks to show how being named HIV-positive often interpellates a particular kind of subject, one that enters into representation only to be unmade as a subject.[9] Over the course of writing this book I have come to see representation itself as a problem, one that is bound both to recognition and to loss. *Impossible Mourning* raises the question of what is at stake in failing to recognize the enormity of the losses of HIV/AIDS. It is written in a context where personal experiences of HIV and AIDS have largely been made unspeakable and spaces of public mourning have been few.

In a place and time where so much about the crisis of the epidemic is made invisible and so much painful history remains repressed, the work of visual artists takes on a particular significance. In the chapters that follow I explore how representation operates as a field of transformation and contest where the political and cultural are continually reconfigured. This book makes an argument for how visual forms of representation can allow for powerful, evocative and transformative modes of engagement with traumatic experience. It also seeks to mark how such forms of engagement are delimited by

the socio-political contexts in which they occur. Several chapters of this book seek to think about the difficulties we face in mourning the losses of AIDS in relation to the problem of mourning under apartheid. The visual works that I read here make these challenges visible. At the same time the affective force of the images that provide the focus for this book initiate, even compel, the ceaseless task of facing loss.

The first chapter is entitled "Speaking Bodies" and foregrounds some of the complexities of bringing the stories of people living with HIV/AIDS in South Africa into public view. The chapter focuses on the self-portraits made by the HIV-positive women with whom I worked in Khayelitsha in 2001–2002. These images form part of the *Long Life* book project,[10] a collaborative endeavor funded by MSF and intended to draw attention to the ways in which access to ART changes patients' lives. The portraits, known as "body maps," have been exhibited in South Africa, in London, and across the United States. The chapter considers how a powerful discourse was at work that informed the production of the book and resulted in the painful narratives of trauma the book contains being framed as "Positive HIV Stories." In seeking to show the efficacy of ART and in order to oppose the deadly rhetoric of the state, the book and readings of it that followed its publication foreground the hopeful elements of each person's story. My chapter asks what kinds of stories about HIV/AIDS can enter the public sphere and what forms of experience are rendered invisible? I read three portraits from the book focusing on symbols: Nomawethu's drawing of an anatomically correct broken heart surrounded by flames to signify the loss of her sister who committed suicide by pouring paraffin over her body and setting herself on fire when she discovered she was HIV positive; the scar on Bongiwe's head that marks the place where she was struck by a beer bottle and left for dead at a roadside after being raped; and Ncedeka's depiction of her baby who died at four months old and who floats above her image like a ghost.

Chapter 2, "Passing and the Politics of Queer Loss" centers on the work of South African photographer, Zanele Muholi, and raises the question of how experience that is deemed unspeakable can enter representation. I focus in particular on a series of photographs that depict lesbians who have been subject to so-called "corrective rape" and on Muholi's portraits of women who have subsequently died of AIDS. My reading of Muholi's portraits that constitute her "Faces and Phases" series explores how her photographs work with the ambiguities of "passing"—passing *away*, passing *between* states of gendered being, and passing *through* the prohibitions against making lesbian experience visible and mourning lesbian loss. In their "queer" approach to the representation of black women's bodies and sexuality, Muholi's work presents a beautiful contrast to the images I read in the preceding chapter. There are

also disturbing parallels between these images—experiences of violence, rape and murder figure in the life histories of all the women whose portraits are the subject of these chapters.

This chapter also engages with the question of visibility, invisibility, and the archive. Muholi describes herself as engaged in the production of an archive of images that portray experiences that would otherwise be misrepresented or entirely invisible. Her work can be understood as the production of a counter-archive that makes visible the limits of the dominant official archive, illuminating how queer subjects are written out of national history.

The third chapter, "Traumatic Witnessing: Photography and Disappearance," focuses on the work of Gideon Mendel, a photojournalist whose monograph *A Broken Landscape*[11] provides a detailed visual portrait of the effects of the epidemic in southern Africa. This chapter takes up the question of what it means to look upon the suffering of others and provides a close reading of a series of photographs of a man who dies while Mendel is photographing him. I argue that Mendel's photographs raise questions about the ways in which AIDS is commodified and inaugurate "a crisis in witnessing." At the same time I consider how photographs place a demand on those who look at them and can open the possibility for identification and recognition. I then turn to an analysis of how Mendel's practice has changed in the wake of the South African government's failure to respond adequately to the epidemic and in response to the work of the activist movement, the TAC. In a series of lengthy court battles against the state, people living with HIV/AIDS have testified to their own experiences and asserted their constitutional right to equal citizenship. Testimony and bearing witness are critical aspects of these processes and Mendel's work reflects the intertwining of legal discourse and personal narrative in representations of people living with HIV/AIDS in South Africa since 2000.

In chapter 4, "Mourning the Present," I juxtapose two sets of visual images that engage with HIV and AIDS and mourning—one, a series of corpses photographed in the Khayelitsha morgue by South African photographer Pieter Hugo, and the other, a group of portraits of people living with HIV rendered with candle smoke on paper by South African artist Diane Victor. The first section of the chapter engages with Victor's "Smoke Portraits," which suggest that recognizing the losses of AIDS implies recognizing our own fragile embodiment. The chapter argues that the process of mourning is one of remembering the past through marking the relation between the living and the dead. In this sense mourning is also futural; the ways in which we mourn, the ritual practices of mourning, play a central part in imagining life beyond the dead, the afterlife of community that is formed through the relation between the living and the dead.

I then turn to a reading of Hugo's "The Bereaved," portraits intended to form part of a larger series depicting people who have died of AIDS in South Africa and the effects of these losses on their families. However, Hugo's four photographs of corpses, which I consider in this chapter, are the only works he produced for this series. The chapter thinks about how, once they are detached from the social contexts in which these men lived their lives, such photographs might be connected to mourning. My analysis draws on Judith Butler's work on mourning and her articulation of "publicly ungrievable losses" in *Antigone's Claim*[12] and in *Precarious Life*[13] to think about how those who have died of AIDS enter, and are erased from, public memory in South Africa.

Over the course of the ten years that I have been working in this field and immersed in thinking about the epidemic and the experiences of people living with HIV/AIDS, I have been struck by how invisible this crisis remains. In spite of the remarkable work of the TAC and allied organizations campaigning for the rights of people living with HIV/AIDS, such as MSF and the AIDS Law Project, the lives, struggles and deaths of so very many people in South Africa continue to go unmarked in the public domain. The fifth chapter draws on two accounts of funerals which take place in the same graveyard; the first a mass burial of young people killed by the police under apartheid, and the second that of a young person who has died of AIDS and whose cause of death is made unspeakable. The funeral that took place in 1985, as described in *The Diary of Maria Tholo*,[14] is made the site of enforced communal mourning, a practice that strengthens social bonds at the same time as it instrumentalizes individual grief. This instance of public mourning is in marked contrast to the isolation of the grieving mother who is the subject of Sindiwe Magona's short story, *Leave-Taking*.[15] Magona's portrayal of how AIDS-denialism and stigma have contributed to the premature deaths of people living with AIDS also illuminates the psychic effects of the disavowal of grief.

The final chapter focuses on photographs and artworks that depict the murdered body of Steve Biko to raise a series of questions about the trauma of the past and the trauma of the present. The chapter reads Biko's corpse as a living wound that keeps open the question of our relation to the past and the ways in which our history shapes experience in the present. I argue that the compulsion to make visible Biko's corpse is both a sign of our failure to mourn and an injunction to begin the ceaseless work of mourning for that which is irreparable.

This chapter also seeks to intervene in a conversation about national memory and forgetting in South Africa and draws on Jacques Derrida's *Archive Fever*[16] in order to argue for understanding the archive as a space of repression. I read the stubborn appearance and re-appearance of images of Biko's corpse in South Africa as a marker of those aspects of our experience that refuse as-

simulation in the coherent narratives we seek to tell about our past. In this sense, Biko's corpse transgresses "the law of what can be said" to make us aware of what we cannot say.

In a lecture delivered at a colloquium at the University of Cape Town in November 2006,[17] Judge Edwin Cameron called for the establishment of "an AIDS TRC" (Truth and Reconciliation Commission) to allow the experiences of people living with HIV/AIDS to be publicly recognized and for the state's failings in dealing with the epidemic to be laid bare.[18] Besides the shadow of the mountain, this book has been written in the shadow of the actual Truth and Reconciliation Commission and the discourses that have proliferated around it. The powerful discourses that have shaped the post-apartheid body politic—discourses of healing from the wounds of the past, of reconciliation and of the "African Renaissance"—are chronically incommensurable with the experiences of the majority of South Africans living with HIV/AIDS. The marginalized position of people living with HIV/AIDS in South Africa cannot be disconnected from their marginalization within the ur-narrative of South African history and new-nation building. The conclusion to this book argues for the epidemic to be understood as continuous with, rather than distinct from, the larger history of South Africa.

In spite of what might seem like an obsessive focus on death, this book is about life. It is centered on the question of what constitutes life in the political sense. It is concerned with how certain lives come to be recognized as valuable, as lives worth protecting, worth caring for, and worth grieving, and how the lives of so many come to be expendable, lives given over to death. The book argues for the importance of public mourning. Its central premise is that those we fail to mourn are those whose lives are unrecognized in the political sphere. The 1,000 people who die of AIDS in South Africa each day testify to this fact, their lives for the most part as invisible within public memory as their deaths. This, then, is the thread that holds together the various forms of visual representation I discuss here, ways of becoming visible that all too often lead to new or intensified forms of invisibility, and the work of mourning, the making manifest of the fact that these lives and deaths do indeed *mean*. The meaning of our monumental failure to mourn the losses of AIDS is the question that gives shape to each chapter of this book, and for that matter, public life in South Africa post-apartheid. To be writing criticism in the midst of the crisis this epidemic presents is, as Ross Chambers so eloquently puts it, "like getting on with one's needlework while the house burns down."[19] In his meditation on writing and AIDS, at the same time a reflection of what it means to engage in literary criticism, Chambers suggests that the work of the critic can be understood as a work of mourning. His suggestive analysis of the relation between reading, recognition and mourning has provided a way for me to hold onto the significance, however slight, of this work.

NOTES

1. For a fascinating account of the history of Khayelitsha, see G. P. Cook, "Khayelitsha: Policy Change or Crisis Response?" *Transactions of the Institute of British Geographers* 11, no. 1 (1986): 57–66.

2. See Renée C. Fox and Eric Goemaere, "They Call it 'Patient Selection' in Khayelitsha: The Experience of Médecins Sans Frontières—South Africa in Enrolling Patients to Receive Antiretroviral Treatment for HIV/AIDS," *Cambridge Quarterly of Healthcare Ethics* 15, no. 3 (2006): 302–12. There are now an estimated one million people living in Khayelitsha.

3. "I Eat with Robbed Money," an article by Pearlie Joubert in the weekly South African newspaper the *Mail & Guardian*, February 9–15, 2007, 13, shows how extreme violence and poverty characterise conditions of life in Khayelitsha today. See also my account and analysis of vigilantism in Khayelitsha: Kylie Thomas, "The Power of Naming: 'Senseless Violence' and Violent Law in Post-apartheid South Africa," available online on the Center for the Study of Violence and Reconciliation website, http://www.csvr.org.za/images/docs/VTP3/k_thomas_the_power_of_naming_senseless_violence_and_violent_law_in_post_apartheid_sa.pdf (accessed April 29, 2013).

4. Kylie Thomas et al., *Clutching onto Hope* (Center for Social Science Research Publications: University of Cape Town, 2002).

5. UNAIDS reports that 23.5 million of the estimated 33.3 million people infected with HIV live in sub-Saharan Africa, nearly half of these in southern Africa alone ("UNAIDS Sub-Saharan Africa Regional Factsheet, 2012, https://www.unaids.org/en/media/unaids/contentassets/documents/epidemiology/2012/gr2012/2012_FS_regional_ssa_en.pdf [accessed April 4, 2013]).

6. Gideon Mendel's photographs of people living with HIV/AIDS provide the focus for chap. 3, "Traumatic Witnessing" (see figs. 3.1–3.13).

7. One man joined the project at its inception but left the group after a short time. He was the only member of the group who was employed (he ran his own vegetable stall) and did not have enough time to attend the workshops. I discuss the significance of the central place women's bodies have been made to hold in the discourse surrounding HIV and AIDS in South Africa in chap. 1.

8. See Jonathan Morgan and Bambanani Women's Group, *Long Life: Positive HIV Stories* (Cape Town: Double Storey Press, 2003). Jane Solomon facilitated the art-making process and Kali van der Merwe designed the book.

9. Eric Michaels, *Unbecoming* (Sydney: EM Press, 1990).

10. Morgan and Bambanani Women's Group, *Long Life*. See figs. 1.1–1.4.

11. Gideon Mendel, *A Broken Landscape: HIV & AIDS in Africa* (Barcelona: Blume in association with ActionAid, 2002).

12. Judith Butler, *Antigone's Claim: Kinship Between Life and Death* (New York: Columbia University Press, 2000).

13. Judith Butler, *Precarious Life: The Powers of Mourning and Violence* (London: Verso, 2004).

14. Carol Hermer and Maria Tholo, *The Diary of Maria Tholo* (Johannesburg: Ravan Press, 1980).

15. Sindiwe Magona, "Leave-Taking," in *Nobody Ever Said AIDS: Poems and Stories from Southern Africa*, ed. Nobantu Rasebotsa, Meg Samuelson and Kylie Thomas (Cape Town: Kwela, 2003), 124–41.

16. Jacques Derrida, *Archive Fever: A Freudian Impression* (Chicago: University of Chicago Press, 1996).

17. Edwin Cameron, Unpublished speech HIV/AIDS colloquium (University of Cape Town, November 15–16 2006).

18. Edwin Cameron is a justice in the Constitutional Court of South Africa. He founded and was the first director of the AIDS Law Project in Johannesburg and is one of the most visible public figures openly living with HIV in South Africa. His autobiographical memoir, *Witness to AIDS*, is both a compelling personal account of living with HIV and AIDS and an excellent history of the epidemic in South Africa. See Edwin Cameron, *Witness to AIDS* (Cape Town: Tafelberg, 2005).

19. Ross Chambers, *Facing It: AIDS Diaries and the Death of the Author* (Ann Arbor: University of Michigan Press, 1998), vii.

· 1 ·

Speaking Bodies*

In January 2007, Nomawethu Ngalimani, a woman I would call my friend if that were not to disavow all that made real friendship impossible between us, was stabbed to death in her home in Khayelitsha, a township outside of the city of Cape Town in South Africa.

I met Nomawethu in 2002 while I was working on a book project that told the stories of the lives of thirteen HIV-positive South African women.[1] Over the course of several months Nomawethu was one of the participants in an art and narrative therapy workshop process through which she shared the story of her life. She also created a life-sized self-portrait that conveys how the context of extreme violence in which she lived has made its marks on her body.

She had always been a loudmouth, a fighter, confident and self-assured. As a teenager she had been attacked by a group of men. She had been stabbed, but she refused to give them the money she was carrying. She had been carrying a knife of her own, and she wounded one of the men in his chest and they had run away.

The last time I saw her, in December 2006, she had had an operation to remove the cancerous growth in her eye, and it had been successful. She seemed different—she looked happy, more at ease in herself. She was wearing a green dress. In retrospect, the appearance of her slight body in uncharacteristically feminine clothing made her look smaller, more vulnerable.

In 2003 the South African Constitutional Court bought reproductions of the self-portraits the women I worked with had made. Nomawethu's self-portrait is among them. It hangs in the gallery at Constitution Hill in Johannesburg, a sign of her symbolic inclusion in the body of the nation. But now she is dead, and her death is a stark reminder of the disjuncture

that exists between the promises set out in the Constitution and conditions of life in contemporary South Africa.

In December 2007, almost a year after her death, the exhibition of which Nomawethu's image forms part re-opened in a gallery in Johannesburg. I decided to go to see the exhibition, and I prepared myself for standing before Nomawethu's life-sized image. When I got there I found that only ten of the thirteen images were hung. Among the missing three was Nomawethu's portrait. I asked the gallery attendant about the missing images, and she dismissed the query by saying that there wasn't sufficient space in the gallery for all the paintings to be shown. In spite of her explanation, the absence of Nomawethu's image chilled me. I couldn't help but think that rather than having to explain the gruesome facts of her death the curators had simply opted to leave her image out of the show.

Nomawethu's murder, her literal disappearance, was read by those around her as bound to her public appearance. Participants in the *Long Life* project said that she was murdered by her lover. It was said that her involvement in the book project made her a target. I have begun with the murder of Nomawethu Ngalimani in order to remember her, to insist on her presence, even in death. And also because it is questions of visibility and invisibility, appearance and disappearance, and representation—in all its senses—visual, semiotic and political, that forms the central concern of this chapter.

AUTHENTICITY AND EXPOSURE

The images that provide the focus for this chapter were created as part of a collaborative book project that highlights how access to anti-retroviral therapy (ART) has affected the lives of people living with HIV/AIDS in South Africa. *Long Life: Positive HIV Stories* centers on these images and the life narratives of the women who made them. The portraits, known as "body maps," have been interpreted variously as representative of people living with HIV/AIDS in South Africa, as "maps" that provide a way to navigate the social and biomedical aspects of the lives of the women who made them and of poor people living with AIDS generally, and as sites of truth through which the subject of the body can be made known. They have also been cast as spectacle, reproductions of which have become fetishized commodities that can be bought and sold.

Once they became objects for consumption, these images also became sites of contest with different stakeholders claiming rights of ownership and the right to profit from their exhibition and sale. This chapter offers a critique, with the benefit of hindsight, of the *Long Life* project and engages with issues

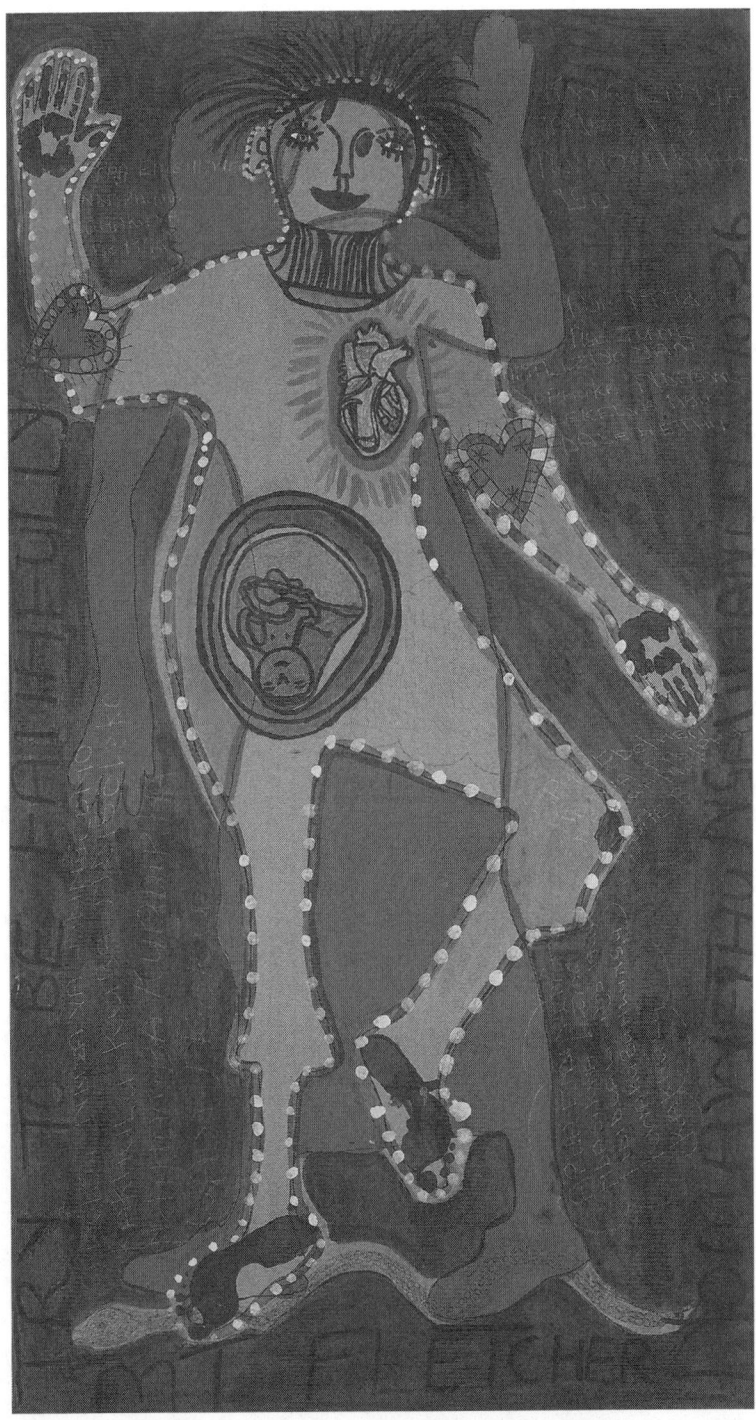

Figure 1.1. *Self-portrait*, 2002, Nomawethu Ngalimani, courtesy of the Bambanani Women's Group.

of gender, race, representation, and authenticity. In particular, I consider some of the implications of circulating and selling images that are promoted and read as making visible the transparent "truth" of AIDS as it is written on the body.

The *Long Life* project aimed to produce a book that would highlight how Médecins Sans Frontières were successfully treating people with ARVs in the resource-poor setting of Khayelitsha.[2] A lengthy workshop process, involving storytelling, narrative therapy, art-making, and photography, followed. We began with the idea that the body holds memory and invited participants to reflect on their experiences as embodied subjects. Cape Town-based artist Jane Solomon worked with participants to create life-sized self-portraits. While from the beginning of the project it was clear to all participants that the "work" they produced would enter the public domain, no one was aware of quite how visible the portraits would become. This was one of the reasons why there was no contractual agreement made between the University of Cape Town and the participants in the beginning of the project.[3] However, as I argue here, the position of the participants in relation to the long afterlife of the project, taken up as it has been by multinational corporations and by the global art market, was skewed from the start.

Between 2003 and 2012, the "Body Maps" exhibition has appeared in multiple venues around the world, including the United Nations in New York, at several universities and private galleries in North America, and in the United Kingdom. Since 2004, the project has been co-ordinated and curated by David Krut Art Galleries.[4] The portraits were used by the pharmaceutical company Johnson & Johnson in 2005 for their cultural project for that year, and the World Food Programme have also created a series of posters using the images. Large-scale reproductions of the portraits appear in mosaic form outside of the medical school buildings at the University of Cape Town.

For the women who made these paintings, the shift from invisibility to hyper-visibility has been dramatic, and one could argue that the global reach of their images is a sign of the success of the project. In fact, I argue something like this myself in a paper I wrote about these images where I claim that "the women whose bodies are depicted in these images stand exposed in the face of a society, indeed a global community, which largely ignores and thereby condemns them" and in which I refer to the paintings as "acts of resistance against the regimes of erasure that seek to make the lives and bodies of people living with HIV/AIDS in South Africa invisible."[5] I also observed then that "in spite of the power of these images and the recognition of the plight of people living with HIV/AIDS that their visibility signifies, the women who made them continue to occupy a space of extreme vulnerability to the violence, both individual and systemic, that continues to characterise life in South Africa in the time of AIDS."[6]

What I failed to note however was that such violence also conditions the entry of these subjects into the sphere of representation and places limits on how they can be seen. I have found myself increasingly troubled by what this means about the space on offer for the subjects of these images. I suggest here that the popular appeal of these self-portraits is connected to how they have been cast as sites of authenticity, points of access to the real. The ways in which the portraits were produced and the ways in which they have been circulated and interpreted have been premised on the idea that their subjects can be known, not only by the artists themselves but also, and more importantly, by those who view them.

In her essay "The 'Eternal Return': Self-Portrait Photography as a Technology of Embodiment," art historian Amelia Jones reads photographic self-portraits by artists who engage in "an exaggerated mode of performative self-imaging."[7] Jones considers the work of contemporary American photographic artists Cindy Sherman, Lyle Ashton Harris, Hannah Wilke, and Laura Aguilar to "open the question of how subjectivity is established and how meaning is made in relation to *all* representations of the human body."[8]

She argues that images like Cindy Sherman's performative self-portraits, in which Sherman figures enacting a subject that both is and is not herself, destabilize both "the conception of the self-portrait and the very notion of the subject." Jones defines the terms "portrait" and "self-portrait" in the following way:

> In the portrait image of any kind, a subject is apparently revealed and documented. In the self-portrait, this subject is the artist herself or himself, and the promise of the artwork to deliver the artist in some capacity to the viewer, a promise central to our attraction to the images, is seemingly fulfilled.[9]

In the case of the images Jones reads, however, the notion that the image is a replication of, and incontestably attached to, the real, is subverted. "Through an exaggerated performativity, which makes it clear that we can never 'know' the subject behind or in the image," Jones writes, "these works expose the apparently seamless conflation of intentionality with meaningful visible appearance in the self-portrait as an illusion."[10] The juxtaposition of the images Jones analyzes with this series of self-portraits made by HIV-positive women in South Africa and the contrasting ways in which they have been received, throws the distinctions that are often thought to exist between western subjects and their marginalized others into sharp relief.

The ways in which the "Body Maps" exhibition has been framed in articles and publicity material is particularly revealing in this regard. For instance, in his article "'Body Maps' are Images of Hope," Daniel Aloi cites Meredith

18 Chapter 1

Small, professor of anthropology and the organizer of the "Body Maps" exhibition held at Cornell University in December 2006:

> This [exhibition] has such visual appeal, and emotional appeal. . . . They didn't even know they were artists before this project. . . . The anthropologist in me loves that it comes from a different culture; the mother in me loves that there are babies in all the body maps, [Small says]. And I love the message of hope. These are people from undeveloped nations, and if they can be hopeful, there's hope for all of us. It shows the tenacity of the human spirit.[11]

For Small, the "visual and emotional appeal" of the exhibition is connected to the assumed naïveté of the artists and to their having produced images that she reads as signs of cultural specificity.[12] It is important to remember here that just as maps represent rather than replicate the "real," so too these images are constructed and produce what they purport to reveal. It is also interesting to note how Small translates the life narratives the book contains, many of which describe episodes of trauma and despair, into an overarching "message of hope." Her failure to read the meanings of the portraits is perhaps most evident in her claim that "the mother in me loves that there are babies in all the body maps."[13] Aside from the fact that not all the women involved in the project portrayed babies in their images, the presence of babies in the portraits of those who chose to depict them is by no means unambiguous.

For many of the women, the story of their bodies is bound to the stories of their children, and their images contain representations of their children's bodies. For example, one of the central images in many of the paintings is that of the unborn fetus. This representation of the fetus living within the center of the body affirms the body as a site that generates and produces life and counters the idea of the HIV-positive body as the locus of death. Of the thirteen women in the collective, ten were mothers, and several of the women chose to depict themselves as pregnant.

In Ncedeka's painting (fig. 1.2), the over-sized figure of a baby is shown superimposed over her body. Both inside and outside of Ncedeka's body, this figure represents her baby who died of AIDS at three months old. The larger-than-life-sized body of Ncedeka's daughter conveys the enormity of the impact of her death on her mother and the place she continues to occupy in Ncedeka's memory. Ncedeka's image illustrates how she continues to experience the trauma of the loss of her child at the level of the body; her baby hovers above her like a phantom limb.

Indeed, what the markings on Ncedeka's painting of her body and all the other women's bodily paintings illustrate is how the body, rather than being immune to the outside, is intrinsically connected to the world in which bodies

Figure 1.2. *Self-portrait*, 2002, Ncedeka, courtesy of the Bambanani Women's Group.

move. HIV infection is a sign of the sociality of bodies, of the life of the body in the world with others. The stories that these images of bodies tell expose the ways in which bodies act and interact, and the ways in which the bodies of women in particular are often violently acted upon. In this light, what is striking about these images is not so much what is there but what gets left out. Conspicuously absent from these paintings are sexual partners, husbands, lovers, and rapists; the infection of the body through the body of another is only represented in these paintings through the presence of HIV itself. In the absence of these ghostly male bodies, aspects of the violence to which these women's bodies have been made subject remain invisible, and their lives as a result can only be partially understood. It is thus necessary to read with care the stories that are linked to each incision, wound, and broken heart; only in reading the paintings in this way can the violence that these women have encountered be understood.

These portraits clearly convey that the effects of infection with HIV reach beyond the body. While illness is revealed as only one aspect of each person's life, the portraits do indicate how the experience of being ill radically transforms how people perceive their own bodies. In particular, the images made by those who have been extremely sick show how overwhelming the appearance of the symptoms of AIDS can be. For example, Nondumiso's depiction of the presence of the virus all over her skin effectively conveys her sense of having been physically disfigured (see fig. 1.3). Moreover, in significantly magnifying the virus that covers her body, she indicates that she perceives her entire body to be marked by HIV/AIDS.

It is interesting to consider the extent to which the virus has entered both the body and the consciousness of each person, depending on the stage of infection they have experienced. The images made by Noloyiso, Bongiwe, and Nondumiso, all of whom had been extremely sick and were receiving ART at the time of creating their portraits, contrast with the images made by those women who had not yet developed the symptoms of AIDS. In the images made by those who were relatively healthy, the virus is depicted as affecting only a small part of their bodies or is shown outside of the bounds of their bodies. For Nomonde, a woman who had not yet become ill, the virus is depicted as a fire that has not yet begun to consume her. She shows herself hovering above flames that burn just beneath her feet. For Bongiwe, the person she was when she was severely ill and before she began to take ARVs is still inside her body. In contrast to the images made by those women who have had babies and who depict their pregnant bodies, Bongiwe's painting is of her body pregnant with her own sick, smaller self (fig. 1.4). In the interview I conducted with her she said:

> This small person inside my stomach: it's me. This picture shows me when I started using ARVs. I was small and so tiny. I was weighing forty-six

Figure 1.3. *Self-portrait*, 2002, by Nondumiso Hlwele, courtesy of the Bambanani Women's Group.

> kilograms. It was March this year. Then I started using ARVs and I gained a lot of weight. I have improved a lot. I am weighing fifty-eight kilograms now. So this big body around the small body is me now. When I look at that small person there I feel so sad. But now, I feel happy but at first I was so sad. I thought of many things, that I might die. Anything might happen to me. I was scared at that time because I was losing a lot of weight. That was in March, not so long ago. Now we're in July. It was quick that I got better. Very quick.[14]

Bongiwe's self-portrait within a self-portrait, conveying as it does the tiny person she literally became as the virus caused her body to physically waste away, also shows that she perceived herself at this stage in her life as helpless and small. The emaciated body that was hers prior to gaining access to treatment has not been swallowed up by time and forgotten but is shown as living on inside the larger figure of her healthy self.

Like Bongiwe, Noloyiso had been extremely sick with tuberculosis. She imagines the virus as a storm inside her body, complete with a bolt of lightning tearing across her stomach. Her image of raindrops fills the entire middle section of her body and conveys how she felt her body to be completely overwhelmed by her illness. As for Nondumiso, her depiction of the virus's lurid flowering over her skin is not a literal depiction, but one that effectively conveys the trauma she experienced as her skin changed color. "I feel like going underground," she told me when I asked her how she felt about the ways in which HIV had affected her body.[15]

In general, the tendency of these women to depict the presence of the virus both in and on their bodies in ways that render it highly visible can be read as indicating their acute awareness of the stigma attached to HIV/AIDS in South Africa. If these women symbolize HIV through the thorough coding of the body as visibly HIV positive, it is not only because they have experienced physical symptoms that affected every part of them; it is also their way of making manifest the social symptoms that equally affect them—symptoms like widespread discrimination and the creation of a climate of fear which make living with HIV and AIDS a psychologically, as well as physically, harrowing experience.

In other words, these are images in which the vulnerability of the body at all levels is exposed. In these images the surface of the body has been peeled away, those layers of skin and blood and bone that make one body discrete from another lifted off to reveal the individual meanings of the person who lives that body. In each case, the body is not a surface but an endless depth. These stories are not simply told from the outside in, nor is the inside of the body exteriorized. Rather, the divisions between the outside and inside of the body no longer hold. The body is not the envelope inside of which the nar-

rative "I" is enclosed; the self is the body and the story told is an embodied story. Because of the ways in which these stories are told they do not allow the reader to travel along the surface but draw us in, beneath the skin. There is something transgressive about this practice, this telling which does not close the reader out, which makes the body of the reader porous to the telling itself. For as prevention campaign messages perpetually reiterate, HIV-positive bodies are bodies whose bounds we must not, in any event, cross.

These paintings make visible what is invisible; they depict internal organs, living, dead, and unborn children, traumatic experiences, loss, sexual violence, and HIV itself. The women whose bodies are depicted in these images stand exposed in the face of a society, indeed a global community, which largely ignores and thereby condemns them. The courage necessary to make and to display these images in this context should not be underestimated. In many of these images the arms of the person depicted are raised: a position that can be read as openness but which is equally a sign of defenselessness—the position of a person being arrested, a position that arrests. Either way, it is a position that exposes the vulnerability of the body, one that does not conceal or defend the body but opens the body to scrutiny. The intention of these bodies is to be seen and to face them is discomforting in that they lead to a series of questions about power and injustice that cannot be easily resolved.

Although their portraits have been understood as providing an interior view of the lives and embodied experiences of those who made them, the women themselves have not been perceived as individual artists. This is perhaps most clearly evident in the fact that they are not paid individually for the sale of the reproductions of their images. According to publicity material at David Krut Galleries, 60 percent of the money from the sales of the prints is paid to the artists. However, in an interview I conducted with David Krut in January 2008 he acknowledged that the money is paid to the AIDS and Society Research Unit at the University of Cape Town and not to the women themselves. A portion of the proceeds is then divided among all the members of the Bambanani Women's Group.[16]

While it may have made sense to work with the memories the body holds in a therapeutic context, it has become clear that those of us responsible for conceptualising the *Long Life* project failed to reflect on how a long history of the display of black women's bodies, and of black African women's bodies in particular, would come to overdetermine how these images are viewed. Nor did we adequately think through how these portraits would intersect with the discourse of "African AIDS" within which Africa is cast as a space of suffering, disease, and death.[17] While the project was intended to challenge how people living with HIV/AIDS in South Africa are perceived, disrupting the codes of connotation through which images of HIV-positive black women's

bodies are read requires something more radical than replacing a "negative" image with a "positive" one. Postcolonial and feminist theorists, human rights activists, anthropologists, and others have drawn attention to the persistence of a colonial politics of display in representations of marginalized peoples and the related silencing of their experiences.[18] The Memory Box and *Long Life* projects can be understood as responses to this critique in that they place great emphasis on personal narrative and on participatory processes.[19] At the end of her reflections on psychology and relations of power in South Africa, "Can the Clinical Subject Speak? Some Thoughts on Subaltern Psychology," psychoanalytic theorist and psychologist Sally Swartz points to the work of the Memory Box Project as a model for how subaltern psychology might be transformed. She writes:

> The work of Jonathan Morgan and colleagues reporting on encounters with South African men, women and children living with HIV/AIDS in poverty-stricken communities finds a balance between narrative space given to their subjects and reported verbatim, and commentary (often autobiographical or intersubjective) beside it. The "authors" of these pieces position themselves not as *authoritative*, expert or professional, but simply as some among many voices. The written product is multi-textual, with visual variation in the presentation of voices from a range of experiences forming a barrier against interpellation of one by the other. Some text is in boxes, some in italics, there are e-mails, and photographs and body-maps: the multivocal effect is powerful.[20]

For Swartz, a text like *Long Life* grants equal space to all the voices it contains and offers a form of democratic textual practice that she reads as disrupting powerful social scripts that allow the voices of white men to sound most audibly while preventing the voices of black women from being heard at all. However, evacuating the position of author(ity) means something quite different for a middle-class white man (who is acknowledged by name on the cover of the books he produces) and for marginalized black women who have never occupied such a position in the first place. In her paper Swartz brilliantly applies the arguments Gayatri Spivak makes about the "muting of the subaltern woman"[21] in "Can the Subaltern Speak?" to her own reading of the practice of psychology in South Africa. Given this critical engagement with Spivak's work, her reading of the Memory Box Project is a curious one.

In the section that follows I consider the relation between testimony, confession, suffering, and authenticity. I engage with Spivak's critique of the assumed transparency of the subaltern subject in order to point to how the self-portraits produced as part of the *Long Life* project circulate as images that "speak" the truth of the subject.

ART AND ARTIFICE, BODIES OF TRUTH

I want to situate my analysis of the relation between "the testimony of the body" and the transparent subjectivity of HIV-positive African women within what might be termed "testimony studies," which in recent times has attracted a great deal of critical attention. This interest in testimony has engaged theorists across a range of disciplines including literature, political science, anthropology, and psychology. While these disciplines have always engaged with testimony to some extent, the renewal of interest in first-person narrative accounts is connected to studies of the *Shoah* and, more recently, in relation to national reconciliation commissions.[22]

Telling one's personal story has, in South Africa in the wake of the Truth and Reconciliation Commission, come to be understood not only as a vital aspect of personal healing from trauma but as a social good.[23] Testimony has come to be the vehicle for the voice of the oppressed, a genre that opens a public discursive space to those previously marginalized within, or radically excluded from, discourse. In this sense, testimony serves as a means of access to a particular kind of visibility, and even agency, within particular fields. Yet to testify is also to occupy a position of vulnerability and of exposure. I am interested in what the bounds of the testimonial field are and what it means to exceed these bounds, and also how testimonial articulations, confessional self-representations, provide a point of access to what is thought to be the authenticity of the subject.

In *The History of Sexuality: An Introduction*,[24] Michel Foucault provides an account of how the secularization of the ritual of confession has been a key aspect in the expansion and intensification of power's hold over life. Extracting the hidden truths of the subject from the depths of the body has provided the means for what he terms "the entry of life into history," the formation of bio-power:

> The obligation to confess is now relayed through so many different points, is so deeply ingrained in us, that we no longer perceive it as the effect of a power that constrains us; on the contrary, it seems to us that truth, lodged in our most secret nature, "demands" only to surface; that if it fails to do so, this is because a constraint holds it in place, the violence of a power weighs it down, and it can finally be articulated only at the price of a kind of liberation. Confession frees, but power reduces one to silence; truth does not belong to the order of power, but shares an affinity with freedom: traditional themes in philosophy, which a "political history of truth" would have to overturn by showing that truth is not by nature free—nor error servile—but that its production is thoroughly imbued with relations of power.[25]

Besides the disciplines engaged in wresting truths from our bodies—medicine, law and science, a vast network of confessionals, public and private—television talk shows, psychoanalysis, truth commissions, autobiographies—the confiding of our innermost thoughts to strangers, and to those we are most intimate with, constitute our social existence. For Foucault the confessional in all these varying forms is instrumental in exerting control not only over individuals but over the population as a whole.

Indeed, the confessional not only permits power to access the body but also constitutes a claim to subjectivity. The provision of testimony provides the point of entry to the sphere of the law and to recognition as a juridical subject. While the religious confessional restores the speaking subject to a state of grace, testifying to traumatic experience has often been understood as restoring (at least to some degree) the coherence of the subject. Testimony thus depends on a particular conception of the subject, a subject who can speak, a subject who can (and will) speak the truth, a subject who in his or her originary state was coherent, a state to which they can be restored.

The question of how it can be possible for subjugated people to represent themselves through the very discourses of power within which they are unmade as subjects has been most famously addressed by Gayatri Spivak in her foundational essay, "Can the Subaltern Speak?" Spivak begins by interrogating how western intellectuals are implicated in the production of the "'concrete' subject[s] of oppression."[26] Spivak takes as her focus the works of Foucault and Gilles Deleuze, in which she detects not the disappearance of the "knowing Subject," but instead, "the encroachment of the unacknowledged subject of the West," what she terms "a subject that presides by disavowal."[27] For, as her analysis shows, the questions of who it is that speaks and writes, and what the conditions of agency and domination are that conspire to produce the author as "knowing Subject," are left unmarked. For Spivak, this omission is bound to the absence of engagement with the question of the subaltern and failure to examine the ways in which the Subject is constituted through the Other. Spivak terms this unacknowledged constitutive role of the Other "assimiliation." "For those of us who feel that the 'subject' has a history and that the task of the first world subject of knowledge in our historical moment is to resist and critique 'recognition' of the third world through 'assimilation,' this specificity is crucial."[28] "Assimilation" here refers to the process of reducing subaltern subjectivity to the Other, that which can only be thought in relation to the production of the Subject and from the position of the Subject. It is the claim to the possibility of knowing this Other as a subject within and through the schema of western knowledge production that Spivak contests. Like Jacques Derrida, she argues that it is only through acknowledging the relation between the inaccessible and the interpretable, that which can be analyzed and

that which resists, confounds and exceeds interpretation, that the postcolonial intellectual "can attempt to displace their own production."[29]

> To render thought or the thinking subject transparent or invisible seems, by contrast, to hide the relentless recognition of the Other by assimilation. It is in the interest of such cautions that Derrida does not invoke "letting the other(s) speak for himself" but rather invokes an "appeal" to or "call" to the "quite other" (tout-autre as opposed to a self-consolidating other), of rendering delirious that interior voice that is the voice of the other in us.[30]

To recognize the otherness of another as that which cannot be assimilated is to attend to the silences within discourse, to both what has been made unspeakable and to how what is spoken contains the unspoken. At the same time Derrida's conception draws attention to how the voice of the other is also an "interior voice," a voice mediated by the process of listening and interpretation. Derrida recognizes the voice of the other as constitutive of the subject and the subject as constituting the voice of the other and does not seek to disavow this relation.[31] This analysis approaches the philosophy of Emmanuel Levinas and of feminist philosophers Adriana Cavarero and Judith Butler, who have elaborated how the subject is always constituted in relation to another.[32]

Spivak argues that when a voice is attributed to the subaltern "subject," what emerges is not the voice of a Subject but that of the authentic Other. As the pre-subjective object through which the subject comes to be formed, the subaltern does not have access to the realm of speech. If the human is constituted in relation to the non-human, and entry into the symbolic, to language, is what marks the human, systematic exclusion from the symbolic produces the non-human. Spivak argues that the subaltern cannot speak because within the frame of western knowledge, the subaltern is not a subject.

> Reporting on, or better still, participating in, antisexist work among women of color or women in class oppression in the First World or Third World is undeniably on the agenda. We should also welcome all the information retrieval in these silenced areas that is taking place in anthropology, political science, history and sociology. Yet the assumption and construction of a consciousness or subject sustains such work and will, in the long run, cohere with the work of imperialist subject-constitution, mingling epistemic violence with the advancement of learning and civilization. And the subaltern woman will be as mute as ever.[33]

The closing words of "Can the Subaltern Speak?" draw attention to the urgency in questioning "the unquestioned muting of the subaltern woman even within the anti-imperialist project of subaltern studies."[34] Spivak writes:

"The subaltern cannot speak. There is no virtue in global laundry lists with 'woman' as a pious item. Representation has not withered away. The female intellectual as intellectual has a circumscribed task which she must not disown with a flourish."[35] For her, "the subaltern cannot speak" precisely because as the "the lost figure of the colonised"[36] found by western theory, the subaltern circulates as a figure of transparency.

In *Writing Diaspora*, Rey Chow revisits some of the questions raised by Spivak in "Can the Subaltern Speak?" "Is there a way of 'finding' the native without simply ignoring the image, or substituting a 'correct' image of the ethnic specimen for an 'incorrect' one, or giving the native a 'true' voice 'behind' her 'false' image?" Chow asks.[37]

> How could we deal with the native in an age when there is no possibility of avoiding the reduction/abstraction of the native as image? How can we write about the native by not ignoring the defiled, degraded image that is an inerasable part of her status—i.e., by not resorting to the idealist belief that everything would be alright if the inner truth of the native is restored because the inner truth would lead to the "correct" image? . . . How would we write this space in such a way as to refuse the facile turn of sanctifying the defiled image with pieties and thus enriching ourselves precisely with what can be called the surplus value of the oppressed, a surplus value that results from *exchanging* the defiled image for something more noble?[38]

Chow's argument, like Spivak's analysis of subjectivity, representation, and the production of the Other in "Can the Subaltern Speak?" troubles any reading of testimony as a discourse of truth. Their work draws attention to the critical question of how power conditions the entry of the black female body into the sphere of representation. As I have sought to show here, representations of the bodies of black HIV-positive women in South Africa cannot be read as transparent. To take such representations as points of access to the truth of the subjects they represent is to disavow the relations of power that continue to determine how such images appear and how they can be read.

I understand testimony to be a place offered by those who hold power to those who do not, a social space cast as both redemptive and restorative. Yet as this analysis of the *Long Life* project makes clear, staking a claim on a place within the social, political, and juridical realms through testimony and through representations of the body is riddled with complexity. This is particularly so for HIV-positive, economically and socially marginalized black women for whom the body has been a site of subjugation and whose experiences have been silenced. In this moment in which testimony is celebrated as a sign of liberation, we would do well to remember Foucault's rejoinder that the production of truth "is thoroughly imbued with relations of power"

and the notion that there is a fundamental relation between confession and freedom is "to have an inverted image of power."[39]

TRAUMATIC RETURN(S)

In some ways the chapters that follow were written in order to help me to avoid thinking too directly about my own work in Khayelitsha or about the Memory Box and *Long Life* projects. And in other ways the chapters that follow were written precisely to enable a return to reflecting on that work. On revising the manuscript of this book for publication I was struck by how Gideon Mendel's encounter with the person who dies as he is photographing him in a hospital in Zimbabwe brings me back to my own encounter with Xoliswa, a woman I had only known for a few weeks before she became gravely ill and I found myself at her deathbed, holding her head in my hands just before she died.

Xoliswa, Dying

I can't find the words to name the
pain of your body half paralysed now
your neck as it twisted back when you tried
to move and how your head in my hands
weighed too little and how I want to
hold you up and bring you back but I
am of little use although I kneel at your
bedside in this ward where the words provincial
administration are written across the sheet across
your body and in the morning I see
this mountain that does not see
the blind tombstone of your body I cannot say
Xoliswa
I am going to write your name on these stones

Thinking about the politics of loss and disavowed mourning has led me to reflect on what it is I have made invisible through making visible, what it is I haven't said, what I couldn't say. Let me begin with what I'll call "Avoiding Ntombizodwa."

Ntombizodwa Somlayi is one of the women whose story and portrait appear in *Long Life*. I recall that she joined the book-making group a few weeks into the process—if she was there at the beginning I don't remember her presence. But even once she joined the group I didn't connect with her in the way I had with the other women. Ntombizodwa was a difficult person,

a disagreeable, grating presence. Before becoming ill she had sold drugs, had been arrested on two separate occasions, and had spent three years in jail. She was one of the people in the group who had been extremely ill and her skin bore the marks of all its past and present infections.

Ntombizodwa depicts herself as a pariah. Her portrayal of herself as an eyesore is both a distortion and painfully accurate. What her image captures and seems to reflect is my own distaste, my desire to look away. In looking at her painting of her body, which she depicts as covered with a monstrous conglomeration of mustard yellow, brown, green, and red shapes that resemble eyes or frog's spawn and intended to represent the virus, I am made to see my own ways of seeing. For this reason I have avoided looking at her image, have resisted writing about it and recognising the terrible psychic pain it conveys.

PASSING OVER RAPE

Another troubling figure from the *Long Life* book: Bongiwe, a deeply religious young woman, rather self-righteous and prone to arguing with the others in the group. In fact she fell out with the other women before the project drew to a close and stopped coming to our storytelling and art-making sessions. Once she stopped attending the group I never saw her again.

A few years before I met her, Bongiwe had been raped at the side of a highway and then stabbed and left for dead by a group of men. She recounted this incident to me during the interview I conducted with her about her self-portrait. The ways in which her traumatic memory of that time is subsumed by the "positive" framing of the book disturbs me immensely. I did not respond in the ways I wish I had to Bongiwe's painful story, nor did I recognize Ncedeka's unresolved grief, the significance of the stones lodged in Cordelia's forehead as a result of being attacked and raped, or Nondumiso's loss of a coherent sense of self. The primary crisis was the epidemic and the primary trauma was the deaths that were still to come. This way of seeing was also a form of blindness.

NOTES

*An earlier version of chapter 1 was first published as "Selling sorrow: testimony, representation and images of HIV-positive South African women," in *Social Dynamics: A journal of African studies*, Volume 34, Issue 2 (2008): pp. 216–226 and can be accessed at http://www.tandfonline.com/doi/full/10.1080/02533950802280097.

Figure 1.4. *Self-portrait*, 2002, by Bongiwe, courtesy of the Bambanani Women's Group.

1. The full series of thirteen body images and stories based on interviews conducted by my colleague, Jonathan Morgan, and myself have been published under the title, *Long Life: Positive HIV Stories*, Jonathan Morgan and Bambanani Women's Group (Cape Town: Double Storey Books, 2003). Jane Solomon facilitated the art-making process, and Kali van der Merwe designed the book. Copies of the recordings of the interviews I conducted with members of the Bambanani Women's Group are housed at the Center for Popular Memory at the University of Cape Town.

2. Before November 2003, when the government implemented a national treatment plan, patients in the public health sector did not have access to anti-retroviral treatment. The stories of people living with HIV/AIDS in South Africa were also largely unheard. Morgan and Bambanani Women's Group's *Long Life* intended to tell some of these stories in order to advocate for access to treatment for all HIV-positive South Africans.

3. Once the book was published, a contract was drawn up by the University of Cape Town that effectively made the portraits the property of the AIDS and Society Research Unit (ASRU). I contested the contract and asked a private attorney to draw up an alternative contract that would allow the artists to receive 50 percent of the proceeds of the sale of prints of their portraits and the full amount from the sale of their original works. The alternative contract was the one eventually signed; which allowed ASRU the sole right to produce prints of the works but provided for artist royalties.

4. See *David Krut Projects*, "Body Maps Project: Bambanani Women's Group," www.davidkrut.com/bodyMaps.html# (accessed March 30, 2013).

5. Kylie Thomas, "Bodies of Courage," in *Embodiment/Verkörperungen*, ed. Christina Lammer, Kim Sawchuk and Cathrin Pichler (Vienna: Löcker, 2007), 109.

6. Ibid., 110.

7. Amelia Jones, "The 'Eternal Return': Self-Portrait Photography as a Technology of Embodiment," *Signs: Journal of Women in Culture and Society* 27, no. 4 (Summer 2002): 948.

8. Ibid., 949.

9. Ibid., 951.

10. Ibid.

11. Daniel Aloi, "'Body Maps' are Images of Hope," *Cornell Chronicle Online*, November 2, 2006, http://www.news.cornell.edu/stories/2006/11/body-maps-exhibit-has-images-hope-people-hiv (accessed April 3, 2013).

12. Ibid.

13. Ibid.

14. Bongiwe, interviewed by Kylie Thomas, at Khayelitsha, 2002.

15. Ibid.

16. There is some uncertainty around how the proceeds from sales of prints at exhibitions are distributed. Although Daniel Aloi's article about the exhibition at Cornell in December 2006 states, "The artists receive a large portion of proceeds from sales," the ASRU do not have a comprehensive record of sales, and in a telephonic interview in 2007, the administrator at ASRU explained that all money from sales that the unit receives is placed into a fund. The university keeps half the money as costs, and the remaining sum is divided between the members of the Bambanani Women's Group. According to the administrator the artists were paid approximately 1,000 South African Rand (ZAR) each in 2007. In South Africa, a set of fourteen digital prints on

paper sells for ZAR39,900; and individual prints on paper for ZAR3,192. Fourteen digital prints on canvas cost ZAR171,000, and an individual print on canvas sells for ZAR12,540. In the United States, prints on paper sell for $450, and prints on canvas for $2,100. While in the global art market these figures are by no means extraordinary, for the women who made them they are large sums of money.

17. See Evelyn M. Hammonds, "Toward a Genealogy of Black Female Sexuality: The Problematic of Silence," in *Feminist Genealogies, Colonial Legacies, Democratic Futures*, ed. M. Jacqui Alexander and Chandra Talpade Mohanty (London: Routledge, 1997), 170–82, for an analysis of representations of black women and HIV/AIDS. For early critiques of the discourse of "African AIDS" see Paula Treichler, "AIDS and HIV Infection in the Third World: A First World Chronicle," in *Remaking History*, ed. Barbara Kruger and Phil Mariani (Seattle: Bay Press, 1989), 31–86; Cindy Patton, *Inventing AIDS* (London: Routledge, 1990); and Simon Watney, "AIDS, Language and the Third World," in *Taking Liberties: AIDS and Cultural Politics*, ed. Erica Carter and Simon Watney (London: Serpent's Tail, 1989), 183–92.

18. In the South African context see Carmel Schrire, Rustum Kozain, and Yvette Abrahams, "'Miscast': Three Views on the Exhibition curated by Pippa Skotnes with Jos Thorne in the South African National Gallery (April 14–September 14, 1996)," *Southern African Review of Books* 44 (July-August 1996), http://web.uct.ac.za/depts/sarb/ X0034_Miscast.html (accessed April 29, 2013); and Sidney Kasfir, "Cast, Miscast: The Curator's Dilemma," *African Arts* 30, no. 1 (1997): 1–9, 93, for the debates that erupted around the *Miscast* exhibition curated by Pippa Skotnes and Jos Thorne and displayed at the South African National Gallery in 1996. See also the essay on race and representation in post-apartheid South African art by Okwui Enwezor, "Reframing the Black Subject: Ideology and Fantasy in South African Representation," in *Reading the Contemporary: African Art from Theory to the Market Place*, ed. Olu Oguibe and Okwui Enwezor (London: Institute of International Visual Arts, 1999), 376–99. For critical responses to his views, see *Grey Areas: Representation, Identity and Politics in Contemporary South African Art*, ed. Brenda Atkinson and Candice Breitz (Johannesburg: Chalkham Hill Press, 1999).

19. See Annie E. Coombes, "Witnessing History / Embodying Testimony: Gender and Memory in Post-apartheid South Africa," *Journal of Royal Anthropological Institute* 17, no. s1 (2011): S92–S112.

20. Sally Swartz, "Can the Clinical Subject Speak? Some Thoughts on Subaltern Psychology," *Theory and Psychology* 15, no. 4 (2005): 519.

21. Spivak, "Can the Subaltern Speak?" 91.

22. On testimony and the *Shoah* see Shoshana Felman and Dori Laub, *Testimony: Crises of Witnessing in Literature, Psychoanalysis, and History* (New York: Routledge, 1992). See also Giorgio Agamben, *Remnants of Auschwitz: The Witness and the Archive*, trans. Daniel Heller-Roazen (New York: Zone Books, 1999). The central role of testimony in the work of truth commissions is evident in the official reports from Argentina, Chile, and South Africa. See Argentine National Commission on the Disappeared, *Nunca Mas: The Report of the Argentine National Commission on the Disappeared*, (New York: Farrar, Strauss and Giroux, 1986); National Commission on Truth and Reconciliation (Rettig Commission), *Report of the Chilean National Commission on Truth and Reconciliation*, vol. 1 (Notre Dame, IN: University of Notre Dame Press, 1993); and Truth and Reconciliation Commission, *The Truth and Reconciliation*

Commission Report, 5 vols. (Cape Town: Juta, 1998). On the South African Truth and Reconciliation Commission see Madeleine Fullard and Nicky Rousseau, "Uncertain Borders: The TRC and the (Un)making of Public Myths," *Kronos* 34 (November 2008), 215–39; Yazir Henry, "The Ethics and Morality of Witnessing on the Politics of Antje Krog (Samuel's) *Country of My Skull*," in *Trauma, Memory and Narrative in the Contemporary South African Novel*, ed. Ewald Mengel and Michela Borzaga (Amsterdam and New York: Rodopi, 2012), 107–41; *Commissioning the Past: Understanding South Africa's Truth and Reconciliation Commission*, ed. Deborah Posel and Graeme Simpson (Johannesburg: Witwatersrand University Press, 2002); Ulrike Kistner, *Commissioning and Contesting Post-Apartheid's Human Rights: HIV/AIDS, Racism, Truth, and Reconciliation* (Munster: Lit Verlag, 2003); and Fiona Ross, *Bearing Witness: Women and the Truth and Reconciliation Commission in South Africa* (London: Pluto, 2003).

23. See for instance Deborah Posel's article on South Africa as a confessing society, in "The Post-Apartheid Confessional," *Wiser Review* 2 (December 2006), 8–9.

24. Michel Foucault, *The History of Sexuality: An Introduction*, trans. Robert Hurley, vol. 1 (New York: Vintage, 1978), first published in French in 1976.

25. Ibid., 60.
26. Spivak, "Can the Subaltern Speak?," 87.
27. Ibid.
28. Ibid., 88.
29. Ibid., 89.
30. Ibid.

31. Jacques Derrida, *Of Grammatology*, trans. Gayatri Chakravorty Spivak (Baltimore: Johns Hopkins University Press, 1976), 191.

32. See Emmanuel Levinas, *Entre Nous: Thinking-of-the-Other*, trans. Michael B. Smith and Barbara Harshaw (New York: Columbia University Press, 1998); Adriana Cavarero, *Relating Narratives: Storytelling and Selfhood*, trans. Paul A. Kottman (London: Routledge, 2000); and Judith Butler, *The Psychic Life of Power: Theories in Subjection* (Stanford, CA: Stanford University Press, 1997).

33. Spivak, "Can the Subaltern Speak?" 90.
34. Ibid.
35. Ibid., 104.
36. Ibid., 91.

37. Rey Chow, *Writing Diaspora: Tactics of Intervention in Contemporary Cultural Studies* (Bloomington: Indiana University Press, 1993), 29.

38. Ibid., 30. Original emphasis.
39. Foucault, *History of Sexuality*, 60.

• 2 •

Passing and the Politics of Queer Loss Post-Apartheid*

This chapter focuses on the work of South African black lesbian photographer Zanele Muholi and raises the question of how experience that is deemed unspeakable can enter representation. If we always read images through "codes of connotation," through what Roland Barthes terms the "*studium*" of our knowing, how is it possible to overturn ways of seeing that render lesbian subjectivity invisible?[1] And if lesbian subjectivity is made visible through suspending the structures of recognition, what are the political implications of occupying such an "outlaw" position? How does being beyond recognition open or close the field of political possibility? The chapter makes two theoretical claims—one, that Barthes's influential concept of the "*punctum*" can be understood as a mode of queer reading, and two, that Muholi's work constructs an archive that insists on the specificity of lesbian lives and loss through a complex strategy of "passing." The chapter argues that Muholi's most recent body of work "queers" both the conventions of memorial photography and her own earlier representations of lesbian subjectivity.

Zanele Muholi is one of a handful of black women artists who figure prominently in the visual arts field, and her work has been shown both in South Africa and abroad. She is certainly the most visible black lesbian artist in South Africa and has received numerous awards for her work. Her photographs have also generated a great deal of controversy. In August 2009, South Africa's Minister of Arts and Culture, Lulu Xingwana, walked out of an exhibition that contained several of Muholi's photographs on the grounds that they were "immoral, offensive" and worked "against nation-building."[2] This has placed Muholi's photographs at the center of a national debate about homophobia, freedom of expression, and queer experience.[3] I will return to the significance of Xingwana's comments later in this chapter in my discussion

of the tactics Muholi employs in her photographs of black lesbians who have been subject to "corrective rape" and who have died of AIDS-related causes or who were murdered as a result of hate crimes.[4] I read these images as works of mourning that invoke conventional tropes of memorialization to circumvent precisely the socially normative prohibitions so dramatically performed by Xingwana in her role as an authorized voice of the state. The chapter offers an analysis of the transformation in Muholi's mode of working that occurs when she addresses the question of how to represent loss. In particular I trace how her current work draws on the conventions of memorial photography in order to secure a place for queer subjects within representation. At the same time I show how this complex working with and against the "structures of recognition" signals a departure from her earlier and more narrow conceptualizations of lesbian subjectivity.[5] In order to do this I begin by describing some of the ways in which her photographs can be understood as engaged in the task of "differencing the canon," before turning to a reading of her most recent series of portraits, "Faces and Phases."[6] The work of South African feminist theorists Desiree Lewis and Pumla Dineo Gqola and curator and artist Gabi Ngcobo has drawn attention to how Muholi's photographs render the complexity of lesbian lives visible.[7] However, this brave and politically necessary task is not the sum of her work. The import of her current photographs lies in how they both lay bare and contest the ways in which the lives of queer subjects are made invisible and their deaths ungrievable. "Faces and Phases," I argue here, works at the limit of the speakable, and Muholi's photographs mark that limit even as they pass beyond it.

DISRUPTING VISUAL CODES

In *Encounters in the Virtual Feminist Museum*, Griselda Pollock presents an approach to the history of art that embarks on the work of what she terms "differencing the canon."[8] She swiftly lays to rest the notion that the canon is quite "differenced" enough already by noting that "[n]ot only have we had to struggle and still struggle on to ensure equity in the representation of all women as well as all men in our cultural archives, but now our very struggle is being written out of history, brushed off as a passing irritant."[9] Pollock begins her reflections on the place of women in the history of art, in the museum and in the archive, by relating her encounter with a series of postcards that depict *The Three Graces*, a neoclassical sculpture by Antonio Canova. She notes how the prevalence of the female nude in the art museum is so naturalized that we no longer see its strangeness, and as longstanding signifier of western art the naked female form becomes a placeholder for women in art—the place

of "woman" in the museum, a stony limit point for feminist art practice and theory. Her book goes on to produce "a virtual feminist museum" through a constellation of images exhibited in what she terms "rooms" at the beginning of each of her chapters, all of which unsettle and recalibrate the archive of art history. Pollock's work reminds us that "[a]rchives matter. What is included shapes forever what we think we were and hence what we might become. The absence of women's histories in world archives has defined a vision of the human on the pattern of a privileged masculinity."[10] Pollock's approach to reconfiguring how we think about visual culture is suggestive, and her archival feminist aim resonates with the work of Zanele Muholi in several ways. Muholi's project is also an archival one and is concerned with many of the same issues of visibility and invisibility that have consumed feminist scholarship since the 1970s. In her artist's statement that appears in the catalogue for the "Innovative Women" exhibition, she writes: "As an insider within the black lesbian community and a visual activist, I want to ensure that my community, especially those lesbian women who come from the marginalised townships, are included in the women's 'canon.'"[11]

A cursory survey of Muholi's work thus far reveals the intensity of her commitment to producing a visual archive of black lesbian experience. Her photographs have appeared in group exhibitions since 2002, her solo exhibition *Visual Sexuality* was held at the Johannesburg Art Gallery in 2004, and since 2006 she has been represented by Michael Stevenson, a commercial art gallery in South Africa. She has held six additional solo exhibitions there: *Only Half the Picture* (2006); *Being* (2007); *Faces and Phases*, first exhibited as a series in 2009; and *Indawo Yami* (2010); *Inkanyiso* (2011) and *Mo(u)rning* (2012). Her exhibitions in Europe and North America include solo shows in Vienna and Amsterdam. In 2007, together with white South African lesbian photographer Jean Brundrit, Muholi facilitated a series of photographic workshops "to gather diverse opinions and diverse lesbian experiences in South Africa" with eight aspiring photographers.[12] While the artist is now firmly positioned within the commercial art world, she continues her work with the Forum for the Empowerment of Women, Inkanyiso, and with Free Gender, organizations that she cofounded, and to teach others to take photographs.[13] As this chapter shows, the bounds of her photographic archive have expanded to include representations of multiple forms of queer subjectivity.

Muholi's photographs open new spaces of representation in South African visual culture but follow in the tradition of feminist/lesbian art-making practices established over time by artists such as the U.S.-based Judy Chicago, Cindy Sherman, Laura Aguilar, and others. In her *oeuvre* there are numerous works that proclaim their transgressive, disruptive stance, and these are perhaps the images that are easiest to categorize, easiest to dismiss—as some critics

have—as "not very good art" that nonetheless makes an important political point.[14] Some of the images in Muholi's book *Only Half the Picture* and some that appear in her more recent "Being" series are among those that invoke conventional tropes of lesbian/feminist representation to contest the bounds of what is considered proper for women and for art. "Dada, 2003," a black-and-white photograph of a bare-breasted black woman strapping on a dildo, her face beyond the frame of the image, the 2005–2006 "Period" series, and the 2009 "LiZa" series can all be read as testing the limits of propriety in art and as a straightforward claiming of a visual space for embodied black lesbian experience. And through these works, Muholi's project can be said to be aligned with the mainstream feminist position that Pollock articulates in *Encounters in the Virtual Feminist Museum*. For in this conceptualization of the production of a new form of feminist archive that makes the experiences of women visible, it is of course necessary that the women who are represented are recognizable as women. Muholi's project, one that she articulates on her website as "mapping and archiving a visual history of black lesbians in post-Apartheid South Africa,"[15] also engages and affirms a particular form of identity politics in order to lay claim to a place within an existing order of representation.

At the same time, Muholi's concern with securing a place for lesbian experience within "the women's 'canon'" signals that what constitutes lesbian subjectivity is by no means decided. Her words testify to the ontological insecurity of the category of being that is "lesbian" in a context where "corrective rape" is practiced as way to "restore" lesbians to womanhood. Bringing the work of Zanele Muholi into conversation with the feminist position Pollock articulates also opens a way to consider what the limits of "differencing the canon" might be. What happens when radical and disruptive forms of subjectivity seek to enter representation? Does the canon hold? Does the archive seize up, prohibit entry? What kinds of silences remain?

AFTER LIFE: READING PHOTOGRAPHIC IMAGES (OR WHAT THE MINISTER THOUGHT SHE SAW AT THE SHOW)

In response to criticism that her departure from the *Innovative Women* Art Exhibition at Constitution Hill was homophobic, Lulu Xingwana, the Minister of Arts and Culture stated:

> Upon arrival at the Exhibition, I immediately saw images which I deemed offensive. The images in large frames were of naked bodies presumably involved in sexual acts. I was particularly revolted by an image called "Self-rape," depicting a sexual act with a nature scene as backdrop. The notion

of self-rape trivialises the scourge of rape in this country. To my mind, these were not works of arts [sic] but crude misrepresentations of women (both black and white) masquerading as artworks rather than engaged in questioning or interrogating—which I believe is what art is about. Those particular works of art stereotyped black women.[16]

"Contrary to media reports," she went on to claim, "I was not even aware as to whether the 'bodies' in the images were of men or women or both for that matter."[17] There is a strange way in which Xingwana's comments can be read as particularly insightful: Muholi's photographs do trouble the distinctions between men, women, "or both for that matter," and there is a powerful sense in which lesbians can only enter recognizable representation as "crude misrepresentations of women masquerading as artworks." Xingwana's act of turning away from the exhibition, her inability to look, also speaks to how certain images might serve to challenge and even overturn the conventions that govern our gaze. Her statements also reveal more than they intend about the challenges we find when we attempt to describe what it is we see, and in particular when we try to read a photograph. For what emerges is that while Xingwana found herself powerfully affected by her brief immersion in the field of black lesbian visual art, she did not see what she describes, nor is she quite sure of what it was she saw.

In her now classic work, *On Photography*, Susan Sontag explores the ubiquity and importance of photographic images in the industrialized countries of the west, where, she argues, life can no longer be imagined without cameras to provide evidence of life itself and people "feel that they are images, and are made real by photographs."[18] Sontag's reflections on the symbolic power photographic images have come to hold in contemporary society can also be read as an attempt to make sense of photography, to provide an answer to the question: "What is a photograph?" "The photographer both loots and preserves, denounces and consecrates,"[19] she writes, and although "there is a sense in which the camera does indeed capture reality, not just interpret it, photographs are as much an interpretation of the world as paintings and drawings are."[20] While for Sontag, the "force of a photograph is that it keeps open to scrutiny instants which the normal flow of time immediately replaces," for Roland Barthes the photographic image is no more outside of time than those who view it.[21] For Barthes photographs do not "capture" a moment of the real to be seen again and again, but in responding to the image, it is the viewer, and the society of which they are part, that is laid open to scrutiny. The instant in time the photograph is intended to capture is perceived afterward, and it is in this after-time that the significance of the image comes to be constituted. In this sense photographs do not preserve life but instead *create* it, a perpetual afterlife. And it is in this *making* that the critical project of constructing a photographic archive of

queer experience lies, an archive that testifies to the presence of black lesbians in the past, but also one that asserts and ensures their presence in the future.

In his essay "The Photographic Message," Barthes extends and complicates Sontag's definition of photographs and her analysis of how they can be read. He begins his essay with what he terms "the photographic paradox": "analogical perfection," the absence of a code that translates the object into its image, defines the photograph, which, at the same time, is a sign of something other than itself. The photograph appears to be "a mechanical analogue of reality," a "*denoted message,*" and to describe it is to attach to the image a "*connoted message,* which is the manner in which the society to a certain extent communicates what it thinks of it."[22]

> In front of a photograph, the feeling of "denotation," or, if one prefers, of analogical plenitude, is so great that the description of a photograph is literally impossible; to describe consists precisely in joining to the denoted message a relay or second-order message derived from a code which is that of language and constituting in relation to the photographic analogue, however much care one takes to be exact, a connotation: to describe is thus not simply to be imprecise or incomplete, it is to change structures, to signify something different to what is shown.[23]

For Barthes then, a photograph is, and can only be, our reading of it. When we describe what we see we "signify something different to what is shown."[24] And crucially, how one reads is through other images, visible or remembered, alongside and in conjunction with the single image that can never be singular.

In *Camera Lucida*, Barthes extends his thinking about how photographs are read through the concepts of the *studium* and the *punctum*. Most photographs belong to the *studium*, that which I have learned to see by acculturation and that which cannot really reach me. And then there are those photographs that arrest my gaze, photographs that disturb the *studium* of my knowing, photographs that wound me, photographs that I love. This element within the photograph is animated through the particularity of my gaze. It is this Barthes terms the *punctum*: "The second element will break or (punctuate) the *studium*. This time it is not I who seek it out (as I invest the field of the *studium* with my sovereign consciousness), it is this element which rises from the scene, shoots out of it like an arrow, and pierces me."[25] Again we are reminded of Barthes's key insight that there is nothing really internal to the image; I read everything I see and can only see what I read. This is not to disavow the relationship between myself and the image—the image wields a certain power by virtue of what it draws out in me. But as I look, the image becomes what I turn it into: my reading structures the image; I make it mean. Barthes's concepts of the *studium* and the *punctum* set up a method of reading photographs that illu-

minates how all readings are cultural—but at the same time legitimate a deeply subjective mode of response. The concept of the *punctum* allows Barthes (and those who have followed in his wake) to cast his emotional, poetic responses to photographs as a theory. I draw on these concepts here to grant a kind of legitimacy to my readings of Muholi's photographs. At the same time I am struck by how thinking of her work in relation to Barthes's influential terms casts light on the implications of "queering the gaze" beyond gay and lesbian studies. In other words it is not simply that Barthes's method offers a productive mode of reading Muholi's photographs, but Muholi's work shows that reading with and for the *punctum* can be understood as a mode of queer reading, an openness to ways of seeing that disrupt the heteronormative patriarchal hegemony that limits and structures our gaze.

In *Camera Lucida*, Barthes writes of how ". . . to give examples of *punctum* is, in a certain fashion, to *give myself up*."[26] To reveal the ways in which I am affected by a photograph is to be exposed, describing what I see is an act that "outs" me, one that positions my intimate self in a public sphere. "Giving myself up" before a photograph is also to occupy a subject position beyond or outside of my own. Faced with Muholi's portrait of Nomonde Mbusi (fig. 2.1), for example, I know that I have been set up to see in a certain way—this is the photographer's art. As with so many of her photographs, I face a beautiful image of a beautiful woman.

Figure 2.1. *Nomonde Mbusi, Berea, Johannesburg, 2007*, 2007 by Zanele Muholi/Stevenson, Cape Town and Johannesburg.

The lines of this young woman's body are carved in light and are accentuated by the dark cloth behind her. Her head is wrapped in a scarf so that only the faintest trace of her hair is visible on her forehead. She appears to be moving towards the viewer; it seems she is about to speak. She is not wearing a shirt but the photograph is cropped above her breasts. The smooth open expanse of her skin and her wide eyes are a form of invitation—an erotic photograph. The photographic encounter frames my desire—I want to see this woman, to hold her with my gaze. And yet she holds me, a kind of Mona Lisa effect comes into play, she seems to move as I do. To be interpellated by Nomonde Mbusi's eyes in this way is both liberating and disturbing. "Seeing" Muholi's photographs is premised on the exchange of queer looks and recognizing the desire they conjure is to acknowledge the queerness inside ourselves.

What might the Minister have seen had she stayed to look at Muholi's photographs? The incendiary quality of the works Xingwana did and did not see lies in how they make possible a space for us to acknowledge our own (queer) desire, I want to argue, in how they provide an entry point into an intimate archive, one that is embodied, one that is formed through love. Xingwana's inability to look returns us to the question of how Muholi's representations of lesbian subjectivity alert us to the limit of the speakable even as they pass beyond it.

LIGHT WRITING IN DARK TIMES

Muholi's first monograph, *Only Half the Picture*, carefully works with the aesthetics of the body, a complex holding of traumatic histories encoded in skin together with a celebration of lesbian desire and the promise of pleasure. Through Muholi's lens, black female bodies are resignified; framed as the subjects of and for lesbian desire, they make visible an erotics of longing, of sexual intimacy, and of community. At the same time, many of the photographs carry resonances of photographs of black female bodies drawn from a long history of racist iconography and which map the continuities of black female oppression over time. In the cracked toenails of the women in "Triple III" (fig 2.2.), for instance, there are signs of hardship; in the dark markings along the outer edges of the thighs of the reclining figures there is a shadow of darkness, of violence, bruises, or stains. Read in conjunction with the other photographs in the "Triple" series that portray the interlocking legs and buttocks of three women and that bring to mind the erotic nudes of Edward Weston or Imogen Cunningham, the ambiguities of "Triple III" are largely erased. Its erotic dimension comes to the fore.

Figure 2.2. *Triple III*, 2005 by Zanele Muholi. Courtesy of Zanele Muholi and Stevenson, Cape Town and Johannesburg.

The pose of the three women speaks of the stillness of sleep and shows the protective tenderness of bodies curved around one another. And yet there is something disturbing about the arrangement of these bodies on the floor. They are shown to be resting on a strip of carpet, its detail in the foreground so close up it becomes a strange terrain and then fades to merge with what appears to be a stone floor that extends behind them. The marks on the limbs of these women evoke the history of slavery, summon photographs of the bodies of those killed in the Rwandan genocide, provide a visual echo of the legs of schoolgirls who have been teargassed and who run from the police in Soweto in South Africa in 1976. The larger context of Muholi's book, one that includes photographs of women after being raped, raises the question of how it is possible to read black lesbian desire outside of the violence of both the past and present. I want to say that inside the frame of "Triple III" there is no fear, only kinship, intimacy, love. But if this is so, then fear is just beyond the borders of what is made visible here and haunts this beautiful assemblage of bare forms. Here, as in the works that form part of her series portraying lesbians who have been subject to hate crimes that I discuss below, Muholi is masterful in her portrayal of the vulnerability of the human body and the complexity of embodied experience.

44 Chapter 2

Figure 2.3. *Ordeal*, 2003 by Zanele Muholi. Courtesy of Zanele Muholi and Stevenson, Cape Town and Johannesburg.

In "Ordeal, 2003" (fig. 2.3) there is a line of fury that runs through the arm of the woman who crouches at the edge of an enamel basin scrubbing her hands into a blurred frenzy, moving so fast and so slick with water they appear unskinned.[27] At the center of the photograph in which everything else remains still these hands are rendered unrecognizable, a pulpy mass, an internal organ exposed to the air, an aborted fetus or placenta. Something that cannot be washed clean.

This is the first of a series of photographs in *Only Half the Picture* that depicts the survivors of hate crimes. It is followed by a double-page spread of a case number, a crumpled piece of lined paper depicted against a black ground, issued by the South African Police Service in Meadowlands, Soweto (fig. 2.4).

Handwritten on the page are the details of a case—the date of the incident, the name of the inspector assigned to the case, a phone number and an official stamp. There is also a line that reads "ATT. Rape + Assault G.B.H." (Grievous Bodily Harm). The photograph that appears overleaf casts light on

Passing and the Politics of Queer Loss Post-Apartheid 45

Figure 2.4. *Case Number*, 2004 by Zanele Muholi. Courtesy of Zanele Muholi and Stevenson, Cape Town and Johannesburg.

why this hastily written case number should be accorded so much space. "Hate Crime Survivor I, 2004" (fig. 2.5) is a closely cropped portrait of a woman visible from her waist to just above her knees. The vertical lines of her hospital-issue pajama pants angle slightly in toward the center of the photograph and draw the viewers eyes to her slender wrists and hands which are positioned on her lap, her curved finger and thumb forming a dark hollow, a point of entry into her body, a metonym for the violated parts of her we cannot see. Around her wrists are three identification tags that signify her inpatient status but here

Figure 2.5. *Hate Crime Survivor I*, 2004 by Zanele Muholi. Courtesy of Zanele Muholi and Stevenson, Cape Town and Johannesburg.

also read as manacles, handcuffs. And suddenly her striped clothing resembles a prison uniform, and the posture of her body holds the echo of countless images of incarcerated men who stand with their heads bent, their hands and feet bound—a stance of guilt. The implication is that in spite of the indisputable archival evidence represented by the photograph of the case number that immediately precedes this image, lesbians who are raped are often not believed and are treated as criminals both inside and outside of the justice system.

The juxtaposition of these two photographs makes visible the ways in which those who are subject to rape are also often accused of having brought violence on themselves. The concept of "corrective" or "curative" rape is premised on the idea that lesbians have done something wrong to begin with and that rape is that which will set things right, restoring "the natural order." Muholi articulates how rape is used to punish and "correct" lesbians in South Africa: "Curative rapes, as they are called, are perpetrated against us in order to make us into 'real' and 'true' African women—appropriately feminine, mothers, men's property."[28] Yet as Muholi's photographs show, understanding the psychic mechanism that underlies curative rape as an act that restores the order of patriarchy through affirming relations of power between men and women is to grant a kind of rationality to acts of hate. Her series depicting survivors of hate crimes shows how the act of "curative rape" is fundamentally tied to a desire to murder.

One of the most painful photographs in Muholi's *oeuvre* is "Hate Crime Survivor II" (fig. 2.6). It appears alongside the photograph of the "criminal/survivor" and powerfully undoes the flawed and fatal logic that seeks to blame lesbians who are raped. In a hospital ward on a high bed covered with a white sheet is a figure under a heap of dark bedclothes. In fact it is only the caption that accompanies the photograph which renders the figure legible—without the single line that tells us that what we are looking at is a person, a "survivor," there is no way to know for certain that the shape on the bed is a human form.

The camera angle renders the bed enormous and foreshortens the figure so that the person appears shrunken, barely there. The photograph portrays how the human form is overcome by the trauma of psychic collapse. Here the effect of rape is shown to be ontological erasure, the annihilation of subjectivity. The person who we know to be there but that we cannot see has not been made "woman" but has been altogether unmade as a subject.

"Aftermath, 2004" (fig. 2.7) portrays a woman standing and in this sense contrasts the collapsed figure on the hospital bed on the preceding page.[29] However, the large scar that extends down the length of this woman's thigh signifies that there can be no easy moving beyond the trauma of rape. The scar is a sign of a much older wound but serves here as an outer manifestation of her more recent physical and psychic wounding through "corrective rape."

Figure 2.6. *Hate Crime Survivor II*, 2004 by Zanele Muholi. Courtesy of Zanele Muholi and Stevenson, Cape Town and Johannesburg.

Figure 2.7. *Aftermath*, 2004 by Zanele Muholi. Courtesy of Zanele Muholi and Stevenson, Cape Town and Johannesburg.

The scar itself, an elongated teardrop, an opening into her body now closed, like the curled hand of the woman depicted in "Hate Crime Survivor I," serves as a metonym for her violated vagina. There is something unbearable about the positioning of this woman's hands. They seek to shield her, to protect her, in this instance from our gaze as much as from the traumatic memory of attack, but at the same time they are passive. They are hands that speak a history of defeat. If there is a *punctum* here it is not the scar that we cannot fail to see, but the light as it catches the thumb of this woman, her curled fingers, the vulnerability of her being that is encoded in her hands.

Muholi's hate crimes series asks us to think differently about what how we understand sexuality and subjectivity, and this is not restricted to thinking what lesbians are or might be. They show us that to be lesbian is not to perform desire in a way that transforms/queers an underlying essential being that is "woman." Instead they show, through laying bare the painful way in which the corrective rape of lesbians restores absolutely nothing at all, the emptiness at the center of the fiction that animates all forms of gendered being.[30]

QUEERING THE ARCHIVE

The ways in which Antonio Canova's sculpture of "The Three Graces" might be read as pregnant with lesbian/transsexual desire is surfaced in a photographic work by British artist Della Grace/ Del LaGrace Volcano.[31] The black-and-white photograph shows three women, naked but for their jackboots, standing in the pose of "The Three Graces" with their arms around one another and their heads shaved, their bodies scarified, pierced, and tattooed. I first saw LaGrace Volcano's reworking of the sculpture in Parveen Adams's book *The Emptiness of the Image*, and Adams's reading of the photograph is a provocative one. For Adams, the image disturbs the conventional modes of representation of woman to such an extent that she argues: "These women are beyond recognition."[32] She goes on to explain:

> Recognition is a process that may be looked at from two sides. Women who are recognized as such are recognized by a rigorous template of definition. If we do not recognize, in this photograph, these women, it is not because they are recognized as something else. It is rather because the structure of recognition has been suspended.[33]

What Adams draws attention to here is the way in which LaGrace Volcano's photograph inaugurates a way of looking that undoes our gendered gaze. The transgressive power of the image lies in the fact that we cannot simply

50 Chapter 2

substitute "woman" for another recognizable category of being—whether that is "lesbian" or anything else. Adams's reading provides a way to account for the absence of LaGrace Volcano's "The Three Graces" from Pollock's virtual feminist museum. Her analysis of how the photograph works to suspend the structures of recognition raises the question of what it means to be positioned outside the realms of the legible. And this returns us to the significance of the archive, which, as Pollock notes, "is pre-selected in ways that reflect what each culture considered worth storing and remembering, skewing historical record and indeed historical writing towards the privileged, the powerful, the political, military and religious. Vast areas of social life and huge numbers of people hardly exist, according to the archive. The archive is overdetermined by *facts* of class, race, gender, sexuality and above all power" (emphasis mine).[34] Indeed the archive produces these "facts" as much as it holds them and seeks to secure them. The archive is also (and I think this is the sense in which Zanele Muholi employs the term) a site of struggle for legitimacy. A certain kind of entry into the archive will mark queer lives as deviant, perverse, and criminal. Another mode of entry, one that Muholi's work seeks to find, is that which will guarantee visibility within the social that is not at the same time a form of erasure. Central here is the question of what the archive itself demands—what are the conditions of entry into the archive of legibility? If "the archive is the law of what can be said," what is the place of outlaw subjects who are not merely beyond or outside the law but who signify the law's very undoing?[35]

It is in a space of suspension, a kind of limit zone between recognition and invisibility, that Muholi's most powerful photographs are situated. The ways in which Muholi carefully forces the boundaries of the archive's frontier is the subject of the remainder of this chapter. I explore how, through a process that literary theorist Ross Chambers terms "genre-hijacking"[36] and that I draw on and recode here as "passing," Muholi's work performs a complex negotiation of the limits and possibilities of and for queer subjectivity within representation.[37]

MOURNING AND/AS MASQUERADE

There is a second *punctum* that Barthes identifies as he studies the photographs that move him and attempts to identify the secrets of photographic affect. That *punctum* is time. Photographs make visible the passage of time, and they mark our inability to halt its passage. This relation between photography and time is central to understanding how photography, and portrait photography in particular, is linked to mourning. In *Camera Lucida* Barthes reads Alexander Gardner's 1865 portrait of Lewis Payne, a young man who was photographed

in his cell while awaiting execution for attempting to assassinate Secretary of State W. H. Seward: "The photograph is handsome, as is the boy: that is the *studium*. But the *punctum* is: *he is going to die*."[38] Barthes quickly comes to see that all photographs make visible our being-toward-death. "I read at the same time: This will be and this has been; I observe with horror an anterior future of which death is the stake. By giving me the absolute past of the pose (aorist), the photograph tells me death in the future."[39]

The photographs that make up the "Faces and Phases" series exploit the relation between photography and mourning to great effect. All the photographs in the series are shot in black and white. Almost all the subjects face the camera, "returning" the viewers' gaze; most are half-length portraits, and several depict only the head and shoulders of the subject. Each photograph is captioned with the name of the person portrayed, the place in which they were photographed, and the date the image was taken. The uniformity of the images indicates that they form part of a single body of work. The seeming regularity of the series also serves another end—it operates as a visual sign of a shared experience, of a community of being, and is a common practice in photography that aims to memorialize.

Muholi's artist's statement for "Faces and Phases" overtly articulates her desire to assert black queer presence in contemporary South Africa and frames that desire in relation to the ever-present threat of violence, both discursive and material. "It is important to mark, map and preserve our mo(ve)ments through visual histories for reference and posterity so that future generations will note that we were here."[40] In her description of the work she intends the series to perform, Muholi writes: "Historically, portraits serve as memorable records for families and friends as evidence when someone passes. *Faces* express the persons, and *Phases* signifies the transition from one stage of sexuality or gender expression and experience to another."[41] Here Muholi uses the term "passes" in the sense of "passed away" or "to die." An analysis of the work "Faces and Phases" performs also reveals how "passing" operates in another way through these photographs that make visible the "passing away" of lesbians as a result of hate crimes and AIDS-related diseases and a form of "passing" between fixed gendered positions. These portraits simultaneously permit these lesbian lives to "pass" into an archive of mainstream visual representation through their "hijacking" of the generic conventions of memorialization. Ross Chambers has developed this idea in relation to the work of gay writers who have testified to their experiences of living with and dying of AIDS. "Genre-hijacking" makes use of established generic conventions to speak what culture has deemed unspeakable. In the case of Muholi's work in South Africa, what is unspeakable is both lesbian desire and loss. "Faces and Phases" mobilizes the conventions of memorial portrait photography to open a space for mourning

and at the same time queers that space by juxtaposing images of the dead with multiple portraits of living queer subjects.

The question of what is at stake in this act of passing marks the fine line between passing as a strategy of survival, a mechanism that allows one to appear, and "passing away," becoming invisible as a queer subject through one's entry into the realm of the legible. This invisibility can be psychic, a metaphoric loss of subjectivity, and can take material form through the threat of murder that affects lesbian being everywhere in South Africa today. Muholi's artist's statement draws attention to the portraits of those who have died but at the same time positions them among the portraits of the living. Here the presence of the dead signals the precarious position of the living and the living remind us of the subjectivity of the dead:

> Phases articulates the collective pain we as a community experience due to the loss of friends and acquaintances through disease and hate crimes. Some of those who participated in this visual project have already passed away. We fondly remember Buhle Msibi (2006), Busi Sigasa (2007), Nosizwe Cekiso (2009), and Penny Fish (2009): may they rest in peace. The portraits also celebrate friends and acquaintances who hold different positions and play many different roles within black queer communities—an actress, soccer players, a scholar, cultural activists, dancers, filmmakers, writers, photographers, human rights and gender activists, mothers, lovers, friends, sisters, brothers, daughters, and sons.[42]

Positioning the portraits of the dead among those still living implies solidarity with the dead, a community that traverses the boundary between life and death. The rhetorical force of this pairing of the living and the dead powerfully refuses the dehumanization of black lesbians that led to the deaths of the women memorialized here. This positioning which insists on the relation between the living and the dead also means that we necessarily read each portrait in the series as haunted by the possibility of violence, rape, and murder.

The photographs in the series of women who have died—Buhle Msibi, Busi Sigasa, Penny Fish, and Nosizwe Cekiso—make use of the recognizable codes of the obituary form but read in relation to the other portraits in the series these codes are undeniably queered.

Witness the juxtaposition of "Nosizwe Cekiso, Gugulethu, Cape Town, 2008" (fig. 2.8) and "Gazi T Zuma, Umlazi, Durban, 2010" (fig. 2.9). What results is a form of queer memorializing that makes lesbian lives and deaths visible without sacrificing their queerness. It is the particularity of these deaths as lesbian deaths that Muholi will not allow to pass even as they "pass" into the memorial structures of recognition. The photographs that make up "Faces and Phases" suggest the possibilities and impossibilities of and for lesbian

Figure 2.8. *Nosizwe Cekiso, Gugulethu, Cape Town, 2008*, 2008 by Zanele Muholi. Courtesy of Zanele Muholi and Stevenson, Cape Town and Johannesburg.

Figure 2.9. *Gazi T Zuma, Umlazi, Durban, 2010*, 2010 by Zanele Muholi. Courtesy of Zanele Muholi and Stevenson, Cape Town and Johannesburg.

representation involve negotiating the line between passing and death, visibility and invisibility. For in these images what we see is not "woman" and yet we cannot recognize these subjects as lesbians either, for a moment, in looking, the fixity of our gendered look cannot hold.[43] "The structure of recognition has been suspended."[44] All that is thought to separate black lesbians from "human" subjectivity is simultaneously present and absent here. The photographs insist on the particularity of the black lesbians they portray at the same time as they insist on their sameness—to other women, to other embodied subjects, to the human. Through these "straight" portraits we bear witness to queer lives. Muholi's photographs move us through and beyond our perceptions of what lesbian subjectivity might be and at the same time challenge us to reconceptualize the bounds of what is thought to constitute the human. Must the passage between invisibility and visibility entail giving up queerness? In their complex defamiliarizing of the conventions through which we recognize the human, the portraits that constitute "Faces and Phases" suggest this does not have to be so.

Muholi's photographs claim a place for queer subjects in the field of visual art. Through this act of "claiming" her work testifies to the complexity of queer experience in post-apartheid South Africa and at the same time constitutes a demand for political recognition. Muholi's photographs which bear witness to the experiences of lesbians who have been subject to hate crimes, as well as some of the responses her work has generated—like that of Xingwana—illuminate that this demand has yet to be met.[45] The inclusivity of the South African Constitution is often the starting point for debates about gay and lesbian rights in the country, however, as many of Muholi's photographs show, to be queer is still to be subject to multiple, and often violent, forms of erasure.

NOTES

*An earlier version of chapter 2 was first published as "Zanele Muholi's Intimate Archive: Photography and Post-apartheid Lesbian Lives," in *Safundi: The Journal of South African and American Studies*, Volume 11, Issue 4 (2010): pp. 421–436 and can be accessed at http://www.tandfonline.com/doi/full/10.1080/17533171.2010.511792.

1. Roland Barthes, *Camera Lucida: Reflections on Photography*, trans. Richard Howard (New York: Farrar, Straus and Giroux, 1981), 26.

2. Lisa van Wyk, "Xingwana: Homophobic Claims 'Baseless, Insulting,'" *Mail & Guardian Online*, March 5, 2010, http://www.mg.co.za/article/2010-03-05-xingwana-homophobic-claims-baseless-insulting (accessed June 18, 2010). For the media statement issued by Xingwana, see Lulu Xingwana, "Statement by Minister of Arts and Culture Ms Lulu Xingwana on Media Reports Around the Innovative Women

Figure 2.10. *Penny Fish, Vredehoek, Cape Town, 2008*, 2008 by Zanele Muholi. Courtesy of Zanele Muholi and Stevenson, Cape Town and Johannesburg.

Exhibition," *Department of Arts and Culture*, March 3, 2010. http://www.dac.gov.za/media_releases/2010/04-03-10.html (accessed July 2, 2010). It is also instructive to read the Minister's statements on art that does promote nation building. See for instance her address at the launch of "Moral Regeneration Month" in "Address by the Minister of Arts and Culture, Ms Lulama Xingwana, MP at the launch of Moral Regeneration Month, Polokwane," *Department of Arts and Culture*, July 11, 2009. http://www.dac.gov.za/speeches/minister/2009/11Jull09Speech.html (accessed July 2, 2010). Xingwana's remarks were also directed towards the works of artist Nandipha Mntambo which were also included in the exhibition.

3. I employ the term "queer" to open a way of thinking about sexuality and subjectivity that crosses and seeks to undo the bounds between categories of identification such as "gay," "lesbian," "straight," "bisexual," and "intersex."

4. See my discussion of the terms "corrective rape" and "curative rape" in "Homophobia, Injustice and 'Corrective Rape' in Post-Apartheid South Africa" http://www.csvr.org.za/images/docs/VTP3/k_thomas_homophobia_injustice_and_corrective_rape_in_post_apartheid_sa.pdf (accessed April 29, 2013).

5. I draw the phrase "structures of recognition" from psychoanalytic theorist Parveen Adams. The term implies socially constructed ways of seeing and modes by which one becomes recognizable as a subject, as well as the psychic dimension of the operations of the gaze. See Parveen Adams, *The Emptiness of the Image: Psychoanalysis and Sexual Differences* (London: Routledge, 1996).

6. "Faces and Phases" is the name of an ongoing series of black and white portrait photographs that Muholi began in 2006. Her book *Faces and Phases* was published by Prestel in 2010. Muholi has also had several exhibitions titled "Faces and Phases," most recently at Documenta 13 in Kassel. See http://www.stevenson.info/artists/muholi.html (accessed April 29, 2013) and http://d13.documenta.de/ (accessed April 29, 2013).

7. See Desiree Lewis, "Against the Grain: Black Women and Sexuality," *Agenda* 63, no. 2 (2005): 11–24; Pumla Dineo Gqola, "Through Zanele Muholi's Eyes: Re/Imagining Ways of Seeing Black Lesbians," in *Zanele Muholi: Only Half the Picture* by Zanele Muholi (Johannesburg: STE Publishers, 2006), 82–89; and Gabi Ngcobo, "Introduction," in *Zanele Muholi: Only Half the Picture*, by Zanele Muholi (Johannesburg: STE Publishers, 2006), 4–5.

8. Griselda Pollock, *Encounters in the Virtual Feminist Museum: Time, Space and the Archive* (New York: Routledge, 2007), 13. See also Griselda Pollock, *Differencing the Canon: Feminist Desire and the Writing of Art's Histories* (London: Routledge, 1999).

9. Ibid., 13.

10. Ibid., 12.

11. Van Wyk, "Xingwana."

12. A selection of photographs by the participants at the workshop, a description of the project and some of Jean Brundrit's own very interesting photographic work which, like Muholi's, engages with lesbian experience, (in)visibility and the archive is collected in Jean Brundrit, *A Lesbian Story: An Exhibition Project by Jean Brundrit*, contributing essay by L. van Robbroeck (Cape Town: Michaelis School of Fine Art, 2008).

13. For more information about Zanele Muholi's visual activism see her projects on her website, http://www.zanelemuholi.com.

14. See the critiques leveled at Muholi's early work by reviewers such as Gail Smith, and reprinted in Muholi's *Only Half the Picture*, 90–91; and John Hogg, cited in Lewis, "Against the Grain," 17.
15. http://www.zanelemuholi.com.
16. Xingwana, "Statement," 2010.
17. Ibid.
18. Susan Sontag, *On Photography* (New York: Penguin, 1979), 161.
19. Ibid., 64–65.
20. Ibid., 6–7.
21. Ibid., 112.
22. Barthes, *Image, Music, Text*, 16–18.
23. Ibid., 18–19.
24. Ibid., 19.
25. Barthes, *Camera Lucida*, 26.
26. Ibid., 43.
27. This and other images from Muholi's *Only Half the Picture* can be viewed at Michael Stevenson, "Zanele Muholi: *Only Half the Picture*," Stevenson. http://www.stevenson.info/exhibitions/muholi/muholi.htm (accessed March 29, 2013).
28. Zanele Muholi, "Mapping Our Histories: A Visual History of Black Lesbians in Post-Apartheid South Africa," *Zanele Muholi*, 19, http://www.zanelemuholi.com/ZM%20moh_final_230609.pdf (accessed March 12, 2013).
29. For other readings of this photograph see Lewis, "Against the Grain," and Henriette Gunkel, *The Cultural Politics of Female Sexuality in South Africa* (New York: Routledge, 2010).
30. The key text for thinking gender as performative remains Judith Butler's *Gender Trouble* which asks, among other things how "language itself produce[s] the fictive construction of 'sex'" (*Gender Trouble: Feminism and the Subversion of Identity* [New York: Routledge, 1990], xi).
31. Della Grace is now Del LaGrace Volcano, a gender variant visual artist. See http://www.dellagracevolcano.com.
32. Adams, *Emptiness of the Image*, 123.
33. Ibid., 138.
34. Pollock, *Encounters*, 12.
35. Michel Foucault, *The Archaeology of Knowledge*, trans. A. M. Sheridan Smith (London: Routledge, 2002), 145.
36. See Ross Chambers, *Untimely Interventions: AIDS Writing, Testimonial and the Rhetoric of Haunting* (Ann Arbor: University of Michigan Press, 2004), 29. See also his *Facing It: AIDS Diaries and the Death of the Author* (Ann Arbor: University of Michigan Press, 1998) for an excellent study of how writing the experience of living with and dying of AIDS tests the boundaries of autobiographical writing.
37. Natasha Distiller's essay offers a critical reflection on the limits of and for lesbian experience within representation in "Another Story: The (Im)possibility of Lesbian Desire," *Agenda* 63 (2005): 44–57. Interestingly, Muholi refers to Distiller's argument in her discussion of her motivation for producing "Faces and Phases" and

states: "I wanted to resist the heterosexual representation of lesbians through portraits" (Muholi, "Mapping," 26).

38. Ibid., 96.

39. Ibid.

40. Zanele Muholi, "Faces and Phases," *Stevenson*. http://www.stevenson.info/exhibitions/muholi/facesphases.htm (accessed March 29, 2013).

41. Muholi, "Mapping," 27.

42. Muholi, "Faces and Phases."

43. For a representative selection of images, see the website of the Brodie Stevenson gallery in Johannesburg, at which "Faces and Phases" was exhibited in July 2009, http://www.brodiestevenson.com/exhibitions/muholi/index.htm; and the images archived on the Michael Stevenson website after Muholi's "Faces and Phases" Artist's statement, http://www.michaelstevenson.com/contemporary/exhibitions/muholi/facesphases.htm.

44. Adams, *Emptiness of the Image*, 138.

45. See for example the recent incident at the United Nations Human Rights Council in Geneva where South Africa's representative Jerry Matjila objected to the inclusion of sexual orientation in a report on racism as to do so would be to "demean[s] the legitimate plight of the victims of racism" (Peter Fabricius, "SA Fails to Back Efforts at UN to Protect Gays," *Cape Times*, June 23, 2010, 3).

· 3 ·

Traumatic Witnessing

Photography and Disappearance

On the inside cover of one of my notebooks is a photograph of a small boy standing inside a long shadow. Behind him is another child, only partially visible. It's a snapshot, not a very good one. A picture I took outside the Red Cross Support Group for people living with HIV/AIDS in Khayelitsha in 2001. On the facing page I pasted a small note torn from a list of statistics about HIV and AIDS in South Africa:

 Orphans: 500,000 in 2000
 1,400,000 in 2010

The little boy in the picture was the first person I connected with in Khayelitsha and my first real connection to the trauma of AIDS.[1] He was four years old when I met him, his bright eyes in sharp contrast with his dusty, dry skin. He lived with his parents in a shack that threatened to slide down from the edge of the short slope it was built on into the open waste-field below. His family's hold on life was precarious—both his parents were HIV positive and unemployed, his father was extremely sick, his mother overwhelmed by her situation and by the needs of her six-month-old baby and her young son. In 2001, patients in the South African public health care sector had no access to antiretroviral therapy, and people died of AIDS without treatment in the passageways of public hospitals or in their homes.

 When I look at the photograph of this child, he appears weightless, smaller even than in life, and saturated with loss. There is something magnetic in his gaze, a deep pull backward in time, an opening that compels me to reflect on his insubstantial form. To look upon his face is to recognize the affective power of the photographic image, a power that lies in its call on us to bear witness to the experience of others. Susan Sontag has famously

argued[2] that the multitude of photographs of the suffering other has led to a kind of visual immunity—I see but I do not feel. And in *Camera Lucida*,[3] his beautifully written and oft-cited series of meditations on photography, Roland Barthes shows that sometimes the affective power of the photograph is so great that I feel more than I see.

This chapter takes up the question of what it means to look upon the suffering of others and explores some of the complexities of bearing witness to AIDS. I focus on the work of Gideon Mendel, a London-based South African photojournalist who has been documenting HIV/AIDS in Africa for two decades. Mendel's photographs raise questions about the commodification of AIDS and the circulation of photographs of the dead, some of which I take up here. They also open a way to think about how photography can function as a mode of bearing witness to the experiences of others.

Mendel, who began documenting the epidemic in 1993, is one of a small group of photographers who have engaged with the issue of HIV/AIDS over time.[4] His body of work provides the most significant photographic record of the effects of the epidemic in Sub-Saharan Africa, and South Africa in particular.[5] *A Broken Landscape*[6] chronicles the impact of HIV/AIDS on everyday life in Malawi, South Africa, Tanzania, Zambia, and Zimbabwe. A selection of photographs from the book were exhibited at the National Gallery in Cape Town from January to April that same year, and during that time Mendel began work on a new series of photographs focusing on access to anti-retroviral therapy in South Africa. Through an analysis of this body of work it is possible to trace how AIDS, and more recently HIV, has been imagined and represented. In particular, Mendel's work shows how the emergence of an HIV/AIDS activist movement and access to anti-retroviral treatment in South Africa has led to new forms of representation of HIV-positive subjectivity.

PHOTOGRAPHY AND AIDS

In June 2001 the online journal *The Digital Journalist*[7] released a special issue commemorating photography's role in documenting the epidemic over the course of twenty years. The issue includes interviews with many of the leading photographers in the field as well as reproductions of images that provide fascinating insight into how photography has shaped public perception of HIV/AIDS. Mendel is one of several photographers who relate how their work has in turn been shaped by the epidemic:

> In 1993, I was part of a group project called "Positive Lives," organized by my photo agency, Network, in which photographers responded to AIDS

in the U.K. My first exposure to the issue was photographing in an AIDS ward in London. I found the situation different than any I'd ever experienced as a photojournalist. It was only 10 percent photography and 90 percent communication and connection with people, dealing with issues of confidentiality, considering how people should be projected, being sensitive not to portray people as victims. That same year, I made contact with a mission hospital in Zimbabwe and I photographed there. I felt that as an African photographer I needed to find a way to respond to the AIDS crisis which was clearly developing in Africa at that time. So that essay, looking at one remote hospital in an area where more than 25 percent of pregnant women were testing HIV-positive, was the beginning of my work on HIV and AIDS in Africa.[8]

In his statement Mendel draws attention to how photographing AIDS presented a new and unique "situation" for photography, one that led to a shift in his practice. In photographing AIDS, Mendel suggests, a series of issues arise that complicate the process of representation: the need to maintain confidentiality, the need for an awareness of what the effects of the image might be, and recognition of the ideological force of the re-inscription of generic conventions.

I begin my analysis of Mendel's work by reading his first photographic essay representing AIDS in Africa, the images he took in Zimbabwe in 1993 at Matibi Mission Hospital. This series of images is included in *A Broken Landscape* and is one of four sequences of images depicting hospital patients in the book. *A Broken Landscape* is 208 pages in length and contains 127 black-and-white photographs of people living with HIV/AIDS in southern Africa. There are several "portraits" that are made up of a series of images of an individual living with HIV and AIDS and those who care for them. Each of these sequences is prefaced by an extended caption, either the words of the person depicted or of a family member and/or caregiver. With the exception of the sequence depicting Mzokhona Malevu, which I discuss below and which has three pages of text accompanying seventeen images, all of the extended captions are between a half to one page in length. The sequences that depict hospital patients are distinguished from the other sequences in the book in that none of the individuals depicted are named nor is text provided alongside the images relating the stories of those shown.

The caption that begins the Mission Hospital sequence is given as follows: "Mission Hospital. Matibi, Zimbabwe / A remote rural hospital in an area where nearly 30 percent of pregnant women test HIV positive."[9] What is of importance here is what is omitted from the caption. As noted above, unlike many of the other sections in the text, no names are given for those depicted nor is there any testimony or description of their lives. It is also

64 Chapter 3

interesting that while the caption draws attention to the high infection rates among pregnant women in the area, no visibly pregnant women are shown in the section that follows, or indeed, anywhere in the book. While the section begins with an image of two seated women, and women feature in each of the eight images that constitute the sequence, they appear as caregivers to the men who are shown to be sick and dying. Four of the eight images included in this sequence depict a man who is dying and whose death Mendel witnesses and photographs. I analyze the significance of the image of the instant of this unnamed man's death below.

The Mission Hospital sequence shows conditions in the hospital compound and inside the hospital building.[10] It begins with an image of two women sitting on a concrete structure, a square alcove that resembles a window-seat without a window. The women are framed by a concrete wall behind them and a thin square of wood that outlines the alcove in which they sit. One of the women holds her hands in her lap and looks fixedly into the distance. Her clothes are threadbare, her body thin, and in the foreground, her broken shoes and awkwardly positioned feet signify her suffering. Alongside her another woman is engaged in crochet and wears a calm, placid expression,

Figure 3.1. *Patients with HIV and TB at Matibi Mission Hospital in Zimbabwe who are separated from the rest of the patients sit outside in an "isolation" section to prevent the spread of TB. In this area 37 percent of pregnant mothers are testing HIV-positive. Zimbabwe now has the highest level of HIV infection out of any country in the world with 35 percent of the adult population testing positive,* July 1993 by Gideon Mendel. Courtesy of Gideon Mendel.

her eyes downcast. This woman wears white clothing, which contrasts with her extremely dark skin that is stretched taut over her cheekbones and over the exposed area of her chest. Peeping out from the hem of her skirt are her cracked, bare feet. There is a stillness about these women that makes them appear to be a sculpture or a painting, and their position within the wooden frame contributes to this effect.

This photograph and the image that follows it portray the exterior space of the hospital and are followed by a series of photographs of patients inside the hospital building. The first two images work to set up a particular way of looking at the images of the interior space that follow that depends on a perception of Africa as that which is beyond the reach of western medical care.[11] These photographs portray a poverty that, because it is not explained, comes to appear natural. The second image portrays a person lying on a reed mat covered from head to toe with a worn blanket, their knees drawn up towards their chest. At the feet of this person, part of the body of a woman is visible with a small child seated on her lap. In the foreground alongside the head of the person lying on the ground are two cooking pots standing next to the remains of a fire, smoke from which obscures the face of the person lying under the blanket. As the structure of the book until this point has presented image-sequences of a single person that can be read as a narrative, I read the

Figure 3.2. *The wife of a patient with AIDS at Matibi Mission Hospital in Zimbabwe feeds him,* July 1993 by Gideon Mendel. Courtesy of Gideon Mendel.

photograph that follows the image of the person lying on the reed mat as a way to decipher the first image of a patient inside the hospital.

This photograph shows the emaciated face and upper body of a man lying on a white bed. Alongside him is a woman who holds his hand in her right hand, an enamel bowl containing a small fish, whole but for a fragment torn from its middle, cradled in her left. The bowl, it seems, could be the lid of the pot that appears on the preceding page. It is possible that this man could be the figure concealed by the blanket, lying on the reed mat on the ground outside while waiting to enter the hospital. Mendel's depiction of the sanitized interior space of the hospital is in sharp contrast to the photograph that precedes it.

Reading these images in relation to one another casts light on the strange double-page spread of the blanketed figure and the headless woman and child. The photograph of the exterior of the hospital portrays a space of non-reason, a space in which composition has gone awry, a space of "primitive" Africa where all activity takes place around the edge of a fire which does not burn but smoulders, the smoke obscuring the figure, sick, asleep, or dying, beneath their blanket. The interior space of the hospital is a space of order, and in spite of the absence of nurses, the hospital beds are arranged in rows, the bed linen appears clean, and the sick are being ministered to by their female family members.

The next photograph in the sequence depicting the interior of the hospital shows an extremely ill man being supported by a woman who is helping him to drink from an enamel mug. The woman's gaze is directed at the man she is supporting, and her face can only be seen in profile. The man's head is turned towards the camera and one of his eyes is visible, the other obscured by the woman's hand and the cup. The eye that can be seen is also an eye that looks. It appears as if the man has seen the camera and is directing his gaze towards it. The expression in his eye is one of shock or fear, that of a person who, in a moment of vulnerability has realized that they are not unobserved.

The sight of this eye is an instance for me of Barthes's *punctum*. For Barthes, the *punctum* is that which disrupts what he terms the *studium*, the vast field of photographic images that one interprets by means of what one has learned to see. Of the *studium* Barthes writes:

> Thousands of photographs consist of this field, and in these photographs I can, of course, take a kind of general interest, one that is even stirred sometimes, but in regard to them my emotion requires the rational intermediary of an ethical and political culture.[12]

If the *studium* is that which I have learned to see, the *punctum* is that which resonates with my own experience, effectively creating a rupture in the *studium*. Barthes describes the *punctum* in the following way:

> The second element will break or (punctuate) the *studium*. This time it is not I who seek it out (as I invest the field of the *studium* with my sovereign consciousness), it is this element which rises from the scene, shoots out of it like an arrow, and pierces me. A Latin word exists to designate this wound, this prick, this mark made by a pointed instrument: the word suits me all the better in that it also refers to the notion of punctuation, and because the photographs I am speaking of are in effect punctuated, sometimes even speckled with these sensitive points: precisely, these marks, these wounds, are so many points. This second element which will disturb the *studium*, I shall therefore call *punctum*; for *punctum* is also: sting, speck, cut, little hole—and also the cast of the dice. A photograph's *punctum* is that accident which pricks me (but also bruises me, is poignant to me).[13]

Barthes's description of the way in which the *punctum* "reaches" the viewer seems to involve the transformation of the medium of the photograph itself. Certain images are not merely one dimensional but contain an element that "rises from the scene, shoots out of it like an arrow, and pierces me." The *punctum*, defined as a "cut" or "little hole," seems to tear through the structures of representation. Through this tiny opening, the viewer and the viewed are suddenly, even violently, co-present. The *punctum* as that which wounds also implies an opening of the body, an opening of the embodied viewing subject to the injury of memory, to that which is lost but which the image partially returns.

Looking at Mendel's image of the sick man being held up to drink from an enamel cup is disturbing not only because the man has caught sight of the photographer but also because I experience his gaze as one directed at me. The fictional realm the sick man inhabits on account of the fact that for me, the viewer, he exists through, and only as, image, becomes the real. The distance that representation allows is collapsed and at once I am present at the scene of the image. The man's panicked eye catches me and seems to accuse me of that which I already know myself to be guilty; I am a voyeur of his body, of his life verging on death, of what may be his last moment. The photograph itself becomes for me an accusation.

In the same photograph there is another element that disturbs the *studium* of AIDS that makes up *A Broken Landscape*: on one corner of the blanket that partially covers the patient and that appears across the lower-left section of the photograph is a small manufacturers' label that reads "Lady Anne" in a curling script. This tiny sign with its reference to British nobility and imperial industrialism serves as a reminder of Zimbabwe's history of colonial oppression. The "Lady Anne" label and the accusing eye of the sick man articulate with one another, fracturing the vision of Africa as outside of western time and of Africans as beyond the reach of medical assistance. The photographs and

68 Chapter 3

extended captions that accompany them in the other sections depicting hospitals included in *A Broken Landscape* also emphasize how healthcare systems in southern Africa are unable to adequately address the HIV/AIDS crisis due to lack of resources and understaffing. The extended caption for the section titled "Government Hospital. Nkhotakota, Malawi" reads as follows:

> Officially we have beds for 110 patients but we now have about 130 patients and 250 outpatients a day. It's difficult to say accurately how many have died of AIDS because we have run out of reagent for testing and haven't been able to test. We have approximately one death a day. We lack equipment, we lack staff, we don't have medicines. We don't even have plaster tape, so we have to use masking tape to attach drips or splints to patients' arms. We are overwhelmed in every aspect of the epidemic. Dr Maurice Bonongwe, Director.[14]

It is apparent from this statement that Nkhotakota Government Hospital in Malawi did, at some point, have the capacity and the equipment necessary to test patients for HIV. The reasons why the hospital has "run out of reagent" are not made clear. Without this crucial explanation Bonongwe's words are reduced to an affirmation of what Simon Watney terms the "psychic and cultural construction" of the discourse of "African AIDS."[15] One consistent aspect of this discourse is the "singl[ing] out [of] the alleged 'mis-reporting' of African HIV and AIDS statistics as further evidence of 'backwardness' and 'unreliability.'"[16] The photographs of hospitals in *A Broken Landscape* depict crumbling outposts on the margins of bio-power, yet the part played by colonization and its legacy in structuring relations between the hospital as institution and the institutionalized African body is never overtly stated. That colonial history is also what permits the presence of the camera in the space of African hospitals also remains unacknowledged. Mendel's own discomfort with the intrusive nature of his work is made apparent in his statement about the Matibi Mission Hospital sequence, and as I note in my analysis below, this statement, and Mendel's anxiety about his work along with it, are excised from the published collection of photographs. This omission of how the colonial legacy continues to determine the (post)colonial present naturalizes conditions in the hospitals and the presence of the photographer.

It is interesting to note, in relation to the photograph in which I have identified two ruptures in the *studium* of AIDS, that for Barthes, the *punctum* is never that which the photographer intended me to see but rather that which appears in spite of the photographer's intentions. In his essay, "Barthes's *Punctum*,"[17] art historian Michael Fried argues that most scholars who have engaged with Barthes's work on photography have overlooked this crucial aspect of how the *punctum* should be understood and defined.

Fried emphasizes that for Barthes, the *punctum* is not only an individual response to an image but, prior to this, that which escapes or exceeds the photographer's intentions and which the photographer *has not seen*. Fried reads Barthes's work in relation to his own, particularly in relation to what he terms "antitheatrical critical thought."[18] For Fried, Barthes's assertion that the *punctum* is that which appears without the photographer's intent "is an antitheatrical claim in that it implies a fundamental distinction, which goes back to Diderot, between seeing and being shown."[19]

> The punctum, we might say, is seen by Barthes but not because it has been shown to him by the photographer, for whom it does not exist; as Barthes recognises, "it occurs [only] in the field of the photographed thing," which is to say that it is a pure artifact of the photographic event—"the photographer could not photograph the partial object at the same time as the total object" is how Barthes phrases it—or, perhaps more precisely, it is an artifact of the encounter between the product of that event and one particular spectator or beholder, in the present case, Roland Barthes.[20]

Fried's analysis of the antitheatrical quality of the *punctum* provides a way to understand the disruptive capacity of the image of the man who seems to see through and out of Mendel's photograph. The work of Barthes and Fried suggest that while photographs of people living with HIV/AIDS may circulate as commodities within a severely limited field of representation, the power of such images to disturb those who view them cannot be altogether anaesthetized.

AN EXEMPLARY DEATH

The first of Mendel's photographs depicting the death of an unnamed man shows a woman at his bedside. Their relationship is shown to be an intimate one, their togetherness emphasized by another man, visible in the background of the image and who is depicted lying alone on a bed, his hands covering his face. The woman at the bedside is entirely absorbed in the man's suffering; her eyes are directed at him and her face is close to his. His eyes are directed at the ceiling, but he does not seem to see. The woman's hands are moving above his face, perhaps she is about to adjust his blankets, or, as the next image indicates, lift him from the bed.

In the photograph that follows, the woman is using all her strength to support the sick man's body. She is looking at his face and seems terrified, resolute or desperate. The man is in pain, his position is awkward; with his lips apart he looks into the distance and seems about to cry. An open door and an empty bed just beyond it are visible on the far left of the image, behind the

Figure 3.3. *The wife of a patient at Matibi Mission Hospital in Zimbabwe takes care of her husband who was very ill with AIDS-related infections,* July 1993 by Gideon Mendel. Courtesy of Gideon Mendel.

Figure 3.4. *The wife of a patient with AIDS at Matibi Mission Hospital in Zimbabwe carefully lifts up her husband. Seconds later he died from kidney failure,* July 1993 by Gideon Mendel. Courtesy of Gideon Mendel.

woman. The pillow upon which the man was lying seems to hold his shadow, the stain of his body. The pillow seems to be torn, worn through, the folds of the fabric like skin, something visceral, repulsive, opening; a metaphor for the body that has lifted away from the bed.

The photograph that follows is the image of the instant of his death, the sheet around his body now a shroud. His eyes rolled back, half open, in the horrifying pose of death, his body slumped against the woman. On the right-hand side of the photograph, only partially visible is the doctor, a bearded white man equipped with the accessories of modernity: spectacles, a watch on his arm that is extended, reaching to the chest of the dead man, and in his hand the stethoscope, the instrument that enables him to pronounce the man as dead.

Mendel recounts how his presence at the moment of this man's death during his first assignment documenting HIV/AIDS in Africa at the Mission Hospital in Zimbabwe was a defining moment in his career:

> While I was there [at Matibi Mission Hospital] I was photographing a patient whose wife was lifting him up in his bed. As I was documenting that scene, he had a sudden seizure and died from kidney failure. On my contact

> sheet I can follow the sequence as he moves from life to death. These are images I have mixed feelings about: as a news photographer I have photographed many dead people, yet there is something about my role in that situation I do not feel comfortable with. Are there some moments which should be sacrosanct, exempt from the intrusion of a camera? In that situation, seconds after the man had died, and the reality of the situation began to strike me, his family began to wail and break down. I put my camera down and stopped photographing. The doctor who had been called looked at me calmly and said, "Come on, man, do your job." In that context of medical crisis it was the only constructive thing I knew how to do.[21]

What Mendel terms "the reality of the situation" only strikes him after the man's death—he "sees" that what he has been photographing is not a scene but a real situation.[22] The careful construction of "AIDS" as spectacle is radically disrupted by the "real" of AIDS. "Are there some moments which should be sacrosanct, exempt from the intrusion of a camera?" Mendel asks.[23] What might be called a "crisis in witnessing" is quickly swept aside by the doctor's reply, delivered as an instruction through the homosocial rhetoric that structures relations between white men in (post)colonial contexts: "Come on, man, do your job."[24] The doctor's impatience with Mendel's quavering in the face of death is the position of one for whom the political import of telling the story of AIDS is greater than recognizing individual suffering and grief. It is also the position of one for whom it must necessarily be so—in its idealized form, western medical science hinges on the cleanly biological view of life and death. The doctor, confronted by pain and grief, does not lose his head and in the practice of photography, of making visible as a mode of rationality, Mendel too finds a way to hold onto the sense of things. Mendel takes up his camera again and photographs the bereaved family. "In that context of medical crisis it was the only constructive thing I knew how to do," he explains.[25] Documenting the crisis of AIDS, identified here as Mendel's "job," is a way to apprehend death as something more than, something outside of itself. Photographing the dead is here understood to be constructive presumably because through making this one death visible, other deaths will be averted.

WHO OWNS THIS DEATH?

The final photograph in the Matibi Mission Hospital sequence shows three grief-stricken women outside of the hospital building in the compound that was visible in the first two images in the series. In this image I see that the

Figure 3.5. *Grieving family members, Matibi Mission Hospital, Zimbabwe,* July 1993 by Gideon Mendel. Courtesy of Gideon Mendel.

world of the mourners has been shattered but the composition of the photograph is such that their grief does not shatter me. The mourners are photographed from behind, their arms around one another forming a tight circle, their faces hidden from view. I am closed out, positioned safely outside of the intensity of their grief. I see their sorrow, but I do not experience it. Their world is one of disorder, one in which reed mats are scattered haphazardly on the barren ground, empty bowls are upturned, and a blanket has been slung between the branches of a tree that casts no shade. This inhospitable, "broken" landscape bears no resemblance to my own, nor, I imagine, to that of many of the readers of *A Broken Landscape*.

What I see in this image that seems to reflect me is the uncanny similarity between two dark spaces in the concrete wall in the background of the photograph to a pair of hollow, expressionless eyes.[26] The notion that these dark spaces in the center of the concrete wall are a pair of eyes transforms all the dark spaces on the concrete structure into eye sockets, all of them looking down at the three grieving women in their desperate embrace. These "eyes" do not so much return my gaze as absorb it, a metaphoric mirror of the eyes of the mourners that do not see me looking at them.

AIDS AS VISUAL STORY: MZOKHONA MALEVU. ENSELENI TOWNSHIP, SOUTH AFRICA

A Broken Landscape contains several "portraits"—image sequences that depict an individual living with HIV and AIDS and those who care for them. These portraits provide a more detailed insight into the lives of their subjects than a single image would allow. There are nineteen pages depicting the life and death of Mzokhona Malevu who was twenty-nine years old when he died in September 2000.[27] This series, the longest devoted to an individual in the collection, forms an intimate account of his illness and death and of the people who loved and cared for him. Of this sequence Mendel states:

> I'm proudest of a story I did this past year on one person, Mzokhona Malevu, a person with AIDS in South Africa. I think I achieved real depth. I began to photograph him in April of 2000. And I went back to visit him and his family on four different occasions over the year, leading up to attending his funeral in December. I made a strong, personal connection with him and his family, who were taking care of him with amazing love within the context of extreme poverty. Mzokhona was living in a three-room squattershack with twenty-one people. He was open and out about his disease. He had decided that he wanted his funeral to be an AIDS-education event and he made me promise that when he died I would come and take photographs at his funeral. He wanted to tell his story to the world and I was a sort of conduit for him to do it. The quotes which I collected from him, together with the images which tell his story from life to death, make a powerful, personalized statement.[28]

Mendel's description of his relationship with Malevu and with his family and the photographs he took of him "which tell his story from life to death" present a marked contrast to the images that chronicle the death of the unnamed man at Matibi Mission Hospital.

The first image in the series depicting Mzokhona Malevu is a formal head-and-shoulders portrait, one in which the sitter is well aware of being photographed and is posed for the camera. Malevu's face and clothing are shown in sharp focus while the background of the image is blurred. His eyes are at the very center of the image and draw the viewer's attention; he appears to be looking out of the photograph, his gaze both haunting and haunted.

In Mendel's portrait, Malevu wears the look of a condemned man. The poignancy of the image lies in its reappearance in the book a few pages later, in an image that shows Malevu's funeral which appears after several photographs that show Malevu's daily struggles living with AIDS in conditions of extreme economic poverty, of his corpse being prepared for burial, and of his funeral

Figure 3.6. *Mzokhona Malevu (29) and twenty-one family members live in a two room shack in Enseleni. He is bravely open about his AIDS,* by Gideon Mendel. Courtesy of Gideon Mendel.

procession. The photograph of the funeral shows the church choir with Malevu's coffin in the foreground. Positioned on top of the coffin is an enlarged, framed reproduction of the portrait that began the sequence of images. The appearance of this photograph within the photograph of Malevu's funeral is a haunting signifier of how, for those living with AIDS without access to treatment, ill health deteriorates rapidly into death. Time has been compressed for Malevu, and his passage from life to death radically accelerated.

Anxiety about the limitations of visual representation emerges through Mendel's statement about how his practice has shifted in response to his sense that "the story of AIDS" exceeds the photographic medium:

> I've also come to feel that images aren't enough to express the story of AIDS. What I've found very effective is combining visuals with personal quotes from the people I'm photographing to give them a voice alongside their image. I've used this approach in exhibitions, on the website (www.networkphotographers.com/aidsinafrica) and in a book I'm publishing this fall called *A Broken Landscape: HIV and AIDS in Africa* (supported by Action Aid, a charity involved in many AIDS- and poverty-alleviation projects in Africa). It has also become a priority for me that my work be used and seen in the countries where the photographs have been taken. I am currently working with Action Aid to produce a series of twenty educational posters using my images and the quotes I have collected from my subjects. These will hopefully be widely distributed in Africa.[29]

The "voice" of the photographed subject is attached to the image in response to photography's contested claim to represent the truth or the real. This "voice" of truth comes to substitute for visual truth. At the same time testimony affirms the truth of the visual. If we consider the way in which Malevu's testimony operates in the sequence depicting his life and death, it becomes apparent that its function is as a discourse of verification, one that affirms what the images show. The extended captions that accompany the photographs in this sequence consist of two pages of Malevu's testimony and a one-page account of his death related by Nancy Khuswayo, AIDS counselor. Mendel's photographs mirror the script of Malevu's testimony. For instance, the last section of Malevu's testimony reads as follows:

> I was given some drugs, which made me feel much better, but I cannot afford them now. I have heard that in overseas countries the government provides drugs and food free for people with AIDS, but here in South Africa there is nothing now. At the clinic they often say there is nothing they can do. You must go home. It is not fair. People overseas can get better from the good drugs they are given, while we in South Africa have to die.[30]

Figure 3.7. *Mzokhona Malevu sleeps in his family's two-roomed squatter shack in Enseleni Township near Richards Bay in northern KwaZulu/Natal, South Africa,* 2000 by Gideon Mendel. Courtesy of Gideon Mendel.

The sequence of images depicting Malevu's life and illness reinforces the notion that his premature death is inevitable. The first image establishes Malevu as a man condemned, a young man but one who has glimpsed his own death, a tragic portrait, perhaps only made tragic by what is, inevitably, to come.

The two photographs that follow show Malevu engaged in the everyday life of the well; one an image of Malevu absorbed in a card game surrounded by smiling family members, the other a photograph in which Malevu is smiling, his ecstatic face appearing through the space between the arm and the body of a person in the foreground, their body large, dark, and out of focus. These photographs accentuate the suffering and sorrow that saturate the remaining images in the sequence. The image that follows is a double-page spread depicting Malevu's sleeping quarters. The photograph shows Malevu in his bed on the far right-hand side of the image; he is awake but appears in a dreamlike state, seemingly unaware of the presence of the photographer. Alongside him on the floor are the seven children with whom he shares his room, sleeping or feigning sleep, one child returning the camera's gaze. The second page of Malevu's testimony appears overleaf:

78 Chapter 3

> My father is employed sometimes doing piecework on construction sites and my mother works as a maid for whites in Richard's Bay. We live in two rooms here. There is my mother, my father, their eight children and eleven grandchildren—twenty-one of us altogether. I sleep on the bed here in this room, with seven children sleeping on the floor next to me. Sometimes we do not have enough food to go round. My father usually bathes me early in the morning before he goes to work, but since recently we have to pay for water which he collects at the communal taps. It is sixty cents for a bucket. Now even some water for washing can be a problem.[31]

The photograph that follows Malevu's testimony portrays Malevu's father washing his son's head, and those that follow depict Malevu's deteriorating condition, his hospitalization, and the care provided him at home by his brother and sister. These works are followed by Nancy Khuswayo's testimony which provides an account of Malevu's death. The photograph on the facing page shows the arms and part of the legs of a man, presumably a coroner or undertaker, crouched behind Malevu's head and laying a sheet over his corpse. Only Malevu's face is visible through a hole in the heavily embroidered cloth. Malevu's lips are slightly parted and stretched over his teeth, their pearlescence and the tiny sliver of whiteness visible just beneath his closed eyelid, the only disruptions to the otherwise extreme contrast between his dark head and

Figure 3.8. *Mzokonah Malevu who was severely ill with AIDS-related infections is carried by his brother through the squatter camp the family lives in to the nearby road where he can get into a vehicle which will take him to the local clinic,* 2000 by Gideon Mendel. Courtesy of Gideon Mendel.

the white death-sheet and the white-gloved hands of the coroner which are shown beside his face. The sequence that follows depicts the funeral procession, Malevu's coffin being carried to the church, a grieving family member, the choir at the funeral with the coffin and portrait of Malevu in the foreground, a keening woman bent double with grief during the funeral service and, finally, Malevu's father standing in his son's grave.

Read collectively without the accompanying testimony, the images of his life, death, and funeral create a coherent visual narrative. What then is the purpose of Malevu's narrative account? If "images aren't enough to express the story of AIDS" and testimony is included to address this failing, why do Malevu's words not say more? While his account provides additional contextual information (that the provision of water has been privatized, the occupations of his parents), the voice he is given does not provide a more complex picture of his life nor does it contest the photographer's vision. Instead it works to affirm the visual story of AIDS Mendel presents. In the inclusion of testimony lies a claim to authenticity, a claim that works by creating the illusion that the vision of the photographer and that of his subject are one and the same, even when that subject has passed from life to death:

> He [Malevu] had decided that he wanted his funeral to be an AIDS-education event and he made me promise that when he died I would come and take photographs at his funeral. He wanted to tell his story to the world and I was a sort of conduit for him to do it. The quotes which I collected from him, together with the images which tell his story from life to death, make a powerful, personalized statement.[32]

Mendel's assertion is that the story of Malevu's life and death that he tells is, in fact, the fulfillment of Malevu's desire "to tell his story to the world." This claim is an interesting one for a number of reasons, not least of which for the way it disavows the constructed nature of the visual story of Malevu's life. It also points to how the increasingly important place given to narrative in representations of human subjects, particularly non-western subjects, works to secure photography's contested claim to documenting the real.

The inclusion of testimony in Mendel's work is also connected to the fact that in order for representations of people living with HIV/AIDS to have political currency in South Africa, recognizing the agency of those depicted and, importantly, providing an indication that such agency has been recognized has become a necessity. This has come about because of the intense debate around access to antiretroviral therapy and the emergence of the Treatment Action Campaign (TAC), the highly visible and articulate activist movement campaigning for the rights of people living with HIV/AIDS in South Africa. One of the last photographs in *A Broken Landscape* shows a group of South African

80 Chapter 3

Figure 3.9. *Treatment Action Campaign March, International AIDS Conference 2000. Durban, South Africa,* 2000 by Gideon Mendel. Courtesy of Gideon Mendel.

AIDS activists holding hands and toyi-toying at a march at the International AIDS Conference held in Durban in 2000.

Alongside the image is a statement by Zackie Achmat, the chairperson of the TAC:

> The importance of this march historically is that it helped to change international perceptions. The image of AIDS in Africa is usually one of powerless people, emaciated and dying. What the march showed is that there are many of us who are healthy and fighting to stay healthy.[33]

Mendel's photograph of the march captures the energy and vitality of the activists, all of whom are wearing t-shirts issued by the TAC that read "H.I.V.-positive," and who are shown actively campaigning for their rights as citizens to be recognized. This photograph presents a different perspective on HIV/AIDS in Africa from most of the other images in the book and powerfully conveys how the TAC has created the space for the emergence of new and "positive" HIV-positive identities.[34] Like the AIDS Coalition to Unleash Power (ACT UP) in the United States in the 1990s, the TAC has played a crucial role in asserting the presence of people living with HIV and AIDS in a context of silence and shame.

In 2001 *A Broken Landscape* was exhibited at the National Gallery in Cape Town as part of the "Positive Lives" exhibition. During the course of the

show, Mendel began work on a new series of images that reflected the changes that were occurring in South Africa as AIDS activists began to challenge the state and to reconfigure how people living with HIV/AIDS were perceived. These photographs move away from what art historian Svea Josephy, referring to *A Broken Landscape*, describes as a mode of "social documentary in its most conventionalised and traditional form."[35] In his new work, a series of portraits of people living with HIV and AIDS who have access to anti-retroviral therapy through the Médecins Sans Frontières clinic in Khayelitsha, an informal settlement outside of the city of Cape Town, and through clinical trials in Cape Town itself, Mendel makes use of color, draws attention to the fact that the photographs are constructed, and emphasizes personal testimony.[36]

In her essay "Departures," Svea Josephy traces how the practice of documentary photography in South Africa has changed since the end of apartheid. She observes that the "rigid divide between 'documentary' and 'art' has eroded considerably" and that "Mendel has grown from a 'typical concerned journalist' to a point at which he can describe himself in an interview as an 'activist conceptual artist.'"[37] Mendel's new images are intended to highlight the work of Médecins Sans Frontières and of the TAC and in his words, "both challenge the images on the walls [the photographs that constitute *A Broken Landscape*] and explore

Figure 3.10. *Thendeka Mantshi lives in a Khayelitsha squatter community. She discovered that she was HIV-positive when her baby was born HIV-positive. They are part of a new treatment program aimed at demonstrating that people living in poor African communities can benefit from the same medications available in Western countries, or to well-off individuals in Africa*, 2001 by Gideon Mendel. Courtesy of Gideon Mendel.

new ways of depicting people living with HIV and AIDS."[38] In this statement, Mendel acknowledges the need to challenge his own practice, and indeed, the contrast between these new photographs and his earlier work is striking.

Of particular importance is the way in which the images were composed: Mendel created large frames using gaffer tape and invited his subjects to position themselves within the frames in the way in which they wished to be seen. Many people chose to look directly at the camera, rejecting the conventions of traditional documentary photography and effectively returning the gaze of both the photographer and viewer. Josephy observes that these images can be situated, "somewhere between the realm of portraits and documentary (or perhaps 'self-portraits' in the sense that they reference an African tradition of studio photography where the sitter plays a crucial role in the construction of his/her identity)."[39] In her reading of Mendel's portraits as "perhaps 'self-portraits,'" Josephy overlooks how the admission of agency itself is staged.[40] The increasing narrativization of the visual in Mendel's work can be read as part of the broader turn to testimony I discussed in chapter 1, particularly because so much of his work centers on South Africa where, in the wake of the Truth and Reconciliation Commission (TRC), testimony has been accorded a political valence. In her examination of the shifts in the practice of South African documentary photographers in the wake of the transition to democracy, Josephy notes that the inclusion of testimony in Mendel's work can be connected to a more general foregrounding of narrative in cultural practice in South Africa after the TRC:

> In documentary photography of the apartheid era, the only text provided was generally the photographer's captions. Now, in the work of Mendel, the photographer is a witness (in the post-TRC sense), who passes on oral testimony as well. This testimony takes the form of extended captions, in which the subjects tell their own stories—in the first person, in their own words. In this narrative technique, the documentary photographer is the recorder of the story and of the image of the sitter, rather than the interpreter of the sitter and situation. This is a collaboration, a combination of the story the photographer wishes to tell and the one the sitters are trying to tell, and, as such, represents a modest departure from traditional documentary narrative in South Africa.[41]

It is interesting that for Josephy, Mendel becomes "witness" when engaged in the production of what can be understood as the most deliberately constructed series of photographs in his oeuvre. Documentary photography, the image-making genre once understood as an accurate record of the real, has been dismissed as inadequate to the task of telling the whole story. It is precisely because Mendel's new images break with the documentary conven-

tions that they are read as revealing the truth of their subjects. This points to how testimony has been revivified as a marker of truth. In "The Harsh Divide," an interactive, animated series of digital images Mendel produced for the BBC and available for viewing online, Mendel takes photography to the limits of its form.[42] Since 2008 he has co-directed the project "Through Positive Eyes," which has worked with people living with HIV/AIDS in Los Angeles, Mexico City, Rio de Janeiro, Johannesburg, and Washington, D.C. The project, part of Make Art/Stop AIDS, makes use of personal photo-essays, film, and the interactive possibilities offered by online media to reduce stigma and to advocate for treatment access and care. He has also made a series of short films about the experiences of women living with HIV in Lesotho and increasingly works with sound recordings alongside his images.

In the context of the TAC's demand that the rights of people living with HIV and AIDS be recognized, Mendel's reinvention of himself as "activist conceptual artist" and the shift in his practice makes strategic sense. The trend towards the narrativization of the visual in his work is the most cogent sign of his response to this demand. Mendel's work as a visual activist and his experiments with the development of tools for visual advocacy also signals the urgency of his desire to draw attention to the experiences of people living with HIV/AIDS. Through Mendel's photographic work, to draw a phrase from theorist Ariella Azoulay, "the spectator is called to take part."[43]

NOTES

1. When I took the photograph I was just beginning my PhD project and was working in Khayelitsha as part of the Memory Box Project.

2. Susan Sontag, *On Photography* (New York: Penguin, 1979).

3. Roland Barthes, *Camera Lucida: Reflections on Photography*, trans. Richard Howard (New York: Farrar, Straus and Giroux, 1981).

4. See the work of Jane Evelyn Atwood whose photograph of "Jean Louis" appeared in *Paris Match* in 1987 and was the first publicly circulated image of a person living with AIDS in France. Maggie Steiber and J. B. Diederich photographed people living with HIV/AIDS in Haiti, and in the United States, Alon Reininger, Dilip Mehta (who photographed Ryan White), Nan Goldin, and Frank Fournier were among the first photographers to document the epidemic. Reininger was also one of the first photojournalists to photograph people living with HIV/AIDS in southern Africa. Others to have worked in the region include James Nachtwey, Nick Danziger, Don McCullin, David Chancellor and Kristen Ashburn. See also Jeffrey Barbee's images of people living with HIV/AIDS in Swaziland and the work of Jide Adeniyi-Jones in Nigeria.

5. Gideon Mendel won the W. Eugene Smith Grant in Humanistic Photography in 1996. His photographs depicting people living with HIV/AIDS in Africa have been

exhibited across the world. His work appeared in *National Geographic* (September 2005) and often appears in the English newspaper, *The Guardian*.

6. Gideon Mendel, *A Broken Landscape: HIV & AIDS in Africa* (London: Network Photographers, 2001).

7. *Digital Journalist*. "The Digital Journalist: 20 Years: AIDS and Photography," June 2001. http://digitaljournalist.org/issue0106/visions_frameset.htm (accessed April 1, 2013).

8. Gideon Mendel, Untitled. *The Digital Journalist*, June 2001. http://digitaljournalist.org/issue0106/voices_mendel.htm (accessed April 1, 2013).

9. Mendel, *A Broken Landscape*, 32.

10. Ibid., 32–45.

11. I am mindful here of the fact that African medical practitioners play a crucial role in addressing the needs of people living with HIV/AIDS on the continent. I am mindful also of the fact that African scientists and doctors have been at the forefront of HIV/AIDS research. That said, what is at work in these images is an ideological separation of Africa from the west.

12. Barthes, *Camera Lucida*, 26.

13. Ibid., 26–27.

14. Mendel, *A Broken Landscape*, 50.

15. Simon Watney, "AIDS, Language and the Third World," in *Taking Liberties: AIDS and Cultural Politics*, ed. Erica Carter and Simon Watney (London: Serpent's Tail, 1989), 110.

16. Ibid.

17. Michael Fried, "Barthes's *Punctum*," *Critical Inquiry* 31, no. 3 (Spring, 2005): 539–74.

18. Ibid., 545.

19. Ibid., 546.

20. Ibid.

21. Mendel, Untitled, *The Digital Journalist*.

22. Ibid.

23. Ibid.

24. I draw the term "homosocial" from Eve Sedgwick Kosofsky, *Between Men: English Literature and Male Homosocial Desire* (New York: Columbia University Press, 1985).

25. Mendel, Untitled, *The Digital Journalist*.

26. Those familiar with architecture in southern Africa will recognize the gaps in the concrete structure as airbricks, placed to allow air to circulate through buildings. Their appearance high up on the bare wall, which would allow a small amount of light into the building without enabling those inside to see out, gives the structure (most likely an ablution block) the appearance of a prison. As there is no caption to explain the building's function, its appearance only contributes to the desolate effect of the image.

27. In *A Broken Landscape* the date of Malevu's death is recorded as September 29, 2000. In Mendel's statement cited above he states that he attended Malevu's funeral in December 2000.

28. Mendel, Untitled, *The Digital Journalist*.
29. Ibid.
30. Mendel, *A Broken Landscape*, 74.
31. Ibid.
32. Mendel, Untitled, *The Digital Journalist*.
33. Mendel, *A Broken Landscape*, 194.
34. On the Treatment Action Campaign (TAC) see: Steven Friedman and Shauna Mottair, "A Rewarding Engagement? The Treatment Action Campaign and the Politics of HIV/AIDS," *Politics & Society* 33, no. 4 (2005): 511–65; and Steven Robins and Bettina von Lieres, "Remaking Citizenship, Unmaking Marginalisation: The Treatment Action Campaign in Post-apartheid South Africa," *Canadian Journal of African Studies [Canadienne des Ètudes Africaines]* 38, no. 3 (2004): 575–86.
35. Svea Josephy, "Departures," in *The Cape Town Month of Photography*, ed. Geoffrey Grundlingh (Cape Town: South African Center for Photography, 2005), 8.
36. See Gideon Mendel, "They Have Given Me Life," *Mail & Guardian*, February 15–21, 2002, 24–5. The people Mendel portrayed in this new series were among the first in the country to access treatment outside of the private health sector. At this time high-ranking government officials were contesting both the efficacy and safety of anti-retroviral drugs. Universal access to treatment for South Africans living with HIV/AIDS seemed very remote. In 2002 there were an estimated 400,000 people living in Khayelitsha of which approximately 40,000 people were living with HIV/AIDS. MSF began their work in Khayelitsha in 1999 and set up three HIV/AIDS clinics in 2000. By the middle of 2002 MSF were treating 177 people with anti-retroviral drugs. See Renée C. Fox and Eric Goemaere, "They Call it 'Patient Selection' in Khayelitsha: The experience of Médecins Sans Frontières—South Africa in Enrolling Patients to Receive Antiretroviral Treatment for HIV/AIDS," *Cambridge Quarterly of Healthcare Ethics* 15, no. 3 (2006): 302–12.
37. Josephy, "Departures," 10.
38. Mendel, "The Have Given Me Life," 24.
39. Josephy, "Departures," 8.
40. See also Tim Trengrove Jones's critique of Mendel's *A Broken Landscape* in "Simple AIDS Vision Belongs in Museum," *Sunday Independent*, June 16, 2002. See also Michael Godby, "Aesthetics and Activism: Gideon Mendel and the Politics of Photographing the HIV/AIDS Pandemic in South Africa," in *The Culture of AIDS in Africa: Hope and Healing through Music and the Arts*, ed. Gregory Barz and Judah M. Cohen (New York: Oxford, 2011), 215–21.
41. Josephy, "Departures," 9.
42. See Gideon Mendel's online presentation in collaboration with Guillhem Alandry and Tessa Lewin, "Salvation is Cheap," http://www.guardian.co.uk/flash/mendel.swf (accessed April 12, 2013).
43. Ariella Azoulay, *The Civil Contract of Photography* (New York: Zone Books, 2008), 137.

· *4* ·

Mourning the Present

𝒥n her memoir *Hospital Time*,[1] Amy Hoffman writes of how she imagined her responsibility for her friend, Michael Riegle, sick with AIDS and to whom she was the primary caregiver, would come to an end once he died. "I dreamed of the day when I would have no contact with Mike's remains, his possessions or his associates. Of course it didn't happen that way. I ended up with the ashes. In ashes begin more responsibilities. They were heavy."[2] Hoffman's text reveals the ambivalence of her desire—at once to rid herself of Mike and not to let him go. Ultimately, Hoffman refuses to disavow the pain of losing her friend. In a section entitled "Calling the Names," Hoffman writes of how at gay pride marches and activist meetings in the United States she would participate in a ritual recitation of names of lovers, friends, and family members who have died of AIDS. "The accretion of names reveals an image: a glimpsed freeze-frame of our lives hollowed out by loss."[3] She writes of how the list of names goes on and on:

> Will this calling of the names never end? It could, in fact, go on for days—although the MC halts it after a while. There is other business to attend to. We have not gathered only to call out names. Must we not make peace? Must we not move on? But my teeth are chattering, my body humming. I can't stop feeling the reverberations. . . .[4]

Hospital Time ends with Hoffman's answer to these questions and shows that for her, accomplishing the work of mourning is not only an impossibility, but that even if it were possible, it is not what she would choose.

In "Kaddish," the concluding section of the book, Hoffman describes the Jewish prayer for the dead as "a prayer of reconciliation" and "of acceptance,"[5] and also as a prayer that she will not say. Hoffman's book testifies to the

importance of recognizing the interrelatedness of life and death, what Judith Butler has termed "the powers of mourning."[6] *Hospital Time* is a meditation on how the multiple losses of AIDS necessitate an engagement with mourning in and for the present. Mourning the present is to recognize not only what we have lost but also what we are losing in failing to recognize the relation between the living and the dead. For Hoffman the "weight" of Mike's ashes lies both in the responsibility she bears as custodian of his remains and in the work of remembering and mourning him.

THE WEIGHT OF ASHES

The chapter takes as its focus the work of two South African artists who engage with the disavowal of mourning that has attended the deaths of people living with HIV/AIDS. In a similar way to Hoffman's difficult relation to the remains of her friend, Diane Victor's ashen portraits of people living with HIV powerfully evoke the question of the responsibility we bear in relation to the lives and deaths of others. Victor's haunting portraits insist on the importance of bearing witness even as they testify to the impossibility of the monumental. Victor's "Smoke Portraits," rendered with candle smoke on paper, are juxtaposed here with "The Bereaved," a series of photographs of corpses by Pieter Hugo. Taken in a mortuary in Khayelitsha, a township just outside of the city of Cape Town in 2005, the images depict the corpses of four men. While Hugo intended these portraits to form part of a larger series depicting people who have died of AIDS in South Africa and the effects of these losses on their families, he never completed this work.[7] The four close-up head shots of men who have died of AIDS, shown in their coffins before their bodies are returned for burial to their homes in the Eastern Cape, are the only images for this series Hugo produced.[8] This chapter offers a critique of Hugo's images and makes use of these photographs to ask a series of questions about the relation between representation, memorialization, and the bodies of the dead. My analysis draws on Judith Butler's work on mourning and her articulation of "publicly ungrievable losses" in *Antigone's Claim*[9] and in *Precarious Life*[10] to think about how those who have died of AIDS enter, and are erased from, public memory in South Africa.

Both series of works present us with the faces of people, dying or dead, floating apart from their bodies. In this chapter I argue that both artists signal something to us of the impossible task of mourning the endless losses of AIDS, of mourning those we do not, and cannot know. In different ways these works make visible the difficulties of facing and representing loss and press us to reflect on the absence of public mourning in post-apartheid South Africa.

Diane Victor is best known as a printmaker and for her work, exhibited in South Africa and internationally since the late 1980s, that turns an unrelenting and often provocative gaze on the politics and history of the country.[11] Human figures feature prominently in her work, much of which is grotesque and beautiful at once. She has created large-scale prints using multiple plates and has used blind printing, shaped plates, and embossing to great effect.[12] Victor's ethereal "Smoke Portraits," thirty-six images made from photographs she took of patients at St Raphael HIV/AIDS day clinic in Grahamstown in 2004, are rendered with candle smoke on paper. Art historian Karin von Veh describes these works as "a marked departure for Victor in terms of imagery, style and medium" but also notes that "they continue her efforts to be more selective and restrained in her approach,"[13] as Victor has been critiqued for an obsessive excess in both technique and content. Von Veh writes that "Over the years some criticism has been leveled at the perceived excesses of Victor's early work where it seems that everything entering her head pours out again in her art without subtlety or restraint,"[14] but that "Victor's tendency towards visual overstatement also betokens a forceful directness aimed at reviving society's dormant conscience."[15] Her work has often elicited strong and sometimes even violent reactions in those who view them, and her work "Little Deposition Picture" was torn by a viewer when it was exhibited in South Africa. Drawing on interviews she conducted with Victor in 2007, von Veh writes that "Victor considers such extreme reactions complimentary as they indicate the success of her attempts to present work that disrupts complacent viewing."[16] Victor's "Smoke Portraits" are no different as they work not only to make disavowed loss visible but depict living figures in the act of vanishing and in this way expose the liminal position to which so many HIV-positive South Africans have been consigned. Her series was shown alongside Churchill Madikida's "Status," a multimedia installation work that also took the HIV/AIDS epidemic as its subject, at the Michael Stevenson Contemporary Art Gallery in Cape Town from October to December 2005.[17] She has subsequently created a series of images of missing children using the same medium. Besides their technical virtuosity, Victor's images, vulnerable to the slightest touch, are remarkable for their ability to convey the precariousness of embodiment and of life itself in the time of AIDS. In her statement prepared for the exhibition Victor points to how the medium she employs is central to the meaning of the images:

> The portraits are made with the deposits of carbon from candle smoke on white paper. They are exceedingly fragile and can be easily damaged, disintegrating with physical contact as the carbon soot is dislodged from the paper. I was interested in the extremely fragile nature of these human lives and of all human life, attempting to translate this fragility into portraits made from a medium as impermanent as smoke itself.[18]

Part of the power of the work lies in the simple statement displayed alongside the images, which serves to make the overwhelming effects of the epidemic and the losses this entails painfully clear: "These images are derived from photographs of people living with HIV/AIDS waiting at a clinic in Grahamstown and were all taken on a single day."[19] While each image can be read on its own as an individual study, the work is intended to be displayed (and sold) as a group. Viewed together the images create a powerful "portrait" of HIV/AIDS in South Africa and, while Victor did not determine who attended the clinic on the day she photographed the patients, her subjects represent a cross-section of those affected by HIV/AIDS. And yet the performative force of "Smoke Portraits" does not consist only in the beautiful, disturbing series of faces that work to cast light on the *de*facement of people living with HIV/AIDS but in the questions the appearance of these disappearing forms seem to pose. What are the effects of all these disappearances, these mass deaths that have fundamentally altered the order of life and death in so many parts of the world and yet have passed by, unmarked, invisible, disavowed? What does it mean that these losses have been made publicly ungrievable? In raising these questions and in creating a space for those who view them to "face" them, Victor's work points to how we can begin to recognize our loss.

I read these images as works of ceaseless mourning that, unlike photographs which attest to the impossible desire to capture and fix the real through reproduction, do not participate in a logics of permanence. Instead in their vulnerability to time they more closely resemble the lived experience of embodiment and evoke the fragility of human life. Although the medium demanded that the artist work quickly, and the effect of the smoke with which they were created means that the images appear smudgy, the faces depicted laden with soot, every portrait attends to the idiosyncrasies of the individual subject depicted. These are at once incredibly detailed images (like portrait photographs, they are clearly of specific people each with their own unique features) and images of disintegration and disappearance. In this way these portraits make visible the ways in which people living with HIV/AIDS are made invisible. The "Smoke Portraits" carry echoes of other times of mass death: the Nazi death camps and the "ovens," all the bones and teeth and hair transformed into objects of use or burnt away; the atomic bombs detonated in Nagasaki and Hiroshima and the ghostly figures of those close to the epicenter of the explosions that appeared on the walls, black shadows burned into the architecture, a terrifying remainder. Victor's medium captures a sense of those she depicts hovering between life and death, a series of ghostly faces simultaneously present and absent.

Figure 4.1. *Smoke Portrait*, 2005 by Diane Victor. Courtesy of Diane Victor.

Figure 4.2. *Smoke Portrait*, 2005 by Diane Victor. Courtesy of Diane Victor.

Figure 4.3. *Smoke Portrait*, 2005 by Diane Victor. Courtesy of Diane Victor.

In his novel *The Plague*, Albert Camus provides an extended meditation on the effects of loss that seem to exceed our ability to mourn and that are made publicly ungrievable. In Oran, the town in which Camus's novel is set, premature death is not only commonplace but inevitable, and there is no place for grief. Camus connects the erosion of the ability of the townspeople of Oran to mourn the losses they have suffered to the loss of "every trace of a critical spirit."[20]

> None of us was capable any longer of an exalted emotion; all had trite, monotonous feelings. "It's high time it stopped," people would say, because in time of calamity the obvious thing is to desire its end, and, in fact, they wanted it to end. But, when making such remarks, we felt none of the passionate yearning or fierce resentment of the early phase; we merely voiced one of the few clear ideas that lingered in the twilight of our minds. The furious revolt of the first weeks had given place to a vast despondency, not to be taken for resignation, though it was none the less a sort of passive and provisional acquiescence.[21]

The "plague" Camus describes symbolizes the German occupation of France in the 1940s and can be read as an engagement with the difficulties involved in remaining "awake" to the suffering of others. It is also a powerful critique of a world "peopled with sleepwalkers" for whom the conditions of plague—injustice, mass death, the circumscription of grief—become normal and to which they acquiesce.[22] "For there is no denying that the plague had gradually killed off in all of us the faculty not of love only but even of friendship. Naturally enough, since love asks something of the future, and nothing was left us but a series of present moments."[23] For Camus, grief is a form of waking, a reminder of life beyond or outside the amnesiac conditions of plague.

When the somnolence of the townspeople of Oran is interrupted, what flashes up briefly before them is "the mournful visage of their love."[24] Victor's "Smoke Portraits" perform a similar task, making visible what philosopher Emmanuel Levinas terms an "asymmetry of intersubjectivity"[25]—the vulnerability of the other and the recognition of what the loss of the other implies for the self. Victor's portraits are images of faces in the ordinary sense and in the Levinasian sense—"Face as the very mortality of the other man:"[26]

> But in this *facing* of the face, in this mortality—a summons and a demand that concerns the *I*, that concerns me. As if the invisible death which the face of the other faces were *my* business, as if that death "had to do with me." The death of the other man implicates and challenges me, as if, through its indifference, the *I* became the accomplice to, and had to answer for, this death of the other and not let him die alone. It is precisely in this

reminder of the responsibility of the *I* by the face that summons it, that demands it, that claims it, that the other is my fellow-man.[27]

The Levinasian frame provides a way to read Victor's portraits that summon a vision of the human that both marks and transcends specificity. For the face of the other to open a space for recognition and for intersubjectivity that other must be recognized as human. In the section that follows I think through the complex ways in which representation does not necessarily entail humanization or recognition. Through my reading of Pieter Hugo's photographs of the corpses of impoverished HIV-positive black men I consider how the politics of race complicates and even disables Levinasian ethics. Victor's "Smoke Portraits" are beautiful in a way that the works that make up Hugo's "The Bereaved" are not. There is a way in which the ethics of recognition and space of mourning they seem to allow is made possible precisely because of the way those they represent are aestheticised and the force of the specificity of their raced and classed bodies is, if not erased, at least softened. While Victor's series portrays old and young, men, women, babies and children, all those she portrays are black. In her rendering, however, and partly as a result of the medium she has chosen, those she portrays become ethereal beings divested of their earthly weight. Her works facilitate a form of identification that Hugo's photographs radically disrupt.

IMPOSSIBLE MOURNING

If, as Walter Benjamin, and after him Barthes and numerous other theorists of photography assert, photographs foreshadow the deaths of the subjects they depict, then images of the dead present a kind of paradox.[28] Photographs are saturated by loss; both because in depicting the lives of those now dead they remind us of what is no more and because, in the case of images of the living, they tell us of what is yet to be lost. Images of the dead, however, collapse this delicate relation between the medium of photography, memory and mourning. The relation that is widely argued to exist between mourning and photography, and portrait photography in particular, is further complicated by the photographs of corpses I read here.

Photographic portraits have largely been read and understood as working against such forms of erasure. From family snapshots to identification photographs, portraits are thought to make the subject visible both to others and to themselves. And indeed, Hugo's portraits of the four men who have died of AIDS do work to make their deaths visible. These closely cropped images

of the heads of the four dead men provide a detailed full-color rendering of these bruised and passive faces. The photographs are captioned with the names of the deceased, Sixolile Bojana (fig. 4.5), Attwell Vuyani Mrubata (fig. 4.6), Nyameka J. Matiayna (fig. 4.7), and Monwabisi Mtana (fig. 4.8). In each of Hugo's images, only the head of the corpse is depicted and, apart from the portrait of Sixolile Bojana, none of the photographs incorporate the clothing of the dead men.

Figure 4.4. *Smoke Portrait*, 2005 by Diane Victor. Courtesy of Diane Victor and Stevenson, Cape Town and Johannesburg.

The collar and button of the shirt that is visible in the image of Bojana is an indication that he was once part of the world of the living. His clothing also indexes the rest of his body, which, although unseen seems reassuringly intact. The heads of the other men are shown swathed in blankets, imparting the horrifying sense that these men have been decapitated. Their closed eyes ceaselessly absorb the gaze of the viewer, a look that cannot be returned.

These heads without bodies powerfully convey the abject lives of these men and lay bare the relations of power that convert their deaths into saleable objects for display. Creating a body of work that engages with issues of mourning in South Africa in the time of AIDS could be understood as a critical, perhaps even radical, project. Hugo's work gestures toward this aim and then founders against the enormity of the task. "The Bereaved" does not open a space for reflecting on mourning in the wake of the endless losses of the epidemic but forces a consideration of why people living with AIDS have been so stigmatized and why mourning those who have died of AIDS has been so difficult in South Africa.

Effectively beheaded from the social body of which they form part, it is significant that these corpses were photographed in a morgue, a space between the world of the living and the funeral rites that mark the incorporation of death into community. In spite of their resemblance to death-masks, these images do not memorialize these dead but testify to the impossibility of doing so. What might have been relics, personal talismans, remnants of the lives of the deceased, instead are made objects that are exhibited and offered for sale. In this way the relationship that can exist between photographs and both individual and social memory has been severed.[29] These images serve as markers of precisely this severing of sociality, painful reminders of the social and economic divide between black and white, rich and poor that characterizes the post-apartheid condition.

Hugo's photographs can of course be viewed through the lens of well-established critiques of the discourse of "African AIDS." Cultural theorists such as Cindy Patton, Paula Treichler, and Simon Watney have decisively shown how portrayals of people living with HIV/AIDS in Africa have typically invoked racist stereotypes pairing degeneracy and disease.[30] I have argued elsewhere that the force of such representations lies in how they cast their subjects outside of the realms of the properly living and as such foreclose the possibilities both for recognizing the lives of people with HIV/AIDS in Africa and for mourning the losses of AIDS.[31] Viewing the corpses of dead strangers affirms that the one who looks is alive and confirms the separation between the living and the dead. Yet an image of a corpse can also serve as a reminder of the relation between these two states. For what if one did know one of the men Hugo has photographed, if one of these dead were your father, brother,

Figure 4.5. *Sixolile Bojana*, 2005 by Pieter Hugo. Courtesy of Pieter Hugo and Stevenson, Cape Town and Johannesburg.

or lover? Finding a photograph of their corpse on the wall of a gallery of contemporary art would serve to remind you of your own position as a body who might enter the circuits of exchange as a signifier of "the death of a continent," as one who is marked for death. The traffic in images of dead African bodies within the global art market is an indicator of the place economically impoverished, dying Africans occupy within the global order, as subjects al-

ways already given over to death and to spectacle. What Sontag has termed "our culture of spectatorship" is one from which they are radically excluded.[32] However, as in the case of Gideon Mendel's photographs discussed in the preceding chapter, Hugo's portraits open a series of questions, not only about representation and desubjectivization but about the political and economic conditions that make possible the appearance and circulation of such images after the end of apartheid.

Figure 4.6. *Attwell Vuyani Mrubata*, 2005 by Pieter Hugo. Courtesy of Pieter Hugo and Stevenson, Cape Town and Johannesburg.

Judith Butler's argument about the need "to parse the various ways that representation works in relation to humanization and dehumanization," is apposite here.[33] For it is not impossible to imagine these portraits circulating in an entirely different frame, one within which they would signify something quite different. If these images were the property of the relatives of the dead men and were included in their family photo albums they might be read as signs of the value accorded to these men. And if these photographs were part of a process of collective memorialization—along the lines of the Names Project AIDS Memorial Quilt in the United States[34]—then they might be understood as performing a particular political function.[35] But the corpses depicted in these photographs are corpses out of place. Unmoored from the social context within which the dead he depicts might be mourned, Hugo's floating death-heads circulate as high art, their only refrain "black death black death." The terms of their inclusion within the symbolic are paradoxically those of exclusion; as those against and through whom "the human" is constituted, non-subjects appear only in order to disappear.

Thus photography cannot always be said to be a mode of bereavement nor do photographs work to reassure all viewers in equal measure. It depends on who is looking. The circulation of Hugo's images of corpses as works of art depends on the absence of the bereaved—those who might identify with the subjects of these images, who might claim kinship with these lowly dead. I do not recognize these men in the Levinasian sense any more than they can recognize me, however I might wish to make this claim. This is not because they are corpses—and doubly untouchable in that they have died of AIDS— nor is it simply because it is unlikely that one of my own family members would be subject to public scrutiny after death and that an image of their dead body be sold as an artwork. What I see in seeing the corpses Hugo presents is not the human but the limits that have been drawn around what constitutes that term. And what I see writ large and what prohibits any attempt to think about these photographs in relation to mourning is the politics of race that makes possible the existence of such images. The meanings of photographs cannot be fixed—they mean different things depending on the contexts in which they are displayed and depending on who views them. However the politics of race is a less mobile force that stubbornly attaches a certain mode of reading to images of bodies. More than this, conditions of life in the aftermath of apartheid have exposed the bodies of the four men Hugo portrays to HIV infection, material deprivation and premature death and has consigned them in their deaths to the space of the art gallery.

While there is little critical scholarship on Hugo's photography as yet, his work has generated several heated online debates about race and representation. While some of the commentators argue for simply putting arguments

Figure 4.7. *Nyameka J. Matiyana*, 2005 by Pieter Hugo. Courtesy of Pieter Hugo and Stevenson, Cape Town and Johannesburg.

about race aside, it is clear that the politics of race animates engagements with his work.[36] As these debates about Hugo's photographs reveal, it is extremely difficult to lift his images from the social, historical, and political contexts that provide the frame for how they are read. It is interesting to consider why the work of Diane Victor, who is also a white South African artist who has represented black South Africans living with HIV/AIDS, has not surfaced the same

kinds of issues about race and representation that Hugo's work does. This, it seems, is connected to how photographs are often seen as relating to the real so that what we are looking at when we view a photographic portrait is a real person and not the photographer's interpretation of them. In spite of the work of photographers like Cindy Sherman who have emphasised the performative nature of all photographic practice, photographs are still commonly thought to represent the real. While Hugo may be attempting to move away from crude representations of raced subjects, the photographic surface presents a resistant surface for new imaginings. One might say that Hugo's photographs summon "the real" of racialized subjectivity, the body that operates as a visible marker of the pervasive social construct of race.

Hugo's failure to complete his project on the spaces of grief is perhaps what is most interesting about the series. The photographs that have not yet been taken, their failure to appear, opens the question of why it is so difficult to image and imagine AIDS otherwise, beyond the deathly determinist logic of "African AIDS." The photographs of the four corpses circulate under the sign of grief, "The Bereaved." While failing to rename the series in a more appropriate way may simply be oversight, the misnomer points to how the work of mourning the losses of AIDS remains unaccomplished, not merely for Hugo but for us all. And as I have argued here through my readings of Hugo's photographs that circulate as objects within the global image economy, photography and mourning cannot always be paired.[37] In the second version of his essay on how technologies of reproduction have fundamentally altered the meanings of works of art, Walter Benjamin writes:

> *In photography, exhibition value begins to drive back cult value on all fronts.* But cult value does not give way without resistance. It falls back to a last entrenchment: the human countenance. It is no accident that the portrait is central to early photography. In the cult of remembrance of dead or absent loved ones, the cult value of the image finds its last refuge. In the fleeting expression of a human face, the aura beckons from early photographs for the last time. This is what gives them their melancholy and incomparable beauty. But as the human being withdraws from the photographic image, exhibition value for the first time shows its superiority to cult value.[38]

Here Benjamin shows us that the relation between photography and mourning relies on the cult value of the portrait, in other words, on its specificity. Under the conditions of late capitalism "the human being" in his or her singularity can no longer enter the frame—"In the fleeting expression of a human face, the aura beckons from early photographs *for the last time*" (emphasis mine).[39] In looking at the corpses of those we do not know, if mourning enters the scene of the gaze what we are mourning is only our ability to mourn. Perhaps,

Figure 4.8. *Monwabisi Mtana*, 2005 by Pieter Hugo. Courtesy of Pieter Hugo and Stevenson, Cape Town and Johannesburg.

more painfully, Hugo's photographs expose us to the fact of the severed relation between ourselves and the dead his images portray. If, by opening a space for the possibility of mourning, Victor's work offers a form of consolation, Hugo's series provides us with a discomfiting rejoinder. The four works that constitute "The Bereaved" formed part of the Make Art/Stop AIDS exhibition shown in Cape Town in 2010. Within a few days of the show opening

Hugo's works were removed. This seems to indicate not only that visitors to the exhibition found the display of images of the dead to be offensive but that the stark portrayal of the abject conditions of the lives and deaths of the men Hugo photographed was too much for viewers to face.

NOTES

1. Amy Hoffman, *Hospital Time*, foreword by Urvashi Vaid (Durham, NC: Duke University Press, 1997).
2. Ibid., 85.
3. Ibid., 91.
4. Ibid.
5. Ibid., 149.
6. Judith Butler, *Precarious Life: The Powers of Mourning and Violence* (London and New York: Verso, 2004).
7. The photographs can be viewed on the website of the Michael Stevenson Contemporary gallery. The note that accompanies the images reads: "These four portraits were shot at a morgue in Khayelitsha, Cape Town. They show men who died of AIDS-related illnesses, in their caskets prior to their return to the Eastern Cape for burial. The photographs are the start of a new project exploring the spaces associated with mourning and the bereaved families of the deceased." See: Michael Stevenson, "Pieter Hugo, *The Bereaved*," Stevenson. http://www.stevenson.info/exhibitions/hugo/aids.htm (accessed March 29, 2013).
8. Many of the people who live in Khayelitsha and in the other townships around the city of Cape Town are from the Eastern Cape, one of the poorest provinces in the country, and often the bodies of the dead are returned to their extended families to be buried in their ancestral burial grounds.
9. Judith Butler, *Antigone's Claim: Kinship Between Life and Death* (New York: Columbia University Press, 2000).
10. Butler, *Precarious Life*.
11. For an excellent account of Victor's trajectory as an artist see Elizabeth Rankin's "Personalising Process: Diane Victor as Printmaker," in *Diane Victor*, by Elizabeth Rankin and Karen von Veh (Johannesburg: David Krut, 2008), 4–49.
12. See Rankin "Personalising Process," for further details about Victor's techniques.
13. Karen von Veh, "Gothic Visions: Violence, Religion and Catharsis in Diane Victor's Drawings" in *Diane Victor*, by Elizabeth Rankin and Karen von Veh (Johannesburg: David Krut, 2008), 89.
14. Ibid., 50.
15. Ibid.
16. Ibid., 59.
17. Like Victor's portraits and Hugo's images of the faces of the dead, Madikida exhibited a series of luminous death-masks alongside his video installation.

18. See Michael Stevenson, "Diane Victor, *Smoke Portraits,*" *Stevenson.* http://www.stevenson.info/exhibitions/victor/smoke.htm (accessed March 29, 2013).
19. Ibid.
20. Albert Camus, *The Plague,* trans. Stuart Gilbert (Middlesex: Penguin, 1968), 151.
21. Ibid., 149.
22. Ibid., 151.
23. Ibid., 150.
24. Ibid., 151.
25. Emmanuel Levinas, *Entre Nous: Thinking of the Other,* trans. Michael B. Smith and Barbara Harshaw (New York: Columbia University Press, 1998), 105.
26. Ibid., 186.
27. Ibid.
28. See Walter Benjamin, "The Work of Art in the Age of its Technological Reproducibility" (second version), in *Walter Benjamin: Selected Writings, Volume 3, 1935–1938,* ed. Howard Eiland and Michael W. Jennings (Cambridge, MA: Harvard University Press, 2002), 101–36; and Roland Barthes, *Camera Lucida: Reflections on Photography,* trans. Richard Howard (New York: Farrar, Straus and Giroux, 1981). See also Ulrich Baer, *Spectral Evidence: The Photography of Trauma* (Cambridge, MA: MIT Press, 2002); Eduardo Cadava, *Words of Light: Theses on the Photography of History* (Princeton, NJ: Princeton University Press, 1997); and Peggy Phelan, "Francesca Woodman's Photography: Death and the Image One More Time," *Signs: Journal of Women in Culture and Society* 27, no. 4 (Summer 2002): 979–1004.
29. Pierre Bourdieu writes of how photographic practice is understood as securing social bonds, "solemnizing and immortalizing the high points of family life," in *Photography: A Middle-brow Art* (Cambridge: Polity Press, 1990), 19. Bourdieu shows how for amateur photographers and for those who view the images they take, the camera operates as an "instrument of integration" (19). However, in the case of "The Bereaved," the photographic equivalent of body-snatching, the reverse is true. The camera only affirms the marginal status of these corpses and positions them outside of the human. As I argue in this chapter, the status of these images is over-determined by the legacy of apartheid and its force on and in the present.
30. For important early critiques of representations of AIDS in Africa see Cindy Patton, *Inventing AIDS* (London: Routledge, 1990); Paula Treichler, "AIDS and HIV Infection in the Third World: A First World Chronicle," in *Remaking History,* ed. Barbara Kruger and Phil Mariani (Seattle: Bay Press, 1989), 31–86; and Simon Watney, "AIDS, Language and the Third World," in *Taking Liberties: AIDS and Cultural Politics,* ed. Erica Carter and Simon Watney (London: Serpent's Tail, 1989), 183–92.
31. See Kylie Thomas, "Between Life and Death: HIV and AIDS and Representation in Southern Africa," unpublished PhD dissertation, University of Cape Town, 2007.
32. Susan Sontag, *Regarding the Pain of Others* (London: Penguin, 2003), 94. In this work, Sontag revisits and revises her earlier view, articulated in *On Photography,* that photographs "distance the emotions," (New York: Penguin, 1979), 110. She writes: "[t]o speak of reality becoming a spectacle is a breathtaking provincialism. It universalizes the viewing habits of a small, educated population living in the rich part of the

world. . . . It assumes that everyone is a spectator" (*Regarding the Pain of Others*, 98–99). At the same time implicit in her use of the term "our culture of spectatorship" is the marginal status of those who are looked at as opposed to those who look.

33. Butler, *Precarious Life*, 145.

34. See "The AIDS Memorial Quilt," *The NAMES Project Foundation*. http://www.aidsquilt.org/ (accessed April 12, 2013).

35. It is of course extremely unlikely that any kind of intervention to commemorate the losses of AIDS would include images of corpses. David Simpson's discussion of the ways in which the corporeal aspects of death are effectively and necessarily elided in public forms of memorialization is pertinent here. See David Simpson, *9/11 The Culture of Commemoration* (Chicago: University of Chicago Press, 2006).

36. See http://amysteinphoto.blogspot.com/2009/10/response-to-pieter-hugo. See in particular the piece by Sebastien Boncy entitled "White People Are Looking At You." See also Jim Johnson's post "Africa as Freak Show—Pieter Hugo" and the ensuing debate at http://politicstheoryphotography.blogspot.com/2008/07 (accessed August 26, 2013).

37. In her essay on the relation between photography and suicide in the work of Francesca Woodman, Peggy Phelan writes: "Taken together, the works of Benjamin, Barthes, and Woodman suggest that photography might be the best medium we have for responding to the ongoing temporality of the work of mourning" (Phelan, "Francesca Woodman's Photography," 979). The argument I am making here is that while certain photographic images may open the possibilities for mourning, others, like the images under discussion here, foreclose such possibilities. It seems critical to mark the distinction between specific photographs and photography in sum.

38. Benjamin, "The Work of Art," 108. Original emphasis.

39. Ibid.

• 5 •

Disavowed Loss During Apartheid and After in the Time of AIDS

> In this country you may not mourn
> small passings.
>
> —Ingrid de Kok★

In her book *Days and Memory*,[1] writer and Auschwitz survivor Charlotte Delbo relates an account told to her of the massacre by German soldiers of all the men of the village of Kalavrita in Greece in 1943. Her chapter titled "Kalavrita of the Thousand Antigones" describes how the women of the village stood above the ravine in which the bodies of the dead men lay and discussed how it would be possible to bury the 1,300 dead. "For the dead of the ordinary sort one knows what to do," Delbo writes, but what can be made of 1,300 deaths on a single day?[2] Delbo's description of how traditional burial practices are rendered impossible (the carpenter, blacksmith, priest, gravedigger, and stonecutter are all dead) reveals how the ritual practices of mourning are intimately related to the constitution of community. In her account, the process of mourning is one of remembering the past through marking the relation between the living and the dead. In this sense mourning is also futural; the ways in which we mourn, the ritual practices of mourning, play a central part in imagining life beyond the dead, the afterlife of community that is formed through the relation between the living and the dead. For Delbo the loss of those individuals who would have made possible the burying of the dead signifies the loss of the "ordinary sort" of death, the loss of loss itself.

As this book seeks to argue, the question of how to accomplish the work of mourning in a time of unending loss is a suspended question in South African politics and life. It is a question that was overshadowed by the Truth and Reconciliation Commission and the process of national mourning initiated there for the losses incurred under apartheid.[3] It is a question that has been

marginalized, perhaps necessarily, by the struggle to assert the right to life and to treatment for people living with HIV and AIDS. And yet no matter how we forestall it or how helpless we feel in the face of it, it is a question that recurs with each untimely death that is made publicly ungrievable.

Through readings of two texts by South African women that engage with mourning during and after apartheid, this chapter begins to articulate the argument that I make in the chapter that follows and in the conclusion to this book for thinking the losses of the struggle against apartheid in relation to the losses of AIDS. In particular the chapter explores how the difficulty of "working through" the trauma and loss of apartheid is bound to the challenges we face in recognizing and responding to the injustices of the present. In this sense the chapter argues for understanding the post-apartheid condition as one of what Judith Butler, writing of a different context, has termed "national melancholia." Writing in the aftermath of violence that has characterized the response of the United States to the attacks on the World Trade Center on September 11, 2001, Butler considers how "certain forms of grief become nationally recognized and amplified, whereas other losses become unthinkable and ungrievable."[4] For her, the disavowal of mourning leads to a war without end:

> I argue that a national melancholia, understood as a disavowed mourning, follows upon the public erasure from public representations of the names, images, and narratives of those the US has killed. On the other hand, the US's own losses are consecrated in public obituaries that constitute so many acts of nation-building. Some lives are grievable, and others are not; the differential allocation of grievability that decides what kind of subject is and must be grieved, and which kind of subject must not, operates to produce and maintain certain exclusionary conceptions of who is normatively human: what counts as a livable life and a grievable death?[5]

Butler's diagnosis of "national melancholia" can well be applied to South Africa where the difficulties of mourning the losses of the present are bound to our failure to work through the traumatic losses of the past.[6] In this chapter I read Carol Hermer and Maria Tholo's *The Diary of Maria Tholo*[7] and Sindiwe Magona's short story "Leave-taking"[8] in conjunction in order to foreground the continuity and disjuncture between life, death, and mourning in South Africa during apartheid and in the present. *The Diary of Maria Tholo* is an account of life in the townships just outside of Cape Town in 1976, the year of the student uprisings against the apartheid state and a time of intense violence and mass death. Positioned alongside Magona's short story about a mother who has lost three of her children to AIDS and who is isolated in her grief, Tholo's description of politicized mourning casts the disavowal of the losses of AIDS

Disavowed Loss During Apartheid and After in the Time of AIDS 109

Figure 5.1. A mother and grandmother mourning the loss of a tiny babe, Tembisa, 21 October 1989 by Gille de Vlieg. Courtesy of Gille de Vlieg.

in a particularly clear light. The chapter focuses on two accounts of funerals of young people who have died untimely deaths, and while separated in time by more than twenty years, both burials take place in a cemetery in Gugulethu, a township just outside of Cape Town. Through the juxtaposition of these accounts that deal with the mass deaths of young people in South Africa, the first written during apartheid, the second in the age of epidemic, I argue that there is a fundamental relation between mourning and recognition and that failing to mourn the deaths of those who have died of AIDS is intimately bound to an ethical failure to recognize the value of their lives. Reading these works in relation represents an attempt to contest the teleological narrative that would position us definitively post-apartheid. This is not a call to remember, although it is that too, but rather an articulation of the need to recognize in the present what we still have to work through.

MOURNING AND APARTHEID: *THE DIARY OF MARIA THOLO*

The Diary of Maria Tholo began as a study of one family in South Africa by Carol Hermer, an anthropologist and journalist, who conducted a series of interviews with Maria Tholo, a woman living in Gugulethu, over the course

of 1976. In her preface Hermer describes how the explosive political events of that year rapidly displaced other aspects of Tholo's life story:

> Though at first Maria's flood of stories of her experiences during the riots was incidental to our main purpose, it soon became clear that we were compiling a unique historical record, and from the beginning of September we dropped the life history and focused on the present.[9]

The ways in which Maria's own life story is intertwined with and overtaken by the political events to which she was witness is reflected in the form of the book that is something rather more than a diary. The book does indeed contain Tholo's diary entries, and these are divided into sections, each of which consists of a record of approximately two weeks. At the end of each section are a few pages headed "Commentary," contextual information provided by Hermer that both supplements and works to authenticate Tholo's testimony. Hermer's notes are intended not to undermine but to augment Tholo's account. The overall effect however is somewhat awkward, and, in spite of Hermer's best intentions, the form of the text marks the difference in social position between its authors. Like Elsa Joubert's *The Long Journey of Poppie Nongena*,[10] *The Diary of Maria Tholo* can be read as a work of apartheid-era channelling—a process in which the story of a black woman is told through the authorial voice of someone else, oftentimes that of a white woman.[11] This is clearly an instance of the limits of apartheid-era liberalism—Tholo is Hermer's informant rather than co-author. The diary is acknowledged as a record of her own experience, but it is Hermer who is credited as the author on the cover of the book. The book also includes detailed footnotes at the end of each section, a map of the townships around Cape Town, photographs of students protesting in Cape Town and of policemen in Gugulethu reproduced from the *Cape Times*, and a series of images by white South African photographer Ronnie Levetan of black people in Langa and Gugulethu. There are no photographs of Maria, her family, or her home. It is interesting to note that a photograph of Hermer does appear on the book's frontispiece, and while Tholo may have chosen not to be photographed for fear of being identified by the security police, this small instance of Tholo's invisibility in the text is significant for what it reveals about the production and negation of subjectivity under apartheid. For the argument I am advancing here about the ways in which melancholia comes to take the place of mourning, the question of what might constitute Tholo's own experiences of loss is critical. It is also what is displaced as the text abandons her personal story in order to chronicle the history of apartheid and the resistance struggle.

The form of the book suggests that while at the beginning of her life-history project Hermer might not have thought too much about whom her

readers might be, by the end she clearly anticipated an international audience. The text begins with a section headed "Introducing Maria Tholo," and while it does provide an outline of Maria's life history, it is at the same time a description of the social and political world she inhabits. Maria's initial diary entry describes the first student riots in Gugulethu and Langa, the burning of cars and buildings, groups of young people marching in the streets wielding knives and axes, and the police shooting at the protestors. On Thursday, August 12, 1976, schoolchildren stoned police vehicles in Langa, and Xolile Mosi, a student at Langa High School, was shot dead.

As Tholo's account of Mosi's funeral reveals, public mourning was banned by the apartheid state but effectively prescribed by the community. Tholo relates how the state's prohibition on public mourning led to the practice of political funerals:

> Yesterday was a day of funerals. The first one was that of the Mosi boy. Now because he was the first student to be killed in the riots the police were worried that there would be trouble at the funeral so they told Mrs. Mosi that only very close relatives could attend, not more than twenty people. I hear that they threatened her that if she allowed a crowd she would be endorsed out of Cape Town because she is here illegally. . . . Now with Africans twenty people is impossible. Who can decide who is a close relative?[12]

The "day of funerals" Tholo describes marked the beginning of the intensification of the armed struggle and the declaration of the States of Emergency, during which time the state implemented martial law. Between 1976 and 1990, when political prisoners began to be released from South African jails, thousands of people were held in detention without trial, and many were tortured and killed. It is interesting to note that in 1976, however, Tholo de-emphasises the political reasons why it was "impossible" for just twenty people to attend the funeral of Xolile Mosi. "Now with Africans twenty people is impossible. Who can decide who is a close relative?" she writes, indicating that the loss of a person's life affects not only the immediate family but the extended family and the community as a whole.[13]

She goes on to relate how, in spite of being forbidden to attend the funeral, the schoolchildren of the townships disguised their uniforms beneath their parent's work clothes and marched to the cemetery. All the people who lived on the road that led to the graveyard came out of their houses to watch the children pass, and in Tholo's account, all of them were crying. As the children reached the gate of the graveyard the police appeared and threatened to shoot them if they advanced:

> The children didn't stop. One of the boys called out, "They say they don't shoot school children. Let them prove it today." The policemen crowded together to stop them entering the gate.
>
> And then as if a switch had been pulled the girls started wailing. You know how Africans can scream. "Wah, wah, wah. It's not a dog that's being buried. We want to see our comrade. We want to see our fellow-student." The people around took up the chorus and the next moment it was just pandemonium with everybody screaming "Yes! Yes! Yes!" and then the teargas shot out.[14]

In claiming their right to bury their murdered comrade, the children of the township assert not only the value of Mosi's life, his humanness, but also their own.[15] In this time the slogan "an injury to one is an injury to all" characterized the resistance movement, and the lives and deaths of all those united in the struggle against apartheid were recognized as interrelated. Tholo's narrative shows how under apartheid, and particularly in times of emergency and mass death, politics usurped personal grief and mourning was instrumentalized—used to mobilize communities in support of the struggle against the state. Communal practices of mourning served to affirm not only the connection between the living and the dead but also to strengthen the bonds between those who mourned. At the same time, practices of collective grieving meant that few spaces remained open for personal expressions of grief. Public displays of solidarity became a requirement—those who failed to mourn in the appropriate ways risked violent punishment. Tholo recounts how, on Christmas day in 1976 in the townships around Cape Town, the students requested that everyone wear black for a week to show that they were in a state of mourning. In Langa and Guguletu the students forbade anyone from attending church and insisted that everyone go to the graveyard instead. "But who are we burying?" Tholo asks her young neighbour, a high school student in Langa. "Auntie, it's best for you to go and find out for yourself. Those who aren't there will be noticed. And let me tell you, I wouldn't go to church because when we come from the graveyard woe unto those we find there."[16]

On her way to the graveyard with her elderly mother, Tholo encounters two of her friends returning to their homes. They tell her that "the whole town's there" to "tidy up the graves," and when they arrive they find "three long rows of about fifty [graves] in each line" of those killed in riots by the police and buried during the night:[17]

> The people of Section 4 said they used to see the police coming along with big plastic bags, those rubbish bags, and bury them there. Some of the comrades dug them up to find already decomposed bodies, sometimes more than one in a bag. So, it was said, these were the graves of the unknown people who were just shot at random during the riots.

> Well, you couldn't know whether there were also coloureds buried there, or even convicts. But it was still terrible to think that so many people could be buried like that without the parents or people or relatives or anyone knowing.
>
> At the beginning of each line of graves there was a man with a spade with earth on it. You took a handful and put it on the grave. Now all day from six o'clock in the morning people had been coming to put a handful on each grave. You could tell how many people must have been there, from all the townships, Nyanga, Langa, Guguletu and all, because these moulds[sic] were growing.[18]

At the site of these unmarked graves the community claims these dead as their own. The bodies of the murdered victims of police violence are retrieved from the "rubbish bags" in which they were discarded, and through the ritual practices of burial their humanity is posthumously restored. Without knowing whose remains were interred there, the mourners grieve for other people's children, "coloureds," "or even convicts," as if they were their own. The deliberate formation of the mounds represents an attempt to re-individualize those who were killed and to give the graves the appearance of individual burial sites rather than mass graves.[19] At the same time, the graveyard becomes a site of transcendence; collective loss overcomes individualization, overcomes even prejudice. Mourning becomes the law.[20]

> I counted two out of all those graves that had a flower on them, a lousy little plastic flower, where the family had been to the police station and had found out the number of the grave. All over people were crying. There were those who had lost their relatives or who still didn't know where their children were. They couldn't help but cry to think that maybe it was their child on whose grave they were throwing earth, but which one, which one? There were so many.
>
> All the time there was this low singing, the sad hum of the freedom songs, and all the time more people, coming, coming. I am used to going to funerals but it had never felt so heavy, people milling around singing, others crying quietly.[21]

The incident Tholo describes can be read as a communal work of mourning, one which secures the social bond in a time of injustice, violence and mistrust. At the same time, Tholo's own response to the ritual is telling. While she identifies with the families of those who have been killed, she also reveals that she participates in the ritual because it is politically expedient, and even necessary, for her to do so. Her public display of solidarity through grief is not equivalent to private grief, a grief that may be shared but that is not harnessed to political ends.

HIV AND AIDS AND DISAVOWED LOSS

In South Africa today, accomplishing the work of mourning is no less complicated, nor less political, than it was in the time that Tholo describes, for the silences that surround the deaths of people who die of AIDS are not signs of the normalization of processes of mourning. The absence of communal mourning practices for people who have died of AIDS do not signify the opening up of spaces for the expression of a more private form of grief. Instead the stigma and discrimination that has defined the South African response to the epidemic has meant that people living with HIV/AIDS have been positioned outside of the realms within which their lives would be recognized as lives and their deaths considered grievable deaths. This too is political and should be recognized as such. What is lost, as Magona's short story "Leave-taking" so powerfully conveys, is the affirmation of loss as communal and the possibility for community that emerges through the recognition of grief as collective.[22]

The work of the South African activist movement, the Treatment Action Campaign (TAC), has played a significant part in drawing attention to the ways in which the crisis of the epidemic is a crisis for all South Africans, and in the process has constituted a community of people infected with and affected by HIV. In spite of the remarkable work of this organization and of others such as the AIDS Law Project and Médecins Sans Frontières, many people are afraid to disclose their HIV-positive status, and people with AIDS continue to be discriminated against both within their families and communities and in the public sphere.[23]

Magona's "Leave-taking" begins by describing a funeral that takes place in the same cemetery in Gugulethu where Maria Tholo participated in communal mourning rites almost thirty years before. At the graveside of her daughter, the third of her five children to die of AIDS, Nontando publicly renounces her faith: "God—I hate you!" she screams, before collapsing under the weight of her grief.[24] With this curse Nontando rejects not only the God that has forsaken her but also the church and the community that "had offered not the slightest reprieve or consolation" to her while her children were ill.[25] Magona draws attention to how the stigmatization of people living with HIV/AIDS redoubles Nontando's grief. At the end of the story Nontando descends into a deep melancholic state, not, Magona implies, because of the magnitude of the losses she has had to bear but because she has had to face them alone.

When the Mfundisikazi, the priest's wife, asks Nontando what she thinks the women of the church could possibly do about the epidemic, Nontando replies, "Why what we always do when death visits any of our member's families."[26] But the Mfundisikazi is quick to remind her that a death from AIDS is not like any other death. "I thought we could also start talking among our-

selves about *esi sifo sabantwana* [the disease of the children] and perhaps warn those not yet infected," Nontando suggests.[27] The priest's wife refuses to help her and, in despair, "as a last resort," Nontando approaches Mfundisi Seko, whom, "she'd heard, *she knew* [. . .] had buried several young people who had died of AIDS related diseases."[28] The minister offers nothing but platitudes. When Nontando tells her husband, Thando, that she has spoken to the leaders of the church about their children and has disclosed the fact that their daughter is HIV-positive, he is outraged.

> "Is it not enough that the whole world knows of our disgrace, that Luthando has *lo gawulayo*, this chopper of a disease?"
>
> "AIDS?"
>
> "Stop that!" Thando screamed. "I don't want to hear that dirty word in this house."
>
> "It lives here."
>
> "It wouldn't if the decision were up to me."
>
> That stole Nontando's tongue. Silence. She could not believe what she'd just heard her husband say.[29]

For Thando, affirming the presence of AIDS by speaking of it brings it into existence. If no one utters the word "AIDS," he implies, the more quickly it will disappear. And indeed, the bleak picture Magona portrays of the premature deaths of HIV-positive young people bears this out. No one in the story speaks of the existence of anti-retroviral therapy. All Nontando's children rapidly develop severe opportunistic infections, and their early deaths are represented as inevitable. Thami, Nontando's daughter, is pregnant when she is diagnosed HIV-positive but decides to have an abortion. Her decision is portrayed as the only option open to her. In spite of the fact that Thami's husband is a doctor, an oncologist at the state hospital where Thami is admitted when she becomes sick, no mention is made of medical interventions that might ward off her death. Magona's own silence about the contested issue of access to treatment, perhaps a sign of her lack of knowledge about antiretroviral therapy, points to one of the most harmful effects of the injunction not to speak about HIV and AIDS. The social death people living with HIV/AIDS endure hastens their physical deaths.

AIDS, as Nontando puts it, "lives here." Thando's response, however, like that of so many South Africans for whom AIDS remains unspeakable, reveals his attitude that the sooner people living with HIV/AIDS are dead and buried, the better. But as Nontando's melancholic suffering indicates, it is not possible to let go of the dead, to accomplish the work of mourning, if we have

not been permitted to recognize their lives. After the death of her daughter, throughout the seven-day wake, Nontando refuses to eat or to speak. "It was not normal, some said. Not natural, said others."[30] Magona's story makes clear however, that what is not "normal" or "natural" is the failure of the community to mourn the losses that have befallen them. In order to grieve the deaths of her children, Nontando aligns herself with the dead and in her identification with them, is cast out of the community of the living.

THE RIGHT TO GRIEVE

"Mobilise and Mourn" is a slogan that has occasionally appeared on TAC t-shirts over the course of the last ten years. However the focus of the movement has been on campaigning for the right to life for people living with HIV and as a result the question of mourning has been sidelined. In fact, for several years, raising the issue of mourning in relation to AIDS in South Africa was seen as decidedly morbid and misguided in activist circles.[31] The injunctions issued by activist movements to focus on living positively with HIV and to claim the right to treatment and to life were a necessary counter to the government's deathly policies which cast people living with HIV as beyond saving. At the same time not being able to acknowledge the trauma of loss can be understood as another terrible side effect of AIDS-denialism in South Africa. Even today the fact that there is no coherent project to publicly commemorate the losses of AIDS indicates that there is much about our experience that remains unspeakable.[32]

There have been moments when the complexity of the losses the epidemic has brought has been acknowledged, and one such occasion was the death of Ronald Louw, a Durban-based lawyer, and the response to his death written by his close friend, Zackie Achmat. The article entitled "Ronald, Why Didn't You Get Tested?" was first published in South Africa in the *Mail & Guardian* newspaper and then widely circulated through the Internet.[33] Achmat is one of the founders of the TAC, and at the time of Louw's death he was the chairperson of the movement and the most visible public figure living with HIV in South Africa. Louw's unexpected death opened a space to engage with the politics of loss in a time of widespread denial about the epidemic. Achmat begins:

> One of my closest friends and a long-time comrade, Ronald Louw, has died. Two major Aids related factors caused his death: HIV denial and undiagnosed tuberculosis (TB). Denial meant that he did not test for HIV until almost too late. And unreliable TB diagnostics developed more than

100 years ago meant that as his immune system was destroyed by HIV, TB could not be detected until it was too late.[34]

The article resembles a detailed obituary notice and follows some of the conventions of that form—Achmat describes his long friendship with Louw, provides a brief biographical account of his life, and describes the kind of person he was. His description of his own pain at the loss of his friend makes public the personal effects of the epidemic. However, this moment of mourning is brief. The overriding effect of the article mobilizes Louw's death in the service of the struggle against the epidemic:

> I originally wrote this article (with Louw's permission) to ask him to fight to live longer. He is now dead. He died because he did not get tested early. And, when he discovered his HIV status, his lungs and immune system were destroyed. I also write to ask every person to get tested. If you are HIV-negative, practise safer sex and stay negative. If you have HIV, live positively and openly—eat well, reduce stress, exercise, practise safer sex and get treated immediately for any infections. When you need it, start anti-retroviral treatment.
>
> Louw's memory demands that we intensify the struggle for new, accurate diagnostics for TB. It demands that we mobilise to ensure that everyone gets tested for HIV to prevent and treat the illness. His death, together with hundreds of thousands of others in our country, demands that personal, cultural, scientific and political denial is ended. Above all, it requires that we reaffirm the struggle for freedom, equality, dignity and social justice.[35]

Achmat's article indicates just how difficult it was (and is) to articulate personal grief in the face of mass death, to mourn for one person in a time and place when so many are dying or dead. His reflections, like those of Tholo and Magona, bring to the fore the question of the relation between public and private grief. Placing these texts in relation also presses us to reflect on what makes mourning possible. It is through the lives of others that we are constituted; in mourning their deaths we acknowledge their lives as well as how we are indebted to them for our being, so much so that their deaths are experienced as a loss of ourselves. Failing to mourn the death of the other is not only to allow their death to go unmarked, nor is it only to fail to recognize the value of their life. It is also to disavow the constitutive relation between the self and the other—the recognition that their life and death is bound to my own. However, the relation between recognition and mourning is significantly complicated by the history of apartheid and its desire for the permanent sundering of social life along racial and class lines. Apartheid's legacy, like nuclear fallout, contaminates the future and it is unsurprising that

Figure 5.2. *Women mourn the death of Themba Dlamini,* Driefontein, March 23, 1990 by Gille de Vlieg. Courtesy of Gille de Vlieg.

any form of national mourning should be so difficult to achieve. Our ability to come to terms with the enduring consequences of apartheid, I have suggested here, lies in enduring, rather than disavowing, the pain of loss. To ask how it would be possible to accomplish the work of mourning in South Africa is to ask what apartheid did to us, how it led to the constitution of certain forms of community, and how it destroyed others. It is also to ask how the legacy of apartheid—material, political and social—continues to negate the possibility for those forms of sociality without which mourning remains impossible.

NOTES

*Ingrid De Kok, "Small Passing," *Contrast* 14, no. 4 (December 1983): 27–8.

1. Charlotte Delbo, *Days and Memory*, trans. Rosette Lamont (Marlboro, VT: Marlboro Press, 1990).
2. Ibid., 97.
3. Whether the TRC can or should be understood as a process of national mourning has been a matter of some debate. See, among others, Mark Sanders, "Ambiguities of Mourning: Law, Custom, and Testimony of Women before South Africa's Truth and Reconciliation Commission," in *Loss: The Politics of Mourning*, ed. David L. Eng and David Kazanjian (Berkeley: University of California Press, 2003), 77–98; and

Madeleine Fullard and Nicky Rousseau, "Uncertain Borders: The TRC and the (Un)making of Public Myths," *Kronos* 34 (November 2008): 215–39.

4. Judith Butler, *Precarious Life: The Powers of Mourning and Violence* (London and New York: Verso, 2004), xiv.

5. Ibid.

6. For Freud, the primary distinction between mourning and melancholia lies in whether or not the subject is conscious of what it is that is lost (Sigmund Freud, *On Murder, Mourning and Melancholia* [London: Penguin, 2005]). In mourning, "no aspect of the loss is unconscious" (205) but melancholia, however, as a pathological form of mourning, is characterised by "constitutional ambivalence" that "essentially belongs to the repressed" (216).

7. Carol Hermer and Maria Tholo, *The Diary of Maria Tholo* (Johannesburg: Ravan Press, 1980).

8. Sindiwe Magona, "Leave-taking," in *Nobody Ever Said AIDS: Poems and Stories from Southern Africa*, ed. Nobantu Rasebotsa, Meg Samuelson and Kylie Thomas (Cape Town: Kwela, 2004), 124–41.

9. Carol Hermer, "Preface," in *The Diary of Maria Tholo*, by Carol Hermer and Maria Tholo (Johannesburg: Ravan Press, 1980), ix.

10. Elsa Joubert, *The Long Journey of Poppie Nongena* (Cape Town: Tafelberg, 1980).

11. E. Joubert's *The Long Journey of Poppie Nongena* was first published in Afrikaans in 1978 as *Die Swerfjare van Poppie Nongena* and was written by a white Afrikaans-speaking woman. The book is a work of fiction but, according to the publishers of the 2003 edition, "is based on a true South African story." See Jonathan Ball Publishers, "The Long Journey of Poppie Nongena." Jonathan Ball Publishers. http://www.jonathanball.co.za/index.php?page=shop.product_details&flypage=flypage.tpl&product_id=82&category_id=1&option=com_virtuemart&Itemid=6 (accessed March 30, 2013).

12. Hermer and Tholo, *Diary of Maria Tholo*, 23.

13. Ibid.

14. Ibid., 25.

15. The students' act of defiance against the state echoes that of their murdered comrade and can be compared to Antigone's act of defiance against the edict against burying her brother issued by her uncle Creon in Sophocles' play. For a reading that links *Antigone* to mourning and apartheid see Sanders, "Ambiguities of Mourning." Judith Butler writes of the way in which Antigone's refusal "to obey any law that refuses public recognition of her loss" prefigures the "publically ungrievable" losses of AIDS in *Antigone's Claim: Kinship Between Life and Death* (New York: Columbia University Press, 2000, 24).

16. Hermer and Tholo, *Diary of Maria Tholo*, 165.

17. Ibid., 168.

18. Ibid., 168–69.

19. I would like to thank Maurits van Bever Donker for suggesting this reading to me.

20. I draw this phrase from the title of Gillian Rose's book, *Mourning Becomes the Law: Philosophy and Representation* (Cambridge: Cambridge University Press, 1996).

21. Hermer and Tholo, *Diary of Maria Tholo*, 169.

22. Since the publication of "Leave-taking," Sidiwe Magona has written a collection of poems, *Please Take Photographs* (Cape Town: Modjaji Books, 2009), many of which engage with the HIV/AIDS epidemic and a novel on the theme, *Beauty's Gift* (Cape Town: Kwela, 2008), much of which is also set in Gugulethu.

23. To cite some examples: in 1998, a woman named Gugu Dlamini was beaten to death in KwaMashu, KwaZulu-Natal, by members of her community who claimed that she was "degrading her neighbourhood" when she disclosed her HIV-positive status on local radio. Four suspects were arrested for her murder but were released due to lack of evidence (Bareng-Batho Kortjaas and S'Thembiso Msomi, "Mob Kills Woman for Telling Truth," *Sunday Times*, December 27, 1998). Gugu Dlamini's family were afraid to testify in court because they too had received death threats. A schoolteacher named Mpho Motloung was murdered in Meadowlands, Soweto, in August 2000. On her body was a note that read "HIV-positive AIDS." According to police, Motloung's husband killed her and her mother, shot her father who was admitted to hospital in a critical condition, and then killed himself (see Zackie Achmat, "Treatment Action Campaign: Urgent Press Release," *Treatment Action Campaign*, August 23, 2000. http://www.tac.org.za/Documents/Statements/pr000823.txt [accessed March 30, 2013]). In December 2003, Lorna Mlofane—a member of the TAC—was raped and then beaten to death in Khayelitsha in the Western Cape after she told the men who raped her that she was HIV-positive ("Men in Court for Rape and Murder of Cape AIDS Activist," *Mail & Guardian*, January 12, 2004). Since 2003, when the public war over access to treatment ceased and the government initiated the roll-out of anti-retrovirals in the public health sector in South Africa there has been a dramatic decline in media coverage related to the epidemic. Access to treatment has been connected to reducing the stigma attached to HIV/AIDS but the disappearance of the epidemic from the public agenda does not, however, as this book argues, indicate that the crisis is over.

24. Magona, "Leave-taking," 124.

25. Ibid., 134.

26. Ibid.

27. Ibid., 135.

28. Ibid. Original emphasis.

29. Magona, "Leave-taking," 136.

30. Magona, "Leave-taking," 141.

31. Between 2001 and 2003 I worked in support groups for people living with HIV/AIDS in the Western Cape as part of the Memory Box Project which began as a therapeutic intervention focused on bereavement counselling and rapidly shifted to campaigning for access to anti-retroviral treatment and care. See Jonathan Morgan and Bambanani Women's Group, *Long Life: Positive HIV Stories* (Cape Town: Double Storey Press, 2003); and chap. 1 of this book, which discusses the *Long Life* project. On mourning, activism and the HIV/AIDS epidemic in North America see the work of Douglas Crimp and Ann Cvetkovich: Douglas Crimp, "Mourning and Militancy," *October* 51 (Winter 1989): 3–18; and his "Melancholia and Moralism," in *Loss: The Politics of Mourning*, ed. David L. Eng and David Kazanjian (Berkeley: University of

California Press, 2003), 188–202; Ann Cvetkovich, "Legacies of Trauma, Legacies of Activism: ACT UP's Lesbians," in *Loss: The Politics of Mourning*, ed. David L. Eng and David Kazanjian (Berkeley: University of California Press, 2003), 427–57.

32. During his presidency, Thabo Mbeki contested whether HIV caused AIDS and queried the efficacy of anti-retroviral therapy. He argued that the racism of the west and of white South Africans has led to African sexuality, particularly male sexuality, being cast as out of control and as a source of disease. See Mbeki's address, "He Wakened to His Responsibilities," at the Inaugural ZK Matthews Memorial Lecture, University of Fort Hare, Alice, Eastern Cape, South Africa, October 12, 2001. http://www.unisa.ac.za/contents/colleges/docs/2001/tm2001/tm101201.pdf (accessed March 29, 2013): "Convinced that we are natural-born, promiscuous carriers of germs, unique in the world, they proclaim that our continent is doomed to an inevitable mortal end because of our unconquerable devotion to the sin of lust." The connection between Mbeki's denialism and the legacy of apartheid remains under-theorized.

33. Zackie Achmat, "Ronald, Why Didn't You Get Tested?" *Writing Rights*, June 23, 2010, http://writingrights.org/2010/06/23/ronald-louw-died-of-hiv-related-tb-on-26-june-2005/ (accessed December 14, 2010), first published in the *Mail and Guardian*, July 11, 2005.

34. Ibid.

35. Ibid.

· *6* ·

Refusing Transcendence

The Deaths of Biko and the Archives of Apartheid

This chapter is concerned with the question of remains, and in particular what remains after we imagine ourselves to have dealt with the trauma of the past in ways that enable us to move on. Since the time of the murder of the anti-apartheid activist Steve Biko in 1977, photographs and artworks depicting his corpse have been in public circulation. This chapter takes these images as its focus and reads Biko's murder as an instance of what the anthropologist Veena Das terms "bad death"[1]—that is, a death that is difficult, complicated and even impossible to mourn. Through my readings of multiple images of Biko's corpse, I consider the relation between mourning, repression, and the archive. I argue that because of the ways in which they exceed the narrative of the apartheid state and the dominant post-apartheid narrative of reconciliation and healing, such works prevent Biko's death from being consigned to the archive. In this way these works also lead those who view them to engage with the unresolved, unmourned deaths of others, and to recognize that to which we cannot be reconciled.

In the argument I make here, about and through a series of photographs and artworks that portray Biko's corpse, the archive comes to stand for an immense space of national repression. I argue that by eluding archival capture, and thereby a particular kind of coherence and closure, images of Biko's corpse remind us of what remains unresolved, often also of that which we would rather forget.[2]

I read the visibility of Biko's wounded corpse as a gesture toward the possibility of a different kind of body politic from that imagined into being during the transition from apartheid. Such a national body would not be one that neglects its wounds but rather one that would attend to them, carefully stitching together its broken parts. This mending work would not erase its sutures, but

would allow them to be traced, over and over, without end, precisely because, as Derrida writes, it is "necessary to keep loss as loss."[3]

ARCHIVAL DEATHS WE CANNOT MOURN

Archives are conventionally understood as spaces within which the documents that record past events are stored. In this conception the archive is a space of preservation. The archive has also been theorized as a space of disappearance and loss, even of destruction. The first version proclaims the archive as a vast, yet inert, storehouse, a charnel house of history. The second configures the archive as a space of danger and dissolution, a space of classification and rule so powerful that to be entered into the archive is to be subject to a particular kind of erasure. In both formulations the subjects of history surrender their agency at the door to the archive, a door that permits entry but no exit, a heavy door that swings shut on the possibility of a future that does not repeat the past. In both formulations we are rational, if powerless, agents—in one version compulsively recording, in the other endlessly obliterating all our histories that will not be made sensible.

In *Archive Fever*,[4] Jacques Derrida offers a third way to think about the archive. Defined as a place of "consignation," the archive is a place of deep unease, the space of our feverish, delirious desire to seize and freeze events, to insist on their belonging to the past. Our frantic attempts to claim the past, and assert that the past has no claim on us, belie the ways in which we are shaped by that past, the ways in which the events of history remain only partly known and, in some cases, unknowable to us, but nonetheless exert a force on us and determine our lives.

Derrida's text engages in an extended discussion of the relation between the archive and death within which the space of the archive is figured as a kind of tomb, "because the archive, if this word or figure can be stabilised so as to take on a signification, will never be either memory or anamnesis as spontaneous, alive and internal experience."[5] Derrida asks what it is that motivates the desire to archive and, contrary to what we might expect, the answer does not lie in the preservation of the past, but in its "eradication." In his reading of the psychic dimension of archive, the death drive, or what Derrida terms an "archiviolithic force," plays a central part.[6] What is the nature of this *mal d'archive*? For Derrida (drawing on Freud), archive fever arises because of the relation between the will to archive and the psychic mechanism of repression.

Thinking about the archive in relation to repression helps to explain why engagements with the archive can be so emotive, why archives are so often sites of conflict and are bound up with the forbidden, the forgotten

and the secret. The desire to preserve is an anxious and obsessive one, one that announces our fears about loss. The will to archive gives away our fetishization of the transience of the present as we seek to capture events and enter them into the archival record for posterity. We strive to keep that which threatens to disappear and our acts of keeping are, at the same time, processes of storing away, of burying and a deep and singular failure to process, to deal, to resolve and to let go.

It is the relation between the archive, repression, and mourning that forms the focus of my reading of a series of artworks that deal with the death of Bantu Stephen Biko, who was arrested on August 18, 1977 and found dead in his police cell on September 12 of that year. Biko was arrested just outside King William's Town and was held at the Walmer police station in Port Elizabeth. He was confined to his cell for twenty days—he was naked, manacled, and was not permitted to wash. On September 6, Biko was taken to the Sanlam building, the headquarters of the security police in Port Elizabeth, for interrogation. In her account of the circumstances leading to Biko's murder, which is based on the proceedings of the inquest held two months after he was killed, Hilda Bernstein reminds us that "even the barest bones of the Biko story, distilled to its leanest from the evidence—may not be wholly correct."[7] The autopsy performed on Biko's corpse, and the photographs of his head taken just after his death, indicate that Biko died as a result of repeated blows to the head, which led to brain damage, almost certainly sustained during the night of September 6, or early the next morning. Throughout the inquest, the security policemen who interrogated Biko claimed that he had become aggressive and had injured himself during a "violent struggle." In spite of their multiple and conflicting versions of how Biko "fell flat with his face to the floor" (Captain Siebert) or "fell with his head against a wall and his body on the ground" (Major Snyman), the security police continued to assert that they were not responsible for the injury to his head.[8]

On the morning of September 7, Biko's speech was slurred, he was incoherent, and there was visible swelling on his upper lip. The district surgeon, Dr. Lang, was summoned by the chief of the security police in the Eastern Cape, Colonel Goosen, to examine Biko and "at the Colonel's request he made out a certificate that there was no evidence of any abnormality nor pathology on Biko."[9] That night the security police attempted to interrogate Biko again, but he was unresponsive (he was possibly unconscious), and so he was left lying on a mat, manacled and chained by his leg to the bars of his cell. The following day he was examined by Dr. Lang and the chief district surgeon, Dr. Tucker, and Biko was transferred to a prison hospital where he was examined by a specialist physician, Dr. Hersch, who performed a lumbar puncture, which indicated that Biko's cerebrospinal fluid was bloodstained.

The doctors consulted with a neurosurgeon over the phone, who asserted that there was no evidence of brain damage and that as long as Biko was kept under observation, he could be transferred out of the hospital into the custody of the security police. Biko was taken back to a cell at the Walmer police station and within a few hours "a warder found Biko lying on the floor with foam at his mouth, and glassy-eyed."[10] Dr. Tucker examined Biko again and agreed that Colonel Goosen could send Biko to Pretoria, a 1,200-kilometer journey by road, during which Biko was kept naked and manacled in the back of a Land Rover. In Pretoria, Biko was left on the floor of a cell and died unattended during the night of September 12.

The inquest into Biko's death concluded after fourteen days with a finding that, Bernstein writes, "took 80 seconds to deliver in both official languages, English and Afrikaans."[11] The chief magistrate of Pretoria, Mr. Marthinus Prins, found as follows:

> The cause, or likely cause, of Mr Biko's death was a head injury, followed by extensive brain injury and other complications including renal failure. The head injury was probably sustained on the morning of September 7 during a scuffle with security police in Port Elizabeth. The available evidence does not prove that death was brought about by an act or omission involving an offence by any person.[12]

The case of the doctors who disregarded signs that Biko had sustained a head injury and was severely ill was brought before the South African Medical and Dental Council. The investigating committee found that "there was no *prima facie* evidence of improper or disgraceful conduct on the part of the practitioners and decided there was no need for a disciplinary hearing."[13] The five members of the committee were all members of the Broederbond, a powerful right-wing Afrikaner organization. As a result of a case brought against them by a group of doctors led by the neurosurgeon Professor Frances Ames, Tucker was eventually struck off the roll and Lang was warned for unprofessional conduct.[14] Ten years after Biko's death, however, Lang had been promoted to Senior District Surgeon for Port Elizabeth and surrounding areas. All the members of the security police were also promoted, and Major Snyman, the leader of the interrogation team, became head of the security police in the Eastern Cape.[15]

Although he was so young, and in spite of the banning orders placed upon him by the apartheid state to restrict his movement and political activities, at the time of his death Biko was one of the most important political figures in South Africa. He was the leader of the Black Consciousness Movement in South Africa, founder and first president of the South African Students' Organisation (SASO) and, from 1977, honorary president of the Black Peo-

ple's Convention (BPC), an organization formed in protest against apartheid in 1972. His funeral in King William's Town was attended by thousands of mourners. Biko subsequently became an icon of the struggle against apartheid, and the ubiquity of his portrait on t-shirts and in public spaces is rivaled only by images of Nelson Mandela. While Biko was brilliant in life—articulate, literate, brave, and persuasive—it was his murder that drew the attention of the world to the struggle that consumed him.[16] It is his death also—both the way in which he died and his corpse—that has possessed the minds of several South African visual artists and writers.

Biko's death is also, famously, the death that his family refused to mourn publicly, to forgive, and thereby let go of, during the proceedings of the Truth and Reconciliation Commission (TRC). The terrible facts of the circumstances of his death, the brutality of his murder, remain unresolved and unreconciled. The argument I present here reads the visual images of Biko's literal remains as what Giorgio Agamben might term "remnants of apartheid," signifiers of that which resists the regularizing processes of the archive.[17] The visual representations of Biko's corpse exceed both the narrative of the apartheid state and the dominant post-apartheid narrative of reconciliation and healing in that they resolutely refuse to consign Biko's death to the invisibility of the archive.[18] In keeping Biko's corpse unburied, these works insist that we face up to the archive of deaths we have not yet mourned.

THE UNBURIED CORPSE

Of course Biko was buried—a few minutes of footage of his funeral ran over and over at an exhibition devoted to his life and death held at the Slave Lodge in Cape Town in 2009.[19] But alongside the screen that shows this footage is the photograph of Biko's corpse in his coffin that was published in the newspaper *The World* the day after his death. The photograph shows Biko's face, strangely ashen, his eyes sewn shut. The photograph is terrible to behold, gruesome in its unflinching gaze at his transmogrified visage. During the inquest into Biko's death, reports of which were published in newspapers across the world, images from the autopsy were used as evidence.[20]

Biko was buried, but his corpse remains visible.

His corpse circulates as evidence in the police reports, in his medical records, in the autopsy report, as evidence in the trial investigating the circumstances of his death, as photograph and as painting. It is Biko's corpse that will not be buried at the Truth and Reconciliation Commission hearings. There are too many conflicting narratives about the circumstances of his death.

One thing is certain and that is his corpse.

If we examine it closely enough, will we know the truth? This question seems to play a central part in the work performed by South African visual artist Paul Stopforth in his forensic series. The truth lies in the evidence—in Biko's broken skin and bones. And yet Biko's body is again made insensible; it is part of a puzzle too painful to assemble; the story of his death is transparent and yet impossible to tell. And this, I think, accounts for the importance, the mute eloquence, of his corpse.

While images of Biko, both living and dead, now circulate widely, at the time Stopforth made these works this was not the case. Stopforth was given access to the forensic photographs of Biko's corpse through Shun Chetty, the lawyer acting for Biko's family, who at that time would have been one of the few people to have seen them.[21] The artist's work of translating the photographs into works of art in order to render Biko's murder visible defies the prohibition the state placed on mourning his death. Writing of the process of making these images, Stopforth describes how his work both marks and seeks to "remove" the mutilation of Biko's corpse:

1. The body had been cut open from sternum to the pubic bone during the autopsy. This terrible mutilation, visible in the original photograph, had been roughly stitched together with a thick, possibly leather, cord.
2. I removed the evidence of this mutilation by removing the cut altogether through the process of drawing, thereby partially "healing" and making "whole" Steve's body.[22]

Stopforth's painstaking act of restorative care is in marked contrast to the rapid replication and ubiquity of images of Biko's corpse on the internet today. If Stopforth's work can be read as an attempt to acknowledge the wound of Biko's death, the intermittent yet insistent reappearance of reproductions of images of Biko's corpse seems to signal both our failure and our need to do the same.

Stopforth's works of mourning also significantly predate the Truth and Reconciliation Commission and the national, and to some extent prescribed, mourning that was central to the TRCs' work. The Biko family's opposition to the perpetrators' applications for amnesty constitutes a refusal to accept the psychic and political closure that the TRC process aimed to provide. While the TRCs final report acknowledges that there is still "unfinished business" that remains to be done, this is largely defined as the work of the Missing Persons Task Team: the time-consuming and difficult work of locating, exhuming, and identifying the "disappeared." Implicit here is the idea that once we locate the remains, nothing more remains. Coherence, completion, and closure—and the heavy door of the archive begins to swing shut. The past

Figure 6.1. *Amnesty Hearings, Port Elizabeth, Eastern Cape, December 1997,* photograph by Jillian Edelstein. Courtesy of Jillian Edelstein.

and its dead can be laid to rest. And yet, and this is precisely the question the Biko family will not let go, what about when you have the body and you can clearly read the story it tells, but even then you are not restored, reconciled or made whole?

In the photographer Jillian Edelstein's book about the TRC, *Truth and Lies*,[23] there are four images that relate to the death of Biko. The first is a photograph of the photocopied portrait of Biko taped to the wall at the amnesty hearings in Port Elizabeth in December 1997 (fig. 6.1). The caption to the

portrait, just legible beneath Biko's face, reads "Steve Biko's only crime was ignoring his banning orders. His nightmare began when they chained him naked to a wall." This statement is in direct contrast to the head-and-shoulders portrait in which Biko wears a suit and tie and which insists on his personhood, the fact that he was once alive.

On the facing page there is a paragraph describing the facts of Biko's death and informing readers that

> In January 1997 five security policemen came forward to confess to the assault that led to Biko's death. One of the five, Gideon Nieuwoudt, was among the most feared security policemen in the Eastern Cape. His application for amnesty was successfully opposed by the Biko family—Biko's widow, Ntsiki, his two sons, Samora and Nkosinathi, and his sister, Nbandile Mvovo.[24]

Overleaf is one of the most chilling photographs in the book, a portrait captioned "Gideon Johannes Nieuwoudt and Mike Barnardo, a member of the witness protection team, Cape Town, March 31, 1998." (fig. 6.2).[25] Nieuwoudt stands with one hand in his pocket, almost touching the gun in Barnardo's holster, his other hand holds a burning cigarette; he appears quite relaxed, quite sure of himself—a pose and an image Michael Ignatieff describes, in his introduction to the book, as "remarkable."[26]

I am certain that when I first saw the photograph, Nieuwoudt was smiling. The longer I stare at it the more grim his expression appears. Ignatieff writes:

> This man seems to enjoy the scrutiny of the camera, hence his own notoriety. The gaze seems to say: Yes, I am apartheid's secret. At the heart of it all, there was me. Without me, we wouldn't have kept paradise to ourselves. You can judge me all you like. I don't care. Except, of course, that his easy defiance was a contemptible lie. He had actually fought with all his might to stop the hearings, several times taking the Truth Commission to court to prevent disclosure of his name in proceedings, refusing to apply for amnesty, denying all guilt, until the last moment, when he decided that the hearings offered him his best chance of a way out of jail.[27]

On the page following Edelstein's photograph of Nieuwoudt is a portrait of Ntsiki Biko, unsmiling, severe, and dressed in clothes that signal the importance of the occasion: her handbag, small watch, and string of pearls all markers of formal femininity (fig. 6.3). But her pose—with head slightly upturned and hands held together across her body—portrays a person who will not be moved; the struggle slogan, "You have a struck a woman, you have struck a rock," comes to mind.

In the final photograph in the series, Belgium Biko (fig. 6.4), Steve Biko's younger brother, is shown standing in a doorway. He stands at the threshold,

Figure 6.2. *Gideon Johannes Nieuwoudt (left) and Mike Barnardo, a member of the witness protection team, Cape Town, March 31, 1998,* photograph by Jillian Edelstein. Courtesy of Jillian Edelstein.

neither inside nor outside, with a dark room at his back. Immediately above him on the wall above the door is a framed portrait of Steve Biko. The photograph creates the strange impression that Belgium Biko is standing at the entrance to his home and that the portrait of Steve Biko is hanging on a wall outside the house. While it seems unlikely that a framed portrait would be

132 Chapter 6

Figure 6.3. *Ntsiki Biko, widow of Steve Biko, Port Elizabeth, 1997*, photograph by Jillian Edelstein. Courtesy of Jillian Edelstein.

positioned on the outside of a house, it is precisely because it is not inside the dark room that Biko's portrait can be seen. History is not necessarily a space of darkness nor is the archive always and only a space of disappearance. Yet what keeps the brutal fact of Biko's murder visible, Edelstein's image implies, is the body of Biko's brother blockading the door to the dark house, standing in the light.

Refusing Transcendence 133

Figure 6.4. *Belgium Biko, the younger brother of Steve Biko, at the Biko family home, Ginsburg Location, King William's Town, February 1997*, photograph by Jillian Edelstein. Courtesy of Jillian Edelstein.

Advocate George Bizos, who formed part of the legal team at the inquest into Biko's death in 1977, represented the Biko family at the amnesty hearings in 1997. In the case of Gideon Nieuwoudt, Bizos argued that as Nieuwoudt claimed not to have committed a crime he could not be granted amnesty for one. The TRC refused amnesty to the five security policemen responsible for Biko's death:

134 Chapter 6

The basis for their decision was the applicants' failure to make full disclosure and their inability to demonstrate that they acted in pursuit of a political objective. For the Biko family and their lawyers, the Amnesty Committee's decision confirmed their belief that the whole truth about the tragic death of Steve Biko still remains unknown.[28]

BIKO'S CORPSE AS REMAINDER

Many of the major works by South African artists that show the death of Biko appeared in a large-scale exhibition at the South African National Gallery, which ambitiously seeks to represent the history of art in South Africa "From Pierneef to Gugulective, 1910–2010."

Here is Ezrom Legae's *The Death of Steve Biko*, 1983, pencil, watercolor, and printer's ink on paper (fig. 6.5): Biko has the face of a child and his legs are in the air, one hand clawing at the ground, one curled over. The torture scene: the torturers are absent, and Biko's contorted body fills the frame.

Derek Bauer's *Steve Biko—In Memoriam*, 1987, pen and ink: Biko's cell, blood spattering even beyond the frame of the image; the door to the cell is

Figure 6.5. *The Death of Steve Biko,* 1983 by Ezrom Legae. Courtesy of Bruce Campbell Smith.

open; it is an image of the aftermath of Biko's torture and death. There are two vessels in the cell; one a small bucket, the other a large metal basin. These are furnishings for a prison cell—an ablution bucket and a bath—but in the context of apartheid-era prisons, and of Biko's murder in particular, they also read as signs of deprivation and of torture. Although the artist shows his body fully clothed, Biko was in fact kept naked in his cell for twenty days before his death. Bauer's image is based on a photograph in which another person lies in Biko's cell in order to re-enact one of the positions in which Biko was found after being interrogated. The photograph was used during the investigation into the causes of Biko's death.[29]

It Left Him Cold is Sam Nhlengethwa's 1990 mixed-media collage and pencil drawing on paper in which the instruments of interrogation take up the bottom-left corner: a phone, a coffee cup, a policeman's hat and sunglasses (fig. 6.6). And a broken wooden chair—the chair that Biko famously insisted be brought to his cell by the security police in order that he be able to exercise his right to sit down. The grotesque face of Minister of Justice Jimmy Kruger, dressed in a police uniform, is shown in a portrait on the wall of the cell. Through a door in the wall of the cell, soldiers are visible; the sign of the raging war that will not cease even now that Biko is dead. And Biko himself, his face beaten into an assemblage, a montage, of parts, his head oversized and

Figure 6.6. *It Left Him Cold—the Death of Steve Biko,* **1990 by Sam Nhlengethwa. Courtesy of Sam Nhlengethwa and the Standard Bank Collection at Wits Art Museum.**

his body immobile, naked and thin, lying prostrate across the lower half of the image. The title of the image refers to the statement made by Jimmy Kruger on September 14, 1977 to a National Party Congress: "I am not glad and I am not sorry about Mr Biko. It leaves me cold (Dit laat my koud). I can say nothing to you. Any person who dies . . . I shall also be sorry if I die (Laughter)."[30] The title also evokes Biko's "cold-blooded" murderers and his cold corpse.

The collection of images does not present the whole story. Bringing all these images together makes clear that the story of Biko's death becomes more and not less complicated by each telling and that it is through this dense layering that the meanings of Biko's death multiply.

A recent work by the South African artist Brett Murray unequivocally announces *Steve Biko Is Dead*. In one sense this work can be read as implying that in the new South Africa black consciousness and all Biko stood for has been killed off by neoliberal capitalism, by post-racist racism, and by the persistence of injustice after the end of apartheid. But if we are to take this statement at face value, we are led to ask why it is necessary to state that Steve Biko is dead when he died more than thirty years ago. Why would Biko's death be something that requires reiteration?

THE WOUND OF HISTORY

In a paper titled "[Re]forming the Past: South African Art Bound to Apartheid," the visual artist and writer Gael Neke argues:

> The horror of apartheid has been officially laid to rest. Protest art can now be seen to have "traced" its history and highlighted its areas of power abuse, or as Ivor Powell says, "to telling effect [reflecting] the experience of living in this country at this time" (1990, n.p.). This role was vital during the repressive years of apartheid. Now art's transformative qualities take on a different form. Apartheid is 'reworked' through the current concerns of examining our history.[31]

I read Neke's argument as drawing a parallel between art and psychoanalysis, processes of transformation and "reworking," processes which, she argues, seek to lay horror to rest. In the case of works of art depicting Biko's corpse, I want to argue that something else is at work. Biko's murder represents a graphic point of intersection between the physical and psychic trauma of apartheid, and the many artworks that portray his corpse suggest that such trauma remains impossible for us to rework. In other words, in order to examine our history, in order to make the past sensible, the past must first of all remain past. Biko's corpse signifies the wound that is the past in the present, the trauma that we

Figure 6.7. *Biko Series*, Detail, 1980 by Paul Stopforth. Courtesy of Paul Stopforth.

138 Chapter 6

Figure 6.8. *Biko Series*, Detail, 1980 by Paul Stopforth. Courtesy of Paul Stopforth.

cannot consign to the archival tomb, a living corpse that will not pass away. The nature of traumatic experience is such that even once the external cause has long since ceased, the psyche retains the trauma as though it were a fresh wound.[32] If the archive is understood as a place of repression, a place for that which we do not wish to see, but at the same time that which we cannot let go, then traumatic experience is that which exceeds the archive in that it can never be successfully repressed.

In "Sacred Fragments,"[33] the art historian Sandra Klopper reads Stopforth's work retrospectively and traces the shifts and continuities in his practice over almost four decades. Klopper describes the changes in Stopforth's work after he left South Africa for the United States in 1988 but also notes the recurrence of certain key motifs, such as that of "the hand that he first introduced as part of the series of drawings associated with Steve Biko's death."[34] Klopper also focuses attention on the works Stopforth made after his visit to Robben Island in 2003. She goes on to compare these works to those Stopforth produced in response to the injustices of apartheid:

> In some respects these drawings seem far removed from Stopforth's earlier images of apartheid interrogators and their victims, which record the devastating dehumanisation of not only political prisoners, but also the violent perpetrators who routinely maimed and killed men, women and children. These earlier works bore witness to the harsh realities of a society in which detentions without trial and the deaths of political detainees had become

everyday occurrences, but already, some of his graphite drawings focused on seemingly mundane details. Notable in this regard was his treatment of hands and feet, many of which evoked the posthumous forensic photographs of Steve Biko. In these drawings Stopforth's attention to the specific effectively anchored the deaths of political detainees in the ordinary world of everyday experience. Yet it also afforded him an opportunity to reflect on the timelessness [sic] reality of human suffering. Ultimately, therefore, these images transcend the political moment to which they owe their existence.[35]

I am intrigued by the desire that I read in these lines for art to "transcend" the political and the particular. Klopper writes that Stopforth's works "owe their existence" to a "political moment," but argues that at the same time they transcend that moment, presumably by translating events into works of art. I understand this argument to work in a similar way to Neke's articulation of art as a form of psychoanalytic processing. Art shows us something, and, in the case of works that portray Biko's tortured corpse, what we see is something painful to behold. Neke describes Stopforth's work in the following way:

> The drawings are images of terrible solitude. Details, the dry grain of the skin, the cracks in a heel, the inert fingers of a dead hand, the numbered tag on the toe showing the State's dismissal to anonymity, bring ultimate human vulnerability to the fore. Burn marks or abrasions bring evidence of the system of torture.[36]

For Neke and Klopper the value of such works lie in what they help us to see and understand *beyond* Biko's lifeless form. Interestingly, Stopforth himself also draws attention to the symbolic nature of his drawings of Biko's body:

> *I was given access to the photographs taken during the autopsy on Steve's body. His poor hands and feet had been damaged by handcuffs, manacles and beatings. The terrible vulnerability they embodied led me to draw them both as symbols of the war waged by the Nationalist Government against all black South Africans, and as symbols of the martyrdom suffered by many who sacrificed their lives in the struggle against apartheid.*[37]

Counter to these views, I read the stubborn repetition and reappearance of images of Biko's corpse as calling us to the task of bearing witness. His dead body is a sign we cannot read, but this is not to say that it does not mean. The corpse signifies the end of language and the corpse speaks for itself.

In their insistence on the vulnerability of the human form and in their attention to the specificities of the body parts portrayed, I read images of Biko's corpse as refusing transcendence. Let us consider this in relation to what might be read as Stopforth's most transcendentalist work engaging with the subject of Biko's corpse, *Elegy for Steve Biko* (fig. 6.9).[38]

Figure 6.9. *Biko Series*, Detail, 1980 by Paul Stopforth. Courtesy of Paul Stopforth.

Here, Biko's corpse is intact, we see his entire body rather than the fragments or the broken forms that figure in many other works. The red ground conjures the blood that has run out of his body and turned the color of stone. Stopforth's work is an act of preservation, and Biko's body appears to have been sculpted, cast in something like volcanic ash; the texture of his skin is smooth as marble. The work could be read as translating the political into the aesthetic, as creating a monument to a martyr. And yet this is no ordinary monument—one that testifies to heroic acts, to greatness, or even one that provokes us to remember something usually clearly defined for us by a typical monument's content and form. Here we are faced with a corpse of a man we are told is Steve Biko; his body is stretched out before us and at the center his naked sex is helplessly exposed. We are reminded that this is a man who lived, who had lovers, who felt pleasure and pain. In spite of the fact that it is possible to read the image as a representation of "everyman," there are compelling reasons to acknowledge the body it portrays as Biko's alone.[39]

Some of us want Biko to disappear. Some of us want Biko to be Jesus. This amounts to the same thing. In a recent essay[40] the South African art historian David Bunn reflects on the significance of Biko's death. Bunn recalls attending the funeral along with the thousands of other mourners and describes how "from that moment on, the processes of iconographic conversion were at work: images of Biko breaking his chains were already manifest on t-shirts and posters held aloft."[41] Yet, importantly for the argument I am making here, he also draws attention to what he terms "the sheer fact" of Biko's corpse:

> Thinking back on it, Biko's corpse appeared for many of us, I think, to shimmer between two states: that of the evidentiary trace, and of the icon. In an era of apartheid without real archives, or justice, or the law, the sheer fact of the autopsied body seemed to speak out unanswerable accusations to the State and the world.[42]

Converting Biko into a sign—of the struggle for freedom and the timelessness of suffering—is to seek an end to our painful confrontation with his death. It is to bestow an ending, even if not an altogether happy one, something like that of forgiveness and reconciliation, to what remains an open wound. To what remains.

THE VIOLENCE THAT IS STILL TO COME

As this chapter has sought to argue, depictions of Biko's corpse disallow such consolations as the "timeless reality of human suffering" might offer. The facts

of Biko's murder and all that his death has come to symbolize keep open the question of our relation to the brutality of the past and instruct us to be cognizant of the brutality of the present. In many ways the argument I am making here for holding a position that is unreconciled, and one that does not aspire to reconciliation, is not new. It is one that has been made by those who wish not to turn the events of the Second World War and the Nazi death camps into a sign of the "timeless reality of human suffering," and who instead hold to the rather more difficult position of facing that which we cannot make sensible, useful or spiritual. The position is one that demands a constant reckoning rather than a facile reconciliation. I think of the importance of this here in South Africa now, in the wake of murder motivated by xenophobia, of the increase in the murder and rape of gays, lesbians and transgendered people post-1994, and of continuing racist violence symbolized by the Reitz incident at the University of the Free State in 2009.

In Jane Alexander's photomontage (fig. 6.10), Biko is a saintly harbinger of sorrow—he looms in the foreground, juxtaposed with a billboard depicting two white angelic girls praying, and his presence announces mass death, pain, torture, and loss.[43] The children evert into a sinister sign of willed ignorance. There is something heartbreaking about the gap between Biko's teeth: it is a sign of his vulnerability, a dark point of entry into his body.

Alexander's montage does not present Biko's corpse, but the work is suffused with his loss. The image, the event to which we are witness, takes place before Biko's death—here his body remains intact. And yet at the same time,

Figure 6.10. *Elegy for Steve Biko*, 1981, by Paul Stopforth. Courtesy of Paul Stopforth.

Figure 6.11. *Portrait of a Man with Landscape and Procession (Bantu Steven Biko 1946–1977)*, 1995, by Jane Alexander/DALRO, Johannesburg. Licensed by VAGA, New York.

we know this to be a time and place to which we can never return. Biko's death dominates the landscape, the wasteland apartheid has wrought. His gaze is directed at something outside the frame of the image. It is a gaze made more poignant by the fact that it appears hopeful. He sees something we cannot know. At the same time, we who view the image know the terrible fate that is to befall him, we are among those who did not prevent his death, and in this sense find ourselves, if not complicit, then at least subject to the burden of a history we cannot undo. Susan Sontag writes that "Photographs state the innocence, the vulnerability of lives heading toward their own destruction, and this link between photography and death haunts all photographs of people."[44] In portraits of the living viewed after their deaths, this sense of their being haunted is intensified. In the case of Alexander's work the *punctum*, like that which Barthes reads in Alexander Gardener's portrait of Lewis Payne, a young man condemned to death and awaiting execution, is: "he is going to die." Biko's living face is marked by the fact of his murder, his vulnerability to the violence that is still to come. I read Alexander's work as an injunction to remember that there is always a time before acts of violence, before events of unspeakable horror, and that all too often we recognize this only when it is too late.

144 Chapter 6

What Would Biko Say?

Listen to Karl Jaspers writing on the concept of metaphysical guilt:

There exists amongst men, because they are men, a solidarity through which each shares responsibility for every injustice and every wrong committed in the world and especially for crimes that are committed in his presence or of which he cannot be ignorant. If I do not do whatever I can to prevent them, I am an accomplice in them. If I have not risked my life in order to prevent the murder of other men, if I have stood silent, I feel guilty in a sense that cannot in any adequate fashion be understood jurisdicially or politically or morally . . . That I am still alive after such things have been done weighs on me as a guilt that cannot be expiated. Somewhere in the heart of human relations, an absolute command imposes itself: in case of criminal attack or of living conditions that threaten physical being, accept life for all together or not at all.[45]

So I said to them, "Listen, if you guys want to do this your way, you have to handcuff me and bind my feet together, so that I can't respond. If you allow me to respond, I'm certainly going to respond. And I'm afraid you may have to kill me in the process even if it's not your intention."[46]

NOTES

1. Veena Das draws on the work of Nina Serematakis to develop her conception of "bad death." in *Life and Words: Violence and the Descent into the Ordinary* (Berkeley: University of California Press, 2007), 48.

2. I am constituting an imagined post-apartheid community in this paper when I refer to "us" and to "we." At the same time I want to acknowledge the fractured nature of such a community and the ways in which race determined, and in many ways continues to determine, our relation to the violence of the past and of the present. In other words, it is necessary to mark the difference between being *responsible for* and *subject to* the violence of apartheid.

3. Jacques Derrida, *Copy, Archive, Signature: A Conversation on Photography* (Stanford, CA: Stanford University Press, 2010), 18. I am grateful to Michael Nixon for bringing this passage to my attention.

4. Jacques Derrida, *Archive Fever: A Freudian Impression* (Chicago: University of Chicago Press, 1996).

5. Ibid., 11.

6. Ibid.

7. Hilda Bernstein, *No. 46—Steve Biko* (London: International Defence and Aid Fund, 1978), 29.

8. Ibid., 46–49.

9. Ibid., 32.

10. Ibid., 33.

11. Ibid., 115.

12. Ibid.

13. Elliott, Marilyn. "Biko: The Case is Over but the Row Still Rages," *Cape Times*, November 14, 1980, 13.

14. Extensive documents relating to the case brought against the doctors can be found in the Biko Doctors and Dot Cleminshaw collections held at the University of Cape Town Manuscripts and Archives.

15. Bulbring, Edyth. "Ten Years After: Those Inquest Names," *The Weekly Mail*, September 11–17, 1987, 15.

16. For an example of Steve Biko's incisive mind, see the record of his interrogation and extracts from the evidence he gave in the SASO–BPC trial in May 1976 and included in *I Write What I Like*. See in particular the section entitled "The Righteousness of our Strength" in *I Write What I Like* (Johannesburg: Ravan Press, 1996; first published 1978), 120–37.

17. The phrase "remnants of apartheid" reworks the title of Giorgio Agamben's book, *Remnants of Auschwitz: The Witness and the Archive*, trans. Daniel Heller-Roazen (New York: Zone Books, 1999).

18. It could, of course, be argued that in representing the death of Biko, artists are not resisting the archive but are contributing to it. However, if these works enter the archive simply by virtue of their coming into being and their public circulation, it seems that the defining qualities of an archive are so elastic that they cease to mean. The argument I am making here is that these artworks do not supplement the archive, nor do they form a new archive, nor should they be understood as an animate, visible archive that opposes, but remains coterminous with, a far less visible archive. Rather, they are *outside* the archive, and it is precisely this position that makes mourning possible. Representations of Biko's corpse disrupt the order of things, refusing assimilation, just as the Biko case makes visible how the TRC, its proceedings, its archive, its comprehensive final report—the ur-document of apartheid history—is by no means complete. The production of an archive is always a political act. So too is resisting incorporation into what is thoroughly knowable and therefore neutralized. The struggle between these two conflicting dynamics is what defines the always-shifting borders of any archive.

19. The first version of "Biko: The Quest for a True Humanity" opened at the Department of Education in Pretoria in October 2007 and was curated by Emilia Potenza for the Steve Biko Foundation in partnership with the Apartheid Museum. In 2008, the exhibition, coordinated by Bongi Dhlomo-Mautloa opened at the Apartheid Museum in Johannesburg and from November 2008–December 2009 was shown at the Slave Lodge in Cape Town.

20. Shannen Hill, "Iconic Autopsy: Post-Mortem Portraits of Bantu Stephen Biko," *African Arts* 38, no. 3 (Autumn 2005): 17.

21. Paul Stopforth, email communication to author March 9, 2011. Stopforth's intimate encounter with the autopsy photographs and his subsequent reworking of the images finds a parallel in the work of artist and writer Colin Richards who, at the time of Biko's murder was working as a medical illustrator and who annotated the forensic photographs of Biko's corpse. However, Richards's series of works which engage with

that experience were produced post-1994. These were were exhibited in Cape Town in 1996. Richards has written a beautiful essay about those works and the production of them. See Colin Richards, "Drawing a Veil," paper presented at the Wits History Workshop: The TRC; Commissioning the Past, June 11–14, 1999, http://wiredspace.wits.ac.za//handle/10539/8062 (accessed October 12, 2010). See also Hill, "Iconic Autopsy," for an extended discussion of Richards's Veil Series.

22. Stopforth, email communication to author, March 9, 2011.

23. Jillian Edelstein, *Truth and Lies: Stories from the Truth and Reconciliation Commission in South Africa* (London: Granta Books; and Milpark, South Africa: M&G Books, 2001).

24. Ibid., 55.

25. Ibid., 56.

26. Michael Ignatieff, "Introduction," in *Truth and Lies: Stories from the Truth and Reconciliation Commission in South Africa*, by Jillian Edelstein (London: Granta Books; and Milpark, South Africa: M&G Books, 2001), 15–21.

27. Ibid., 18.

28. Legal Resource Center, "2006 Truth and Reconciliation Commission (TRC)," *Legal Resource Center*, http://www.lrc.org.za/papers/436-truth-and-reconciliation-commission-trc (accessed July 18, 2011).

29. The photographs of the re-enactment of the events of Biko's interrogation and murder are included in the exhibition "Biko: The Quest for a True Humanity."

30. Bernstein *No. 46–Steve Biko*, 20.

31. Gael Neke, "[Re]forming the Past: South African Art Bound to Apartheid," paper presented at the Wits History Workshop, TRC: Commissioning the Past, 1999, 8, http://wiredspace.wits.ac.za/handle/10539/8032 (accessed March 29, 2013).

32. This idea forms the basis of Freud's thinking about the symptoms of hysteria. The persistence of the psychic effects of traumatic experience in the present is now diagnosed as post-traumatic stress disorder.

33. Sandra Klopper, "Sacred Fragments: Looking Back at the Art of Paul Stopforth," *African Arts* 37, no. 4 (Winter 2004): 68–73, 96.

34. Ibid., 71.

35. Ibid., 68–70.

36. Neke, "[Re]forming the Past," 3.

37. Stopforth in Neke, "[Re]forming the Past," 3, italics in original.

38. See for instance Hill's reading of this work as interpellating viewers as both witnesses to history and to "the miraculous ascent of a martyr's body and spirit, a prominent theme of Western iconography" (Hill, "Iconic Autopsy," 18).

39. In her reading of David Koloane's series "The Journey," Hill argues that Biko is "[d]epicted as Everyman" and that in this way "Biko's heroism extends to all viewers who regard police brutality as inhumane" (Hill, "Iconic Autopsy," 24).

40. David Bunn, "Sitting for the Post-Mortem Portrait," *The Salon*, vol. 2, Johannesburg Workshop in Theory and Criticism, 2010, http://www.jwtc.org.za/the_salon/volume_2/david_bunn_sitting_for_the_post_mortem_portrait.htm (accessed July 2, 2011).

41. Ibid., n.p.

42. Ibid., n.p.

43. *Portrait of a Man with Landscape and Procession (Bantu Stephen Biko 1946–1977)*, incorporates photographs of two other works by Alexander, a sculpture—entitled "something's going down"—made in 1993/4 and a portrait of Biko that the artist painted in the late 1980s for one of Steve Biko's relatives. In correspondence with me Alexander related how before the end of apartheid a domestic worker produced photocopies of the painting, glued them onto board and framed the images with shells and glass which she then distributed to people living in Orange Farm, a township approximately 45 kilometres from the city of Johannesburg. Jane Alexander, email correspondence to author, September 15, 2011.

44. Susan Sontag, *On Photography* (New York: Penguin, 1979), 70.

45. Biko, *I Write What I Like*, 78. This passage from Jaspers is also cited by Frantz Fanon in *Black Skin, White Masks*, trans. Charles Lam Markmann (New York: Grove Press, 1967), 89.

46. Biko, *I Write What I Like*, 153.

· 7 ·

(Without) Conclusion

The Crisis is Not Over

—Statement printed on a banner and displayed in the center of the Make Art/Stop AIDS exhibition, Cape Town Castle, Cape Town, South Africa, 2010

Impossible Mourning emerges from, and provides a kind of chronicle of, my thinking about the paradox of the magnitude of the HIV/AIDS epidemic in South Africa and the denial and absence of mourning in the public sphere that accompanied it. Several years ago, while I was a graduate student in the English Department at the University of British Columbia, I took a course called "Witnessing and the Discourses of Extremity" taught by Professor Ross Chambers.[1] We read novels and poetry by and about witnesses to traumatic events; the First World War, the *Shoah*, and what Chambers terms "AIDS Witnessing." In the section of the course on bearing witness to AIDS we watched John Greyson's film, *Zero Patience*,[2] and read Paul Monette's elegies written for his lover, Roger Horwitz,[3] Eric Michaels's autobiography, *Unbecoming*,[4] and Jamaica Kincaid's *My Brother*.[5] This was the start of my thinking about HIV and AIDS in South Africa, and at the time I made a note to myself, "What is missing? Third-world AIDS patients." That I imagined such people living with AIDS at that time to be "patients" provides an indication of just how little I knew about the epidemic.

In the winter of 1998, I returned home to South Africa to visit my family. I traveled to stay with my aunt, Dr. Trudy Thomas, who was, at that time, Minister of Health in the Eastern Cape province. I went with her to the opening of a clinic in rural Transkei at a place not far away from where Nelson Mandela was born. The president himself was going to be at the opening

ceremony. Hundreds of people from the surrounding community gathered outside the clinic on that cold day and waited for him to arrive. When his helicopter landed, the post-1994 euphoria and the presence of President Mandela made everyone forget the cold. The crowd danced and ululated; Madiba jived. Executives from Siemens were there to donate expensive medical equipment to the clinic as a birthday gift to the president. He shook their hands and thanked them because, he said, they recognized that people in the third world need the best and most expensive equipment just as much as people in the first world. Then my aunt gave her speech. She thanked Madiba for asking the people at Siemens to donate equipment to the clinic but also requested that training be provided to the clinic staff so that it would be possible for the equipment to be used. After the ceremony she introduced me to President Mandela. He asked me what I was doing, and I told him that I was studying in Canada. He said, "That's good, but you must come back home."

At the end of 1999 I returned to South Africa, and in the beginning of 2000 I went to live in rural KwaZulu-Natal. I befriended several farm workers and women who were employed as domestic workers in the houses in the area. It seemed that everyone who lived there was ill; everybody was thin; everyone coughed. I attributed the ill health of those I met to their living and working conditions. I immediately set about organizing for the Department of Labour to come out and give a workshop informing local workers of their rights. When I think back to that time I can hardly believe my own ignorance. Somehow, the fact that KwaZulu-Natal was the epicenter of the HIV/AIDS epidemic in South Africa had completely escaped my notice. This was the year the International AIDS Conference was held in Durban, only an hour away from where I was living. Needless to say, I did not attend. Like President Mbeki, I did not see people living with HIV/AIDS. I saw extreme economic poverty, I saw racism and injustice, and I saw that people were suffering. At that time I was an inhabitant of what Susan Sontag has termed, "the kingdom of the well," and I did not enter the shadowy realm of the ill, nor did I reflect too much about what it would mean to dwell there.[6] My failure to recognize the crisis of HIV/AIDS is striking in retrospect, as too is the fact that no one ever mentioned it to me at the time. That it was possible not to think about the epidemic in a context where so many people were infected with HIV, and ill and dying of AIDS, is an indication of how acute the marginalization of people living with HIV/AIDS was and continues to be. Just four years later I co-edited a book of poems and stories about HIV and AIDS from southern Africa titled, *Nobody Ever Said AIDS*.[7] The title of the collection is drawn from Eddie Maluleke's poem by the same name, which so powerfully evokes the denial that has plagued us in South Africa. The final stanza of her poem runs:

> We all died
> Coughed and died
> We died of TB
> That was us
> Whispering it at funerals
> Because Nobody Ever Said AIDS[8]

On the December 1, 2009, World AIDS Day, South African President Jacob Zuma proclaimed the era of AIDS denialism officially over. Zuma called for an end to stigma and discrimination against people living with HIV/AIDS and announced that access to anti-retroviral treatment would be significantly increased. At the same time Zuma exhorted South Africans to take responsibility for their own lives and to make considered choices. Zuma's statements have been lauded as signaling a fundamental break with the failings of the past, and indeed, in their recognition of the lives and struggles of people living with HIV/AIDS Zuma's remarks are to be celebrated. His words also indicate that the complexity and contradictions that have riddled public discourse about the epidemic in South Africa are not so easily laid to rest.

One of these contradictions lies in how people living with HIV/AIDS are represented as deserving of health care services and treatment but at the same time, as responsible for the fact that they are HIV positive. It is this kind of rhetoric that permits the government to claim that the epidemic is costing the state billions in public funds, and not only that people ought to behave more responsibly but that the state cannot be held accountable for their well-being.

In calling on us to put an end to stigmatizing behavior what becomes clear is that the imagined listeners of Zuma's address, his public, are HIV negative. People living with HIV/AIDS are not us. They are those toward whom we will henceforward adopt a different relation, one of recognition and respect, one of caution, one that preserves the bounds between us. The imagined active citizens of the South African national body politic are in good health. This kind of imagining places a question mark over the position of people living with HIV/AIDS: what kind of citizens are these; what is their role in the debates about the epidemic, access to health care, human rights, and the constitution, the ways in which they are represented? If under the reign of Mbeki people living with HIV/AIDS were made to occupy a place between life and death, effectively positioned outside of the political sphere, what are the possibilities for social and political agency now? Have people living with HIV/AIDS been admitted into full citizenship? How do we understand the ways in which our government has treated people living with HIV/AIDS? How does that history continue to affect us in the present? What are we to make of the fact that the kinds of behavior change and prevention initiatives embarked on thus far have proved largely un-

successful and that 1,000 people are newly infected with HIV in South Africa each day? And what of the 1,000 people who die of AIDS each day and whose deaths pass virtually unnoticed in the public sphere? In spite of the certainty of Zuma's World AIDS Day proclamations, these questions remain undecided and demand close critical engagement.

World AIDS Day marks a particular moment of heightened visibility of the crisis of HIV/AIDS in the year calendar. It is often commemorated with art exhibition openings, benefit concerts, and events that seek to raise awareness about the epidemic and to bring it into public view. And it is quite telling to note how the excess of words and images about HIV and AIDS on and around December 1 is equaled by the invisibility of the lives and struggles of the majority of people living with HIV/AIDS on all the other days of the year. Cultural theorist Paula Treichler has written that HIV/AIDS is an "epidemic of signification," and she has noted that no other illness has sparked off quite the same quantity of words, pictures, and debate.[9] This is certainly the case in South Africa, where debate about HIV and AIDS dominated public discourse about the state of governance and democracy in the country for close to ten years. At the same time, and as this work has aimed to show, the lives and experiences of people living with HIV/AIDS have for the most part been placed under erasure. This national failure to recognize and respond to the crisis of HIV/AIDS post-apartheid is, this book has argued, intimately bound to ways of (not) seeing and acting during apartheid.

The policies of the apartheid state have significantly affected the course and magnitude of the epidemic in South Africa, and their effects have not been undone in the post-apartheid present. The epidemic in South Africa and even in southern Africa more broadly can be linked to what might be termed "apartheid fallout" and in some instances forms of deprivation and oppression experienced under apartheid have been compounded in the wake of the implementation of neoliberal policies after 1994. For people living with HIV/AIDS without access to the medical treatment and care they require, the euphoria of South Africa's transition to democracy was short-lived. Since the 2003 roll-out of antiretroviral drugs in the public health sector people living with HIV, many of whom continue to live in conditions of extreme material deprivation, have been granted a hard-won point of entry into the bio-political state. Writing of the Ukraine in the aftermath of the Chernobyl disaster, anthropologist Adriana Petryna describes the perverse economy in which diagnosis as a "sufferer" with radiation sickness became a desirable condition. She writes that:

> . . . these citizens' experiences expose the existence of patterns that ought to be traced in other post-socialist contexts: the role of science in legitimating democratic institutions; increasingly limited access to health care and welfare as the capitalist trends take over; and the uneasy correlation of human rights with biological self-preservation.[10]

While there are significant differences between post-apartheid South Africa and the post-socialist states, Petryna's analysis of the position of "sufferers" in the Ukraine and their struggle for recognition by the state in an emerging neoliberal democracy has striking parallels with the position of economically impoverished South Africans living with HIV/AIDS. In post-apartheid South Africa, as in post-socialist Ukraine, juridical rights have been extended to all citizens and yet in each state, "a large and largely impoverished segment of the population has learned to negotiate the terms of its economic and social inclusion in the most rudimentary life-and-death terms."[11]

Impossible Mourning has made an argument for making the connections between the past and the present explicit in order to prohibit the past from being put behind us, as if apartheid could be reduced to a kind of anti-foundation myth against which "the new South Africa" constitutes itself. Instead it demands that we attend to the ways in which we are foundering against that past, all its remnants made visible through our cities, our hospitals, our bodies, our "child-headed households," our affluence, our rapists, our invisible prov-

Figure 7.1. *Anonymous (covering face) is a university student at Maputo University in Mozambique. Due to the extreme stigma he might face, he chose to not include any of his clothes in the photograph in case they might identify him. "I can't be identified because it may have a bad impact on my position as a university student. I can't even allow you to say what my faculty is. Here in Mozambique there is discrimination promoted by the government. In one of his speeches the prime minister said Mozambique should not invest in educating people with AIDS as there is no hope for them. The government only cares about getting enough qualified technicians for its objectives. If my faculty discovered my status there is a real possibility that they would discriminate against me. Even if they don't expel me straight away, they would try all sorts of devious means to get rid of me." c. 2002 by Gideon Mendel. Courtesy of Gideon Mendel.*

inces populated by the starving and the sick, our epidemic, and through all that divides us still. I understand this unresolved relationship to the injustice of the past to be at the heart of the challenges we face in recognizing and responding to the injustice of the present.

What will make mourning possible in the aftermath of apartheid? This book has engaged with a number of provocative aesthetic works, arguing alongside them to think about this question. The answer, however, rests in collective political action that art might serve to awaken, but cannot replace.

NOTES

1. Ross Chambers is Professor Emeritus of French and Comparative Literature, University of Michigan. He was a visiting Professor in the Department of English at the University of British Columbia in 1998. He is the author of, among other books, *Facing It: AIDS Diaries and the Death of the Author* (Ann Arbor: University of Michigan Press, 1998); *Room for Maneuver: Reading (the) Oppositional (in) Narrative* (Chicago: University of Chicago Press, 1991); and *The Writing of Melancholy: Modes of Opposition in Early French Modernism*, trans. Mary Trouille (Chicago: University of Chicago Press, 1993).

2. John Greyson, *Zero Patience* (Telefilm Canada, Zero Patience Production, 1993).

3. Paul Monette, *Love Alone: Eighteen Elegies for Rog* (New York: St. Martin's Press, 1988).

4. Eric Michaels, *Unbecoming* (Sydney: EM Press, 1990).

5. Jamaica Kincaid, *My Brother* (New York: Noonday, 1998).

6. Susan Sontag, *Illness as Metaphor* (New York: Farrar, Strauss and Giroux, 1978), 3.

7. *Nobody Ever Said AIDS: Poems and Stories from Southern Africa*, ed. Nobantu Rasebotsa, Meg Samuelson, and Kylie Thomas (Cape Town: Kwela, 2003), 124–41.

8. Eddie Maluleke, "Nobody Ever Said AIDS," in *Nobody Ever Said AIDS: Poems and Stories from Southern Africa*, ed. Nobantu Rasebotsa, Meg Samuelson and Kylie Thomas (Cape Town: Kwela, 2003), 20.

9. Paula Treichler, "AIDS, Homophobia and Biomedical Discourse: An Epidemic of Signification," in *AIDS: Cultural Analysis and Cultural Activism*, ed. Douglas Crimp (Cambridge, MA: MIT Press, 1991), 31–70.

10. Adriana Petryna, *Life Exposed: Biological Citizens after Chernobyl* (Princeton, NJ: Princeton University Press, 2002), 7.

11. Ibid.

Bibliography

Achmat, Zackie. "Ronald, Why Didn't You Get Tested?" *Writing Rights*, June 23, 2010. http://writingrights.org/2010/06/23/ronald-louw-died-of-hiv-related-tb-on-26-june-2005/ (accessed December 14, 2010). First published in the *Mail & Guardian*, July 11, 2005.
———. "Treatment Action Campaign: Urgent Press Release." *Treatment Action Campaign*, August 23, 2000. http://www.tac.org.za/Documents/Statements/pr000823.txt (accessed March 30, 2013).
Adams, Parveen. *The Emptiness of the Image: Psychoanalysis and Sexual Differences*. London: Routledge, 1996.
Agamben, Giorgio. *Remnants of Auschwitz: The Witness and the Archive*. Translated by Daniel Heller-Roazen. New York: Zone Books, 1999.
Alexander, M. Jacqui, and Chandra Talpade Mohanty, eds. *Feminist Genealogies, Colonial Legacies, Democratic Futures*. London: Routledge, 1997.
Aloi, Daniel. "'Body Maps' are Images of Hope." *Cornell Chronicle Online*, November 2, 2006. http://www.news.cornell.edu/stories/2006/11/body-maps-exhibit-has-images-hope-people-hiv (accessed April 3, 2013).
Argentine National Commission on the Disappeared. *Nunca Más: The Report of the Argentine National Commission on the Disappeared*. New York: Farrar, Strauss and Giroux, 1986.
Atkinson, Brenda, and Candice Breitz, eds. *Grey Areas: Representation, Identity and Politics in Contemporary South African Art*. Johannesburg: Chalkham Hill Press, 1999.
Azoulay, Ariella. *The Civil Contract of Photography*. New York: Zone Books, 2008.
Baer, Ulrich. *Spectral Evidence: The Photography of Trauma*. Cambridge, MA: MIT Press, 2002.
Barthes, Roland. *Camera Lucida: Reflections on Photography*. Translated by Richard Howard. New York: Farrar, Straus and Giroux, 1981.
———. *Image, Music, Text*. Translated by Stephen Heath. Glasgow: Fontana, 1977.
Barz, Gregory, and Judah M. Cohen, eds. *The Culture of AIDS in Africa: Hope and Healing through Music and the Arts*. New York: Oxford, 2011.

Bibliography

Benjamin, Walter. *Walter Benjamin: Selected Writings*, edited by Howard Eiland and Michael W. Jennings, vol. 3, 1935–1938. Cambridge, MA: Harvard University Press, 2002.

———. "The Work of Art in the Age of Its Technological Reproducibility" (second version). In *Walter Benjamin: Selected Writings*, edited by Howard Eiland and Michael W. Jennings, vol. 3, 1935–1938, 101–36. Cambridge, MA: Harvard University Press, 2002.

Bernstein, Hilda. *No. 46–Steve Biko*. London: International Defence and Aid Fund, 1978.

Biko, Steve. *I Write What I Like*. Johannesburg: Ravan Press, 1996. First published 1978 by Bowerdean Press.

Bourdieu, Pierre. *Photography: A Middle-brow Art*. Cambridge: Polity Press, 1990.

Brundrit, Jean. *A Lesbian Story: An Exhibition Project by Jean Brundrit*. Contributing essay by L. van Robbroeck. Cape Town: Michaelis School of Fine Art, 2008.

Bulbring, Edyth. "Ten Years After: Those Inquest Names," The Weekly Mail, September 11–17, 1987, 15.

Bunn, David. "Sitting for the Post-Mortem Portrait." *The Salon*, vol. 2. Johannesburg Workshop in Theory and Criticism, 2010. http://www.jwtc.org.za/the_salon/volume_2/david_bunn_sitting_for_the_post_mortem_portrait.htm (accessed July 2, 2011).

Butler, Judith. *Antigone's Claim: Kinship Between Life and Death*. New York: Columbia University Press, 2000.

———. *Gender Trouble: Feminism and the Subversion of Identity*. New York: Routledge, 1990.

———. *Precarious Life: The Powers of Mourning and Violence*. London and New York: Verso, 2004.

———. *The Psychic Life of Power: Theories in Subjection*. Stanford, CA: Stanford University Press, 1997.

Cadava, Eduardo. *Words of Light: Theses on the Photography of History*. Princeton, NJ: Princeton University Press, 1997.

Cameron, Edwin. Unpublished speech HIV/AIDS colloquium. University of Cape Town, November 2006.

———. *Witness to AIDS*. Cape Town: Tafelberg, 2005.

Camus, Albert. *The Plague*, translated by Stuart Gilbert. Middlesex: Penguin, 1968. First published as *La Peste*, 1947.

Carter, Erica, and Simon Watney, eds. *Taking Liberties: AIDS and Cultural Politics*. London: Serpent's Tail, 1989.

Cavarero, Adriana. *Relating Narratives: Storytelling and Selfhood*. Translated by Paul A. Kottman. London: Routledge, 2000.

Chambers, Ross. *Facing It: AIDS Diaries and the Death of the Author*. Ann Arbor: University of Michigan Press, 1998.

———. *Room for Maneuver: Reading (the) Oppositional (in) Narrative*. Chicago: University of Chicago Press, 1991.

———. *Untimely Interventions: AIDS Writing, Testimonial, and the Rhetoric of Haunting*. Ann Arbor: University of Michigan Press, 2004.

———. *The Writing of Melancholy: Modes of Opposition in Early French Modernism*. Translated by Mary Seidman Trouille. Chicago: University of Chicago Press, 1993.

Chow, Rey. *Writing Diaspora: Tactics of Intervention in Contemporary Cultural Studies*. Bloomington: Indiana University Press, 1993.

Cook, G. P. "Khayelitsha: Policy Change or Crisis Response?" *Transactions of the Institute of British Geographers* 11, no. 1 (1986): 57–66.

Coombes, Annie E. "Witnessing History/Embodying Testimony: Gender and Memory in Post-apartheid South Africa." *Journal of Royal Anthropological Institute* 17, no. s1 (2011): S92–S112.

Crimp, Douglas, ed. *AIDS: Cultural Analysis and Cultural Activism*. Cambridge, MA: MIT Press, 1991.

———. "Melancholia and Moralism." In *Loss: The Politics of Mourning*, edited by David L. Eng and David Kazanjian, 188–202. Berkeley: University of California Press, 2003.

———. "Mourning and Militancy." *October* 51 (Winter 1989): 3–18.

Cvetkovich, Ann. "Legacies of Trauma, Legacies of Activism: ACT UP's Lesbians." In *Loss: The Politics of Mourning*, edited by David L. Eng and David Kazanjian, 427–57. Berkeley: University of California Press, 2003.

Das, Veena. *Life and Words: Violence and the Descent into the Ordinary*. Berkeley: University of California Press, 2007.

David Krut Projects. "Body Maps Project: Bambanani Women's Group." www.davidkrut.com/bodyMaps.html# (accessed March 30, 2013).

De Kok, Ingrid. "Small Passing." *Contrast* 14, no. 4 (December 1983): 27–28.

Delbo, Charlotte. *Days and Memory*. Translated by Rosette Lamont. Marlboro, VT: Marlboro Press, 1990.

Derrida, Jacques. *Archive Fever: A Freudian Impression*. Chicago: University of Chicago Press, 1996.

———. *Copy, Archive, Signature: A Conversation on Photography*. Edited with an introduction by Gerhard Richter, translated by Jeff Fort. Stanford, CA: Stanford University Press, 2010.

———. *Of Grammatology*. Translated by Gayatri Chakravorty Spivak. Baltimore: Johns Hopkins University Press, 1976.

Digital Journalist. "The Digital Journalist: 20 Years: AIDS and Photography," June 2001. http://digitaljournalist.org/issue0106/visions_frameset.htm (accessed April 1, 2013).

Distiller, Natasha. "Another Story: The (Im)possibility of Lesbian Desire." *Agenda* 19, no. 63 (2005): 44–57.

Edelstein, Jillian. *Truth and Lies: Stories from the Truth and Reconciliation Commission in South Africa*. London: Granta Books; and Milpark, South Africa: M&G Books, 2001.

Elliott, Marilyn. "Biko: The Case is Over but the Row Still Rages," *Cape Times*, November 14, 1980, 13.

Eng, David L., and David Kazanjian, eds. *Loss: The Politics of Mourning*. Berkeley: University of California Press, 2003.

Enwezor, Okwui. "Reframing the Black Subject: Ideology and Fantasy in South African Representation." In *Reading the Contemporary: African Art from Theory to the

Market Place, edited by Olu Oguibe and Okwui Enwezor, 376–99. London: Institute of International Visual Arts, 1999.

Fabricius, Peter. "SA Fails to Back Efforts at UN to Protect Gays." *Cape Times*, June 23, 2010, 3.

Fanon, Frantz. *Black Skin, White Masks*. Translated by Charles Lam Markmann. New York: Grove Press, 1967.

Felman, Shoshana, and Dori Laub. *Testimony: Crises of Witnessing in Literature, Psychoanalysis, and History*. New York: Routledge, 1992.

Foucault, Michel. *The Archaeology of Knowledge*. Translated by A. M. Sheridan Smith. London: Routledge, 2002.

———. *The History of Sexuality: An Introduction*. Translated by Robert Hurley. vol. 1. New York: Vintage, 1978. First published in French in 1976.

Fox, Renée C., and Eric Goemaere. "They Call it 'Patient Selection' in Khayelitsha: The Experience of Médecins Sans Frontières—South Africa in Enrolling Patients to Receive Antiretroviral Treatment for HIV/AIDS." *Cambridge Quarterly of Healthcare Ethics* 15, no. 3 (2006): 302–12.

Freud, Sigmund. *On Murder, Mourning and Melancholia*. London: Penguin Books, 2005.

Fried, Michael. "Barthes's *Punctum*." *Critical Inquiry* 31, no. 3 (Spring 2005): 539–74.

Friedman, Steven, and Shauna Mottair. "A Rewarding Engagement? The Treatment Action Campaign and the Politics of HIV/AIDS." *Politics & Society* 33, no. 4 (2005): 511–65.

Fullard, Madeleine, and Nicky Rousseau. "Uncertain Borders: The TRC and the (Un)making of Public Myths." *Kronos* 34 (November 2008): 215–39.

Godby, Michael. "Aesthetics and Activism: Gideon Mendel and the Politics of Photographing the HIV/AIDS Pandemic in South Africa." In *The Culture of AIDS in Africa: Hope and Healing through Music and the Arts*, edited by Gregory Barz and Judah M. Cohen, 215–21. New York: Oxford, 2011.

Gqola, Pumla Dineo. "Through Zanele Muholi's Eyes: Re/Imagining Ways of Seeing Black Lesbians." In *Zanele Muholi: Only Half the Picture*, edited by Sophie Perryer, 82–89. Johannesburg: STE Publishers, 2006.

Greyson, John. *Zero Patience*. Telefilm Canada, Zero Patience Production, 1993.

Grundlingh, Geoffrey. *The Cape Town Month of Photography*. Cape Town: South African Center for Photography, University of Cape Town, 2005.

Gunkel, Henriette. *The Cultural Politics of Female Sexuality in South Africa*. New York: Routledge, 2010.

Hammonds, Evelyn M. "Toward a Genealogy of Black Female Sexuality: The Problematic of Silence." In *Feminist Genealogies, Colonial Legacies, Democratic Futures*, edited by M. Jacqui Alexander and Chandra Talpade Mohanty, 170–82. London: Routledge, 1997.

Henry, Yazir. "The Ethics and Morality of Witnessing: On the Politics of Antje Krog (Samuel's) *Country of My Skull*." In *Trauma, Memory and Narrative in the Contemporary South African Novel: Essays*, edited by Ewald Mengel and Michela Borzaga, 107–41. Amsterdam and New York: Rodopi, 2012.

Hermer, Carol. "Preface." In *The Diary of Maria Tholo*, by Carol Hermer and Maria Tholo, ix–x. Johannesburg: Ravan Press, 1980.

Hermer, Carol, and Maria Tholo. *The Diary of Maria Tholo*. Johannesburg: Ravan Press, 1980.

Hill, Shannen. "Iconic Autopsy: Post-Mortem Portraits of Bantu Stephen Biko." *African Arts* 38, no. 3 (Autumn 2005): 14–25, 92–93.

Hoffman, Amy. *Hospital Time*, foreword by Urvashi Vaid. Durham, NC: Duke University Press, 1997.

Ignatieff, Michael. "Introduction." In *Truth and Lies: Stories from the Truth and Reconciliation Commission in South Africa*, by Jillian Edelstein, 15–21. London: Granta Books; and Milpark, South Africa: M&G Books, 2001.

Jonathan Ball Publishers. "The Long Journey of Poppie Nongena." http://www.jonathanball.co.za/index.php?page=shop.product_details&flypage=flypage.tpl&product_id=82&category_id=1&option=com_virtuemart&Itemid=6 (accessed March 30, 2013).

Jones, Amelia. "The 'Eternal Return': Self-Portrait Photography as a Technology of Embodiment," *Signs: Journal of Women in Culture and Society* 27, no. 4 (Summer 2002): 947–78.

Josephy, Svea. "Departures." In *The Cape Town Month of Photography*, edited by Geoffrey Grundlingh, 6–13. Cape Town: South African Center for Photography, 2005.

Joubert, Elsa. *The Long Journey of Poppie Nongena*. Cape Town: Tafelberg, 1980.

Joubert, Pearlie. "I Eat With Robbed Money." *Mail & Guardian*, February 9–15, 2007, 13.

Kasfir, Sidney. "Cast, Miscast: The Curator's Dilemma." *African Arts* 30, no. 1 (Winter 1997): 1–9, 93.

Kincaid, Jamaica. *My Brother*. New York: Noonday, 1998.

Kistner, Ulrike. *Commissioning and Contesting Post-Apartheid's Human Rights: HIV/AIDS, Racism, Truth, and Reconciliation*. Munster: Lit Verlag, 2003.

Klopper, Sandra. "Sacred Fragments: Looking Back at the Art of Paul Stopforth." *African Arts* 37, no. 4 (Winter 2004): 68–73, 96.

Kortjaas, Bareng-Batho, and S'Thembiso Msomi. "Mob Kills Woman for Telling Truth." *Sunday Times of South Africa*, December 27, 1998.

Kruger, Barbara, and Phil Mariani, eds. *Remaking History*. Seattle, WA: Bay Press, 1989.

Legal Resource Center. "2006 Truth and Reconciliation Commission (TRC)." *Legal Resource Center*. http://www.lrc.org.za/papers/436-truth-and-reconciliation-commission-trc (accessed July 18, 2011).

Levinas, Emmanuel. *Basic Philosophical Writings*, edited by Adriaan T. Peperzak, Simon Critchley, and Robert Bernasconi. Bloomington: Indiana University Press, 1996.

———. *Entre Nous: Thinking-of-the-Other*. Translated by Michael B. Smith and Barbara Harshav. New York: Columbia University Press, 1998.

Lewis, Desiree. "Against the Grain: Black Women and Sexuality." *Agenda* 63, no. 2 (2005): 11–24.

Magona, Sindiwe. *Beauty's Gift*. Cape Town: Kwela, 2008.

———. "Leave-Taking." In *Nobody Ever Said AIDS: Poems and Stories from Southern Africa*, edited by Nobantu Rasebotsa, Meg Samuelson and Kylie Thomas, 124–41. Cape Town: Kwela, 2003.

———. *Please, Take Photographs*. Cape Town: Modjaji Books, 2009.
Mail & Guardian. "Men in Court for Rape and Murder of Cape AIDS Activist." January 12, 2004.
Maluleke, Eddie. "Nobody Ever Said AIDS." In *Nobody Ever Said AIDS: Poems and Stories from Southern Africa*, edited by Nobantu Rasebotsa, Meg Samuelson and Kylie Thomas, 17–20. Cape Town: Kwela, 2003.
Mbeki, Thabo. "He Wakened to His Responsibilities," at the Inaugural ZK Matthews Memorial Lecture, University of Fort Hare, Alice, Eastern Cape, South Africa, October 12, 2001.http://www.unisa.ac.za/contents/colleges/docs/2001/tm2001/tm101201.pdf (accessed March 29, 2013).
Mendel, Gideon. *A Broken Landscape: HIV & AIDS in Africa*. London: Network Photographers, 2001. Reprint Barcelona: Blume in association with Action Aid, 2002.
———. "Salvation is Cheap," Online presentation, http://www.guardian.co.uk/flash/mendel.swf (accessed April 12, 2013).
———. "They Have Given Me Life." *Mail & Guardian*, February 15–21, 2002, 24–25.
———. Untitled. *The Digital Journalist*, June 2001. http://digitaljournalist.org/issue0106/voices_mendel.htm (accessed April 1, 2013).
Mengel, Ewald, and Michela Borzaga, eds. *Trauma, Memory and Narrative in the Contemporary South African Novel: Essays*. Amsterdam and New York: Rodopi, 2012.
Michaels, Eric. *Unbecoming*. Sydney: EM Press, 1990.
Monette, Paul. *Love Alone: Eighteen Elegies for Rog*. New York: St. Martin's Press, 1988.
Morgan, Jonathan, and Bambanani Women's Group. *Long Life: Positive HIV Stories*. Cape Town: Double Storey Press, 2003.
Muholi, Zanele. "Faces and Phases." *Stevenson*. Exhibit. http://www.stevenson.info/exhibitions/muholi/facesphases.htm (accessed March 29, 2013).
———. "Mapping Our Histories: A Visual History of Black Lesbians in Post-Apartheid South Africa." *Zanele Muholi*. http://www.zanelemuholi.com/ZM%20moh_final_230609.pdf (accessed March 12, 2013).
———. *Zanele Muholi: Only Half the Picture*. Johannesburg: STE Publishers, 2006.
National Commission on Truth and Reconciliation (Rettig Commission). *Report of the Chilean National Commission on Truth and Reconciliation*, vol. 1. Notre Dame, IN: University of Notre Dame Press, 1993.
Neke, Gael. "[Re]forming the Past: South African Art Bound to Apartheid." Paper presented at the Wits History Workshop, TRC: Commissioning the Past, 1999, 8. http://wiredspace.wits.ac.za/handle/10539/8032 (accessed March 29, 2013).
Ngcobo, Gabi. "Introduction." In *Zanele Muholi: Only Half the Picture*, by Zanele Muholi, 4–5. Johannesburg: STE Publishers, 2006.
Oguibe, Olu, and Okwui Enwezor, eds. *Reading the Contemporary: African Art from Theory to the Market Place*. London: Institute of International Visual Arts, 1999.
Patton, Cindy. *Inventing AIDS*. London: Routledge, 1990.
Petryna, Adriana. *Life Exposed: Biological Citizens after Chernobyl*. Princeton, NJ: Princeton University Press, 2002.
Phelan, Peggy. "Francesca Woodman's Photography: Death and the Image One More Time." *Signs: Journal of Women in Culture and Society* 27, no. 4 (Summer 2002), 979–1004.

Pollock, Griselda. *Differencing the Canon: Feminist Desire and the Writing of Art's Histories.* London: Routledge, 1999.

———. *Encounters in the Virtual Feminist Museum: Time, Space and the Archive.* New York: Routledge, 2007.

Posel, Deborah. "The Post-Apartheid Confessional." *Wiser Review* 2 (December 2006), 8–9.

Posel, Deborah, and Graeme Simpson, eds. *Commissioning the Past: Understanding South Africa's Truth and Reconciliation Commission.* Johannesburg: Witwatersrand University Press, 2002.

Pratt, Minnie Bruce. *Crime Against Nature.* New York: Firebrand Books, 1990.

Rankin, Elizabeth. "Personalising Process: Diane Victor as Printmaker." In *Diane Victor,* by Elizabeth Rankin and Karen von Veh, 4–49. Johannesburg: David Krut, 2008.

Rasebotsa, Nobantu, Meg Samuelson, and Kylie Thomas, eds. *Nobody Ever Said AIDS: Poems and Stories from Southern Africa.* Cape Town: Kwela, 2003.

Richards, Colin. "Drawing a Veil." Paper presented at the Wits History Workshop: The TRC; Commissioning the Past, 11–14 June, 1999. http://wiredspace.wits.ac.za//handle/10539/8062 (accessed October 12, 2010).

Robins, Steven, and Bettina von Lieres. "Remaking Citizenship, Unmaking Marginalisation: The Treatment Action Campaign in Post-apartheid South Africa." *Canadian Journal of African Studies [Canadienne des Études Africaines]* 38, no. 3 (2004): 575–86.

Rose, Gillian. *Mourning Becomes the Law: Philosophy and Representation.* Cambridge: Cambridge University Press, 1996.

Ross, Fiona. *Bearing Witness: Women and the Truth and Reconciliation Commission in South Africa.* London: Pluto, 2003.

Sanders, Mark. "Ambiguities of Mourning: Law, Custom, and Testimony of Women before South Africa's Truth and Reconciliation Commission." In *Loss: The Politics of Mourning,* edited by David L. Eng and David Kazanjian, 77–98. Berkeley: University of California Press, 2003.

Schrire, Carmel, Rustum Kozain, and Yvette Abrahams. "'Miscast': Three Views on the Exhibition curated by Pippa Skotnes with Jos Thorne in the South African National Gallery (14 April–14 September 1996)." *Southern African Review of Books* 44 (July-August 1996). http://web.uct.ac.za/depts/sarb/X0034_Miscast.html (Accessed 29 April, 2013).

Sedgwick, Eve Kosofsky. *Between Men: English Literature and Male Homosocial Desire.* New York: Columbia University Press, 1985.

Simpson, David. *9/11 The Culture of Commemoration.* Chicago: University of Chicago Press, 2006.

Sontag, Susan. *Illness as Metaphor.* New York: Farrar, Strauss and Giroux, 1978.

———. *On Photography.* New York: Penguin, 1979.

———. *Regarding the Pain of Others.* London: Penguin, 2003.

Spivak, Gayatri Chakravorty. "Can the Subaltern Speak?" In *Colonial Discourse and Post-Colonial Theory: A Reader,* edited by Patrick Williams and Laura Chrisman, 66–111. London: Harvester Wheatsheaf, 1993.

Stevenson, Michael. "Diane Victor, *Smoke Portraits.*" *Stevenson.* Exhibit. http://www.stevenson.info/exhibitions/victor/smoke.htm (accessed March 29, 2013).

———. "Pieter Hugo, *The Bereaved*." Stevenson. Exhibit. http://www.stevenson.info/exhibitions/hugo/aids.htm (accessed March 29, 2013).

———. "Zanele Muholi: *Only Half the Picture*." Stevenson. Exhibit. http://www.stevenson.info/exhibitions/muholi/muholi.htm (accessed March 29, 2013).

Swartz, Sally. "Can the Clinical Subject Speak? Some Thoughts on Subaltern Psychology." *Theory and Psychology* 15, no. 4 (2005): 505–25.

Thomas, Kylie. "Between Life and Death: HIV and AIDS and Representation in Southern Africa." Unpublished PhD diss., University of Cape Town, 2007.

———. "Bodies of Courage." In *Embodiment / Verkörperungen*, edited by Christina Lammer, Kim Sawchuk and Cathrin Pichler, 99–111. Vienna: Löcker, 2007.

———. "The Power of Naming: 'Senseless Violence' and Violent Law in Post-apartheid South Africa." available online on the Center for the Study of Violence and Reconciliation website, http://www.csvr.org.za/images/docs/VTP3/k_thomas_the_power_of_naming_senseless_violence_and_violent_law_in_post_apartheid_sa.pdf (accessed April 29, 2013).

———. "Selling Sorrow: Testimony, Representation and Images of HIV-positive South African Women." *Social Dynamics: A Journal of African Studies* 34, no. 2 (2008): 216–26.

———. "Homophobia, Injustice and 'Corrective Rape' in Post-Apartheid South Africa" http://www.csvr.org.za/images/docs/VTP3/k_thomas_homophobia_injustice_and_corrective_rape_in_post_apartheid_sa.pdf (accessed April 29, 2013).

Thomas, Kylie, Nodumiso Payi, Lamla Kete, and Jonathan Morgan. *Clutching onto Hope*. Center for Social Science Research Publications: University of Cape Town, 2002.

Treichler, Paula. "AIDS and HIV Infection in the Third World: A First World Chronicle." In *Remaking History*, edited by Barbara Kruger and Phil Mariani, 31–86. Seattle: Bay Press, 1989.

———. "AIDS, Homophobia and Biomedical Discourse: An Epidemic of Signification." In *AIDS: Cultural Analysis and Cultural Activism*, edited by Douglas Crimp, 31–70. Cambridge, MA: MIT Press, 1991.

Trengrove Jones, Tim. "Simple AIDS Vision Belongs in Museum." *Sunday Independent*, June 16, 2002.

Truth and Reconciliation Commission. *The Truth and Reconciliation Commission Report*. 5 vols. Cape Town: Juta, 1998.

UNAIDS HIV/AIDS Sub-Saharan Africa Regional Factsheet. https://www.unaids.org/en/media/unaids/contentassets/documents/epidemiology/2012/gr2012/2012_FS_regional_ssa_en.pdf (accessed April 4, 2013).

Van Robbroeck, Lize. "Visibly Absent: Jean Brundrit's Photography as Radical Archiving." In *A Lesbian Story: an exhibition Project by Jean Brundrit*. Cape Town, 2008, 28–33.

Van Wyk, Lisa. "Xingwana: Homophobic Claims 'Baseless, Insulting.'" *Mail & Guardian Online*, March 5, 2010, http://www.mg.co.za/article/2010-03-05-xingwana-homophobic-claims-baseless-insulting (accessed June 18, 2010).

Von Veh, Karen. "Gothic Visions: Violence, Religion and Catharsis in Diane Victor's Drawings." In *Diane Victor*, by Elizabeth Rankin and Karen von Veh, 50–95. Johannesburg: David Krut, 2008.

Watney, Simon. "AIDS, Language and the Third World." In *Taking Liberties: AIDS and Cultural Politics*, edited by Erica Carter and Simon Watney, 183–92. London: Serpent's Tail, 1989.

Williams, Patrick, and Laura Chrisman, eds. *Colonial Discourse and Post-Colonial Theory: A Reader*. London: Harvester Wheatsheaf, 1993.

Xingwana, Lulama. "Address by the Minister of Arts and Culture, Ms Lulama Xingwana, MP at the launch of Moral Regeneration Month, Polokwane." *Department of Arts and Culture*, July 11, 2009. http://www.dac.gov.za/speeches/minister/2009/11Jul09Speech.html (accessed July 2, 2010).

Xingwana, Lulu. "Statement by Minister of Arts and Culture Ms Lulu Xingwana on Media Reports Around the Innovative Women Exhibition." *Department of Arts and Culture*. March 3, 2010. http://www.dac.gov.za/media_releases/2010/04-03-10.html (accessed July 2, 2010).

Index

A Broken Landscape, 62–73
Achmat, Zackie, 1, 80, 116–117
Adams, Parveen, 49–50
African AIDS, discourse of, 23, 80, 97–99
Agamben, Giorgio, 127
agency, HIV/AIDS and, 80
AIDS and Society Research Unit (University of Cape Town), 2, 23
AIDS Coalition to Unleash Power (ACT UP), 80
AIDS denialism, 116–117, 121n32, 151
AIDS in Context conference, 1
AIDS Law Project, 8, 114
Alexander, Jane, 142–43, 143, 147n43
anti–retroviral therapy (ART): access to, 2, 3–4, 7, 62, 79, 85n36, 151; effects of, 3, 5. *See also* AIDS denialism; Médecins Sans Frontières program, 3–6; SA government program, 3, 4, 152
apartheid: effect on HIV/AIDS epidemic, 117–118, 152; political funerals, 112–113; student uprising 1976, 111; States of Emergency, 111
archive, 50, 123–125, 145n18
asymmetry of intersubjectivity, 94
authenticity, self–portraits and, 17–18

bad death, 123, 144n1
Bambanani Women's Group, 23. *See also* body maps; *Long Life* book project
Barthes, Roland, 35, 39–40, 50–51, 62, 66–69, 95, 143
Bauer, Derek, 134–135
Benjamin, Walter, 95, 102
The Bereaved series, 8, 88, 95-103, *96, 98, 99, 101*, 103n7
Bernstein, Hilda, 125, 126
Biko, Belgium, 130–132, *133*
Biko, Ntsiki, 130, *132*
Biko Series, 128, *137, 138*, 140
Biko, Stephen Bantu (Steve): circumstances of his death, 125–127; death and Truth and Reconciliation Commission, 127, 128, 129–134; funeral, 127; icon, 141; inquest into death, 126; *I Write What I Like*, 144; photograph of corpse, 127, 128; visual representations of, *129, 133, 134, 135, 137, 138, 140, 142, 143*
Biko: The Quest for a True Humanity (exhibition), 145n19
Bizos, George, 133
Black Consciousness Movement, 126
Black People's Convention, 126–127

166 *Index*

body maps, 13–34; exhibitions, 16; images, *15, 19, 21, 31*
body perception, HIV/AIDS and, 20, 22–23
Bourdieu, Pierre, 104n29
Brundrit, Jean, 37
Butler, Judith, 45, 88, 100, 108

Camera Lucida, 40–41, 62
Cameron, Edwin, 9, 11n18
Camus, Albert, 94
Canova, Antonio, 36, 49
"Can the Subaltern Speak?", 24, 26
Cape Town social geography, 2–3
Cavarero, Adriana, 45
Center for Popular Memory (University of Cape Town), 30–31n1
Chambers, Ross, 9, 50, 147, 154n1
Chow, Rey, 28
citizenship and HIV/AIDS, 151–152
confession, secularisation of the ritual of, 25–26
corrective rape, 6, 35, 46–49, 57n4. *See also* hate crimes
curative rape. *See* corrective rape

Das, Veena, 123, 144n1
Delbo, Charlotte, 107
Della Grace. *See* Del LaGrace Volcano
Del LaGrace Volcano, 49–50
Derrida, Jacques, 26–27, 124
de Vlieg, Gille, *109, 118*
The Diary of Maria Tholo, 8, 108, 109–113
documentary photography in South Africa, 81–83

Edelstein, Jillian, *129*, 129–134, *131, 132, 133*

Forum for the Empowerment of Women, 37
Foucault, Michel, 25–26, 28–29
Free Gender, 37

Freud, Sigmund, 119n6
Fried, Michael, 68–69
From Pierneef to Gugulective, 1910–2010 (exhibition), 134

genre-jacking, 50, 51–52
Gqola, Pumla Dineo, 36
Gugulethu, 109, 110, 111, 114
guilt, metaphysical, 144

The Harsh Divide series, 83
hate crimes: against black lesbians, 44–49. *See also* corrective rape; against people with HIV/AIDS, 120n23. *See also* stigma and HIV/AIDS
Hermer, Carol, 108
Hoffman, Amy, 87–88
Hugo, Pieter, 7–8, 88, 95–103, *96, 98, 99, 101*

Ignatieff, Michael, 130
Inkanyiso, 37
Innovative Women exhibition, 38
International AIDS Conference 2000 (Durban), 80
invisibility. *See* visibility / invisibility

Jaspers, Karl, 144
Jones, Amelia, 17
Josephy, Svea, 81–82
Joubert, Elsa, 110, 119n11

Kalavrita massacre, 107
Khayelitsha, 1–5, 10n1–10n3, 16, 81, 88, 103n8
kingdom of the well, 150
Klopper, Sandra, 138–139
Kruger, James Thomas (Jimmy), 136

"Leave-Taking," 8, 108, 114–116
Legae, Ezrom, 134, *134*
Levetan, Ronnie, 110
Levinas, Emmanuel, 45, 94–95
Lewis, Desiree, 36

Long Life book project, 6, 13, 14, 16
loss, publicly ungrievable, 88–90, 114–118
Louw, Ronald, 116–117

Madikida, Churchill, 89, 104n17
Magona, Sindiwe, 108, 114–116, 120n22
Make Art/Stop AIDS, 83, 149
Maluleke, Eddie, 150–151
Malevu, Mzokhona, portraits of, 74–79, *75*, *77*, *78*
Mandela, Nelson, 149–150
Matibi Mission Hospital series, 65–73, *64*, *65*, *70*, *71*, *73*
Mbeki, Thabo, 121n32
Médecins Sans Frontières, 3, 16, 81, 85n36, 114
Memory Box Project, 2, 3
Mendel, Gideon, 4, 7, 29, 61–85, *64*, *65*, *70*, *71*, *73*, *75*, *77*, *78*, *80*, *81*, *99*, *153*
mourning, 50–51, 107–118. *See also* loss, publicly ungrievable
Muholi, Zanele, 6–7, 35–59, *41*, *43*, *44*, *45*, *47*, *48*, *53*, *54*, *56*
Murray, Brett, 136

Names Project AIDS Memorial Quilt, 100
national melancholia, 108
Neke, Gail, 136, 139
Ngcobo, Gabi, 36
Nhlengethwa, Sam, 135, *135*
Nieuwoudt, Gideon Johannes, 130, 131, *131*
"Nobody Ever Said AIDS," 150–151

Only Half the Picture series, 42–49, *42*, *44*, *45*, *47*, *48*
On Photography, 39, 61–62

passing, 35, 50, 51–52, 55
photography: affective power, 61–62; death. *See* photography and death;
denoted message and connoted message, 40; *studium* and *punctum*, 35, 40–41, 50–51, 66–69, 143; symbolic power, 39–40
photography and death: circulation of photographs of the dead, 62, 97–100, 127–28; foreshadowing of death, 50–51, 74, 95, 143; memorial photography, 35, 51–55, 74
photographing the moment of death, 71–72; voyeurism, 67
political funerals, 112–113
Pollock, Griselda, 36–37, 50
portraiture, 51, 52, 74–76, 80–83, 88, 95. *See also* body maps; photography and death
Positive Lives (exhibition), 4, 80–81
poverty and HIV/AIDS, 150
protest art versus post–apartheid art, 136
punctum. See studium and *punctum*

queer subjectivity, 37–42, 50–55

Red Cross (Khayelitsha), 3
repression, 123–125, 136–138

Smoke Portraits series, 7, 88, 89–95, *91*, *92*, *93*, *front cover*
Sontag, Susan, 39, 61–62, 99, 105n32, 143, 150
South African Students Organization, 126
Spivak, Gayatri, 24, 26–28
statistics, AIDS, 2, 4, 9, 10n5, 61, 85n36, 150
Status exhibition, 89, 104n17
Steve Biko—In Memoriam, 134–135
Steve Biko is Dead, 136
stigma, HIV/AIDS and, 22, 114–116, 120n23, 151
Stopforth, Paul, 128, 137–141, *137*, *138*, *140*, *142*
studium and *punctum*, 35, 40–41, 50–51, 66–69, 143
subaltern subjectivity, 24–28
Swartz, Sally, 24

testimony, 25, 76, 79, 88, 149
Tholo, Maria, 108
The Three Graces, 36, 49–50
"Through Positive Eyes" project, 83
Treatment Action Campaign, 1, 7, 79–80, 114, 116
Truth and Lies, 129–134
Truth and Reconciliation Commission, 25, 82, 107

Victor, Diane, 7, 88, 89–95, *91*, *92*, *93*, *front cover*
visibility / invisibility, 16, 18, 25, 37, 50, 52, 55, 123, 127, 152

von Veh, Karin, 89
vulnerability, 16, 22–23, 25, 43, 49, 66, 90, 132, 142–143

witnessing. *See* testimony
women in art, representation of, 23, 36–37, 49–50
World AIDS Day, 151, 152

Xingwana, Lulama (Lulu), 35–36, 38–39, 42

Zuma, Jacob, 151

About the Author

Kylie Thomas is senior lecturer in visual studies in the Department of Fine Art at Rhodes University, Grahamstown, South Africa.